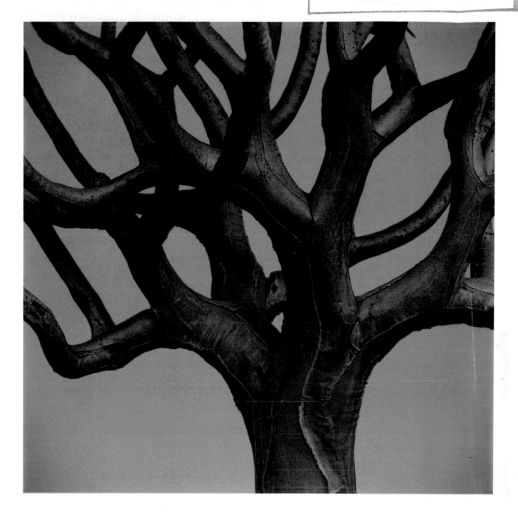

Wildlife Photographer of the Year

Portfolio 12

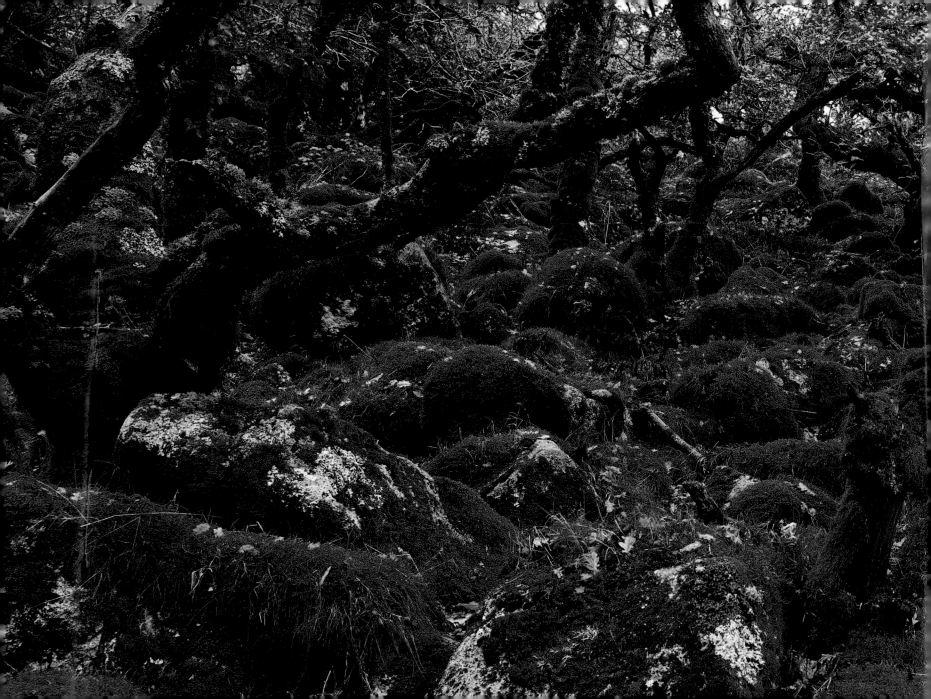

Wildlife Photographer of the Year

Portfolio 12

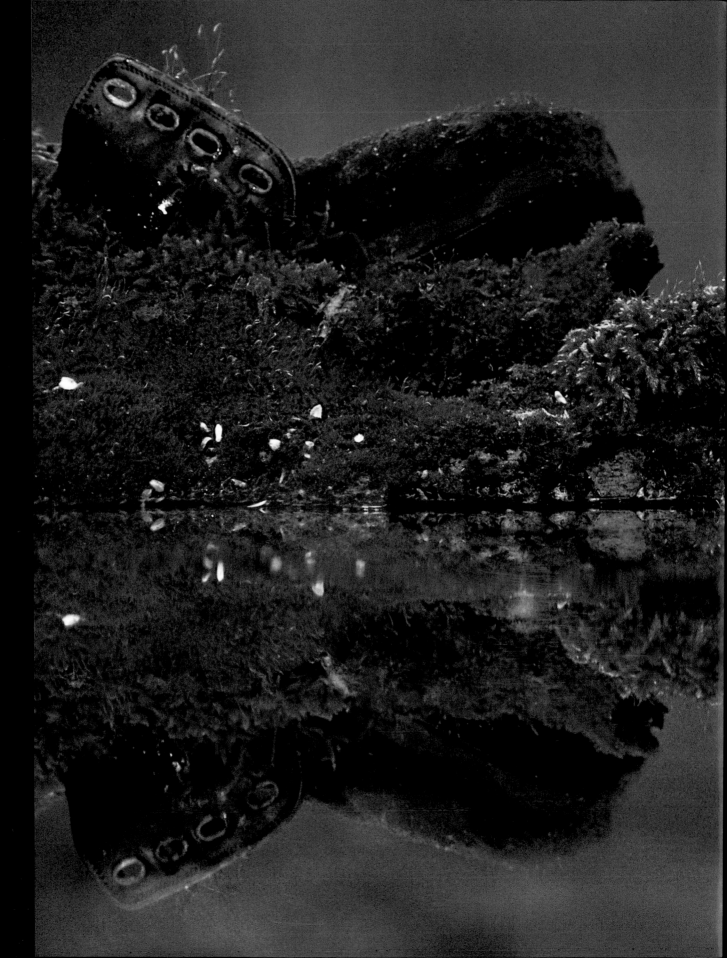

Published by
BBC Worldwide Limited,
Woodlands,
80 Wood Lane,
London W12 OTT

First published 2002

Compilation and text
© BBC Worldwide 2002
Photographs © the individual
photographers 2002

Managing editor
Rosamund Kidman Cox
Editor
Siski Green
Designer
Alex Evans
Jacket designer
Pene Parker
Caption writers
Rachel Ashton
Tamsin Constable
Production controller
Christopher Tinker

Competition manager
Sarah Kavanagh

ISBN 0 563 48819 0

Printed and bound in
the UK by Butler & Tanner
Limited, Frome

Jacket printed by
Lawrence-Allen Limited,
Weston-super-Mare

Colour separations by
Pace Digital Limited,
Southampton

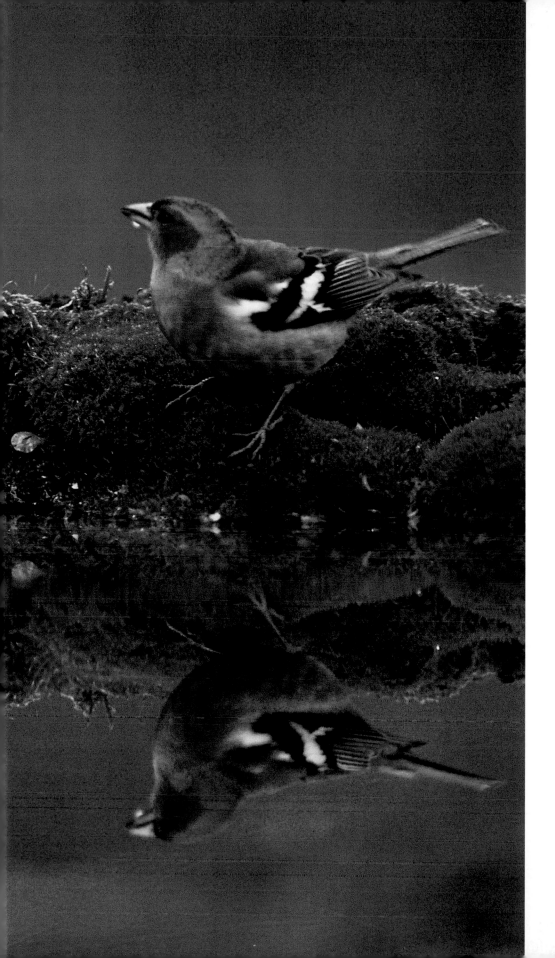

Contents

Grey reef shark by Tobias
Bernhard, the BG Wildlife
Photographer of the Year 2001.

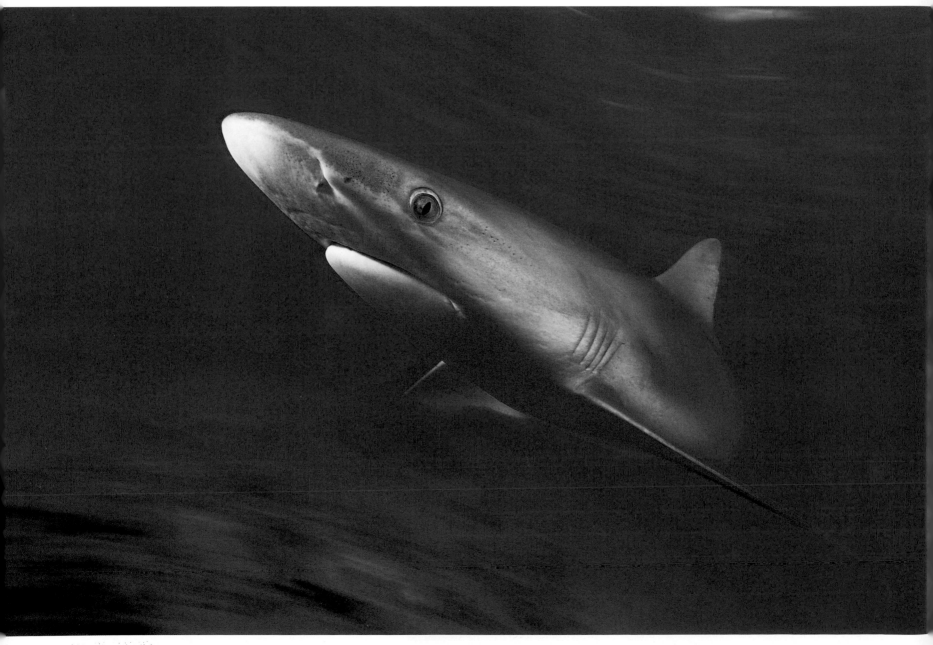

Foreword

by Simon King

In an increasingly virtual world, where even the savagery of the most hostile and challenging of elements is available in coffee-table format, it is all too easy to feel that we have all been there, done that. But we haven't. Far from it. All but a few, that is. And it is the industry of those few that graces the following pages. The trouble lies in our expectations. We have such ready access to increasingly splendid photographic views of the world around us that it is easy to feel we may have actually experienced these things. And then, if we see once more something that bears resemblance to an earlier view, we may tend to be jaded, dulled by an abundance of riches. But look again. Look deeper into what made the photographer tick – or click – and you will see something fresh, something vibrant and new. Ironically perhaps, it is the very people who dedicate their lives to visiting and revisiting wild places and recording them in photographs or film that find themselves hooked. A glance through past editions of this portfolio will see familiar names, great photographers who, again and again, return to their favoured haunts or new pastures for a fix of their wild drug.

We are an essentially lazy species. We want everything for nothing. Even the energy or planning it takes to realise dreams of experiencing wild places and events is too great a price to pay for some. Thank heavens, then, for those with the spirit, the initiative and the drive to get out there and do it. And thank heavens, too, that some are prepared to spend the time and effort to record their experiences, visions and events for all to see.

Some people may talk of certain phenomena – bears catching fish, big cats pulling down antelope – as though they are passé, that we've had enough of such natural spectacles. But how can we ever have enough? It comes down, once again, to what we think we know, rather than what we truly know.

Strangely perhaps, quite the opposite applies to some elements of the human world. Millions are delighted to tune in to soap operas, football matches and any number of other tv shows, which are distinctive only by virtue of the subtle twists that may be enacted through story-telling or fate. And perhaps herein lies the key. We are delighted by familiarity, so long as there is the chance of the unexpected.

As you look through this book, you will see many familiar elements. Lions, elephants, bears, flowers, trees, all things we know at a glance. But nothing within these pages has ever happened before, or will ever happen again. That is the definitive truth of photography. Furthermore, great photography has the capacity to turn the spotlight on the unexpected, to bring the eye to the focus of what makes every moment unique. The competition that spawns this magnificent collection, is undoubtedly one of the most prestigious in the world, encouraging photographers to ever greater feats and achievements. Is it simply the prospect of winning that drives these people on? Nothing could be further from the truth. Almost without exception, it is a passion for the wild world that inspires, drives and thrills the exponents of the art.

The remarkable gallery that follows, each image selected from thousands of the very best in the world, is more than the result of a competition. It is the expression of those people for whom every day, and every moment is a marvel – for whom the difference in every day, be it subtle or otherwise, is reason enough to get out there and witness such diversity first hand. And wittingly or otherwise, the winning photographers are playing an ambassadorial role. Not simply for wildlife photography, or indeed the conservation of the natural wonders of the world, but for the spirit of adventure. Each of the people whose work features in this book have done it; made the effort, got off their backsides and pursued a dream. So in addition to creating the substance that celebrates the world about us, they also send a clear message. Whatever you may think you have seen, you ain't seen nothing yet.

The competition

This is a showcase for the very best photography worldwide featuring natural subjects. It is organised by two UK institutions that pride themselves on revealing and championing the diversity of life on Earth – The Natural History Museum and *BBC Wildlife* Magazine – and is sponsored by the BG Group.

Its origins go back as far as 1964, when the magazine was called *Animals* and there were just three categories and about 600 entries. It grew in stature over the years, and in 1984, *BBC Wildlife* and The Natural History Museum joined forces to create the competition as it is today, with the categories and awards you see in this book. Now there are up to 20,000 entries and exhibitions touring through the year, not only in the UK but also worldwide, from the US and Caribbean and South Africa, through Europe to Kazakhstan and Pakistan and across to Australia, Japan and China. As a result, the photographs are now seen by millions of people.

The aims of the competition are:

- To raise the status of wildlife photography into that of mainstream art.

- To be the world's most respected forum for wildlife photographic art, showcasing the very best photographic images of nature to a worldwide audience.

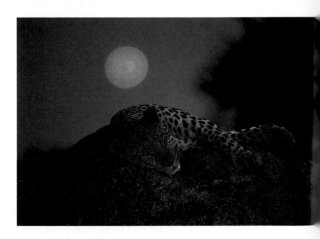

- To inspire a new generation of photographic artists to produce visionary and expressive interpretations of nature.

- To use its collection of inspirational photographs to make people, worldwide, wonder at the splendour, drama and variety of life on Earth and so care about its future.

The judges put aesthetic criteria above all others but at the same time place great emphasis on photographs taken in wild and free conditions, considering that the welfare of the subject is paramount.

Winning a prize in this competition is something that most wildlife photographers, worldwide, aspire to. Professionals do win many of the prizes, but amateurs succeed, too, since achieving the perfect picture is down to a mixture of vision, luck and knowledge of nature, which doesn't necessarily require an armoury of equipment and global travel, as the pictures by young photographers so often emphasise.

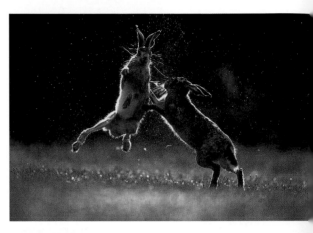

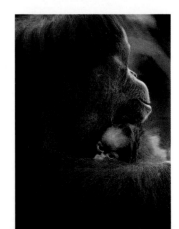

BG Wildlife Photographer
of the Year award-winners:
Common tern fishing
by Tapani Räsänen, 1997.
Boxing hares
by Manfred Danegger, 1998.
Leopard with a rising moon
by Jamie Thom, 1999.
Orang-utan and baby
by Manoj Shah, 2000.

The judges

Frances Abraham
Picture researcher

Cherry Alexander
Wildlife photographer

Simon Bishop
Art editor,
BBC Wildlife Magazine

Ysbrand Brouwers
Artists for Nature Foundation

Giles Clarke
Botanist and
exhibition specialist

Tui De Roy
Wildlife photographer

Rosamund Kidman Cox
Editor, *BBC Wildlife* Magazine

Simon King
Wildlife film-maker,
photographer and presenter

John Norris Wood
Professor of natural-history
illustration, Royal College of Art

Ben Osborne
Wildlife photographer

Chris Packham
Wildlife film-maker,
photographer and presenter

Tim Parmenter
Head of the photographic unit,
The Natural History Museum

Kirsten Sowry
Picture researcher,
BBC Wildlife Magazine

Vickie Walters
Picture researcher

Staffan Widstrand
Wildlife photographer

BG Group

BG Group is proud to
once again be part of this
prestigious competition.
As an international business,
BG is delighted to have the
opportunity to tour the Wildlife
Photographer of the Year
Exhibition throughout the
world and to support the local
communities in the countries
of our international interests.
The places we have taken it
to have included Kazakhstan,
Egypt, Trinidad and Tobago
and India.

Over the years, the stature
of this competition has
reached successive new
heights. As an international
company, we have felt an
affinity with its aims and
aspirations. We applaud the
winning entries shown in this
portfolio and hope that you,
the reader, will also take time
to reflect on the powerful
images displayed here.

www.BG-Group.com

The Natural
History Museum

Home to one of the world's
most important collections of
natural history specimens and
one of London's most beautiful
landmarks, The Natural History
Museum is highly regarded
for its pioneering approach to
exhibitions, welcoming this
year more than two million
visitors of all ages and levels
of interest.

The Wildlife Photographer
of the Year is one of the
Museum's most successful
and long-running special
exhibitions, and we are proud
to have helped to make it the
most prestigious photographic
competition of its kind in the
world. The annual exhibition of
award-winning images – now
in its nineteenth year – attracts
a large audience who come
not only to admire the
stunning images but also to
gain an insight into important
global concerns such as
conservation, pollution and
biodiversity – issues at the
heart of the Museum's work.
This year the exhibition opens
alongside Phase One of the
Darwin Centre, a significant
new development for the
Museum, which reveals for
the first time the incredible
range of our collections and
the scientific research they
support. Both projects
celebrate the beauty and
fascination of the natural
environment and encourage
visitors to see the world
around them with new eyes.

For further information
visit the Museum website at
www.nhm.ac.uk
or call The Natural History
Museum on
+44 (0)20 7942 5000,
e-mail
information@nhm.ac.uk
or write to us at
Information Enquiries,
The Natural History Museum,
Cromwell Road,
London SW7 5BD.

BBC Wildlife Magazine

BBC Wildlife is Britain's leading
monthly magazine on natural
history and the environment.
It contains the best and most
informative writing of any
consumer magazine in its field,
along with world-class wildlife
photography. The latest
discoveries, insights, views and
news on wildlife, conservation
and environmental issues in the
UK and worldwide accompany
regular photographic profiles
and portfolios. The magazine's
aim is to inspire readers with
the sheer wonder of nature
and to present them with a
view of the natural world that
has relevance to their lives.

Further information
BBC Wildlife Magazine,
Broadcasting House,
Whiteladies Road,
Bristol BS8 2LR.
wildlife.magazine@bbc.co.uk

Subscriptions
Tel: +44 (0)1795 414748
Fax: +44 (0)1795 414725
wildlife@galleon.co.uk
Quote WLPF02 for the latest
subscription offer.

The BG Wildlife Photographer of the Year Award

Angie Scott

This is the photographer whose picture has been voted 'best of the year', as being the most striking and memorable of all the competition's entries. In addition to a big cash prize, the award winner receives the coveted title BG Wildlife Photographer of the Year.

Angie Scott was born and raised in Africa, and her lifelong passion for photography dates from childhood memories of her first darkroom hidden away under the stairs in her parents' home. Her love of Africa's wild places, photography and art found the perfect outlet as a career when she met her husband, wildlife photographer Jonathan Scott. They have been able to share their enthusiasm for Africa, its people and its wildlife, and to work as a team, travelling around the world collecting material for their books and television programmes.

AFRICAN ELEPHANT FAMILY WATCHING A GREY HERON

I had seen elephants crossing at this beautiful spot on the Luangwa River in Zambia's South Luangwa National Park the day before and had decided to return in the morning to try to photograph them. I had just got myself settled under a bush when this family came trundling down the sandy bank, eager to cool off and drink. Once in the shallows, they relaxed, and the water settled back to its former glassy stillness. A grey heron plopped down in front of them, ready to catch any fish they stirred up, and this became the focus of their attention for a moment, providing that extra element I needed for the composition. Then, as the matriarch led her family across, the youngest calf started splashing and rolling, thrashing the water with its tiny trunk, barely able to contain its own boundless energy. It was priceless. The others stopped and waited patiently, almost as if in a trance (or maybe simply dozing), eventually nudging the calf along until, finally, they reached the other bank. **Canon EOS-1V with 500mm lens; 1/250 sec at f4.5; Fujichrome Velvia 50; image stabiliser; polarising filter; tripod.**

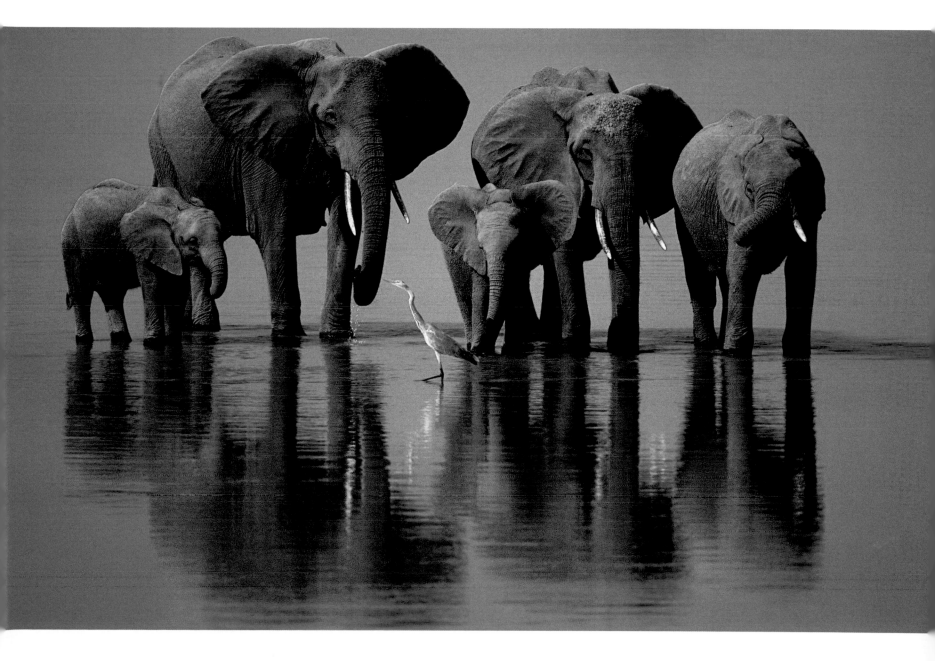

The Gerald Durrell Award for Endangered Wildlife

This award commemorates the late Gerald Durrell's work with endangered species and his long-standing involvement with the competition. It features species that are critically endangered, endangered, vulnerable or at risk (as officially listed in the IUCN Red List of Threatened Species).

Raised in Brazil, Michael has been an avid conservationist since childhood. Fishing trips to the Amazon and abroad during his formative years whetted his appetite for exploration. At 18, he moved to the US to attend university and to begin his career in advertising, consulting and financial services. In 1991, he relocated to South Florida. With the Gulf Stream at his doorstep, he traded his fishing rod for an underwater camera and began photographing the area's rich marine life – a pastime that soon became an occupation. For the past 10 years, he has travelled extensively as a photographer and writer, concentrating primarily on sealife and environmental issues. His work, widely published, aims to educate and communicate to others the beauty and fragility of the oceans – and the need to protect them.

WINNER

Michael Patrick O'Neill
USA/Brazil

LEATHERBACK TURTLE AND REMORAS

Diving off Florida's Juno Beach, I spotted what looked like drifting debris. As I approached, I saw the pale bellies of remoras jiggling in the current. To my amazement, I realised they were hitching a ride on a two-metre leatherback, a species that lives in the open ocean and is usually seen only when coming ashore to lay eggs (fewer than 26,000 nesting females remain worldwide, and the population is severely threatened by poaching, habitat loss, pollution and entanglement in fishing gear). Suddenly, the female shrugged her massive flippers, briefly dislodged the remoras, then succumbed to her natural curiosity and swam over to check me out. That day, I felt like the luckiest photographer on the planet.
Nikon N90s with 20mm lens; 1/125 sec at f4; Fujichrome Provia 100F; underwater housing; two strobes.

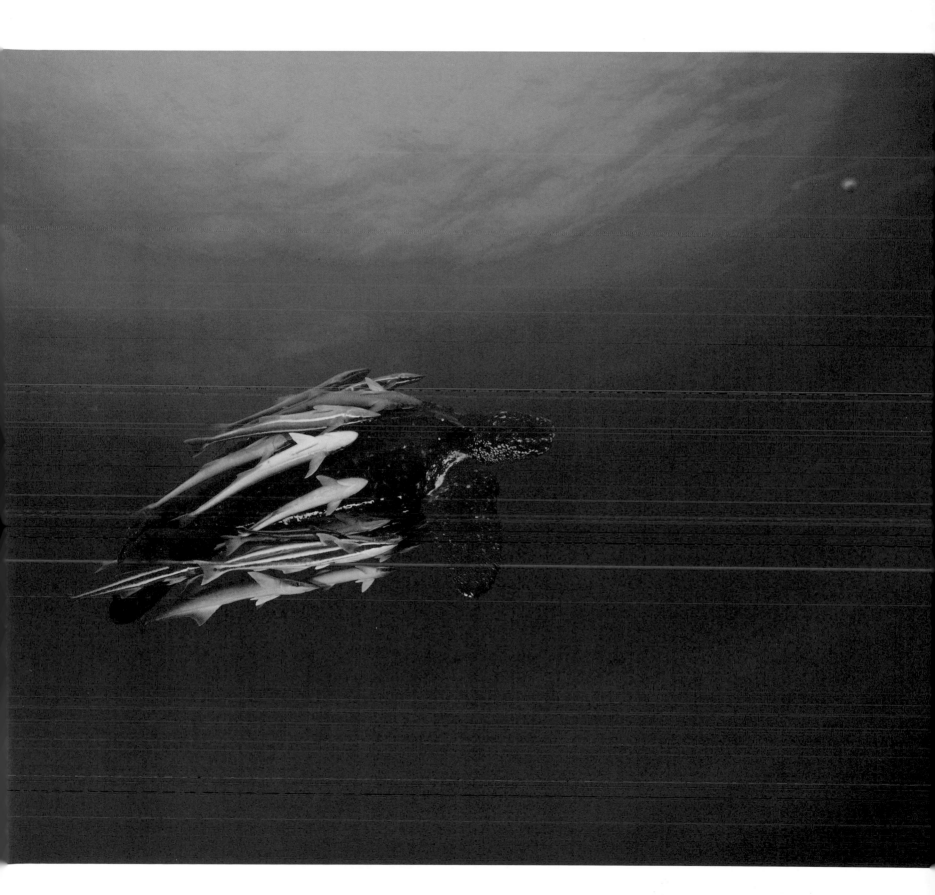

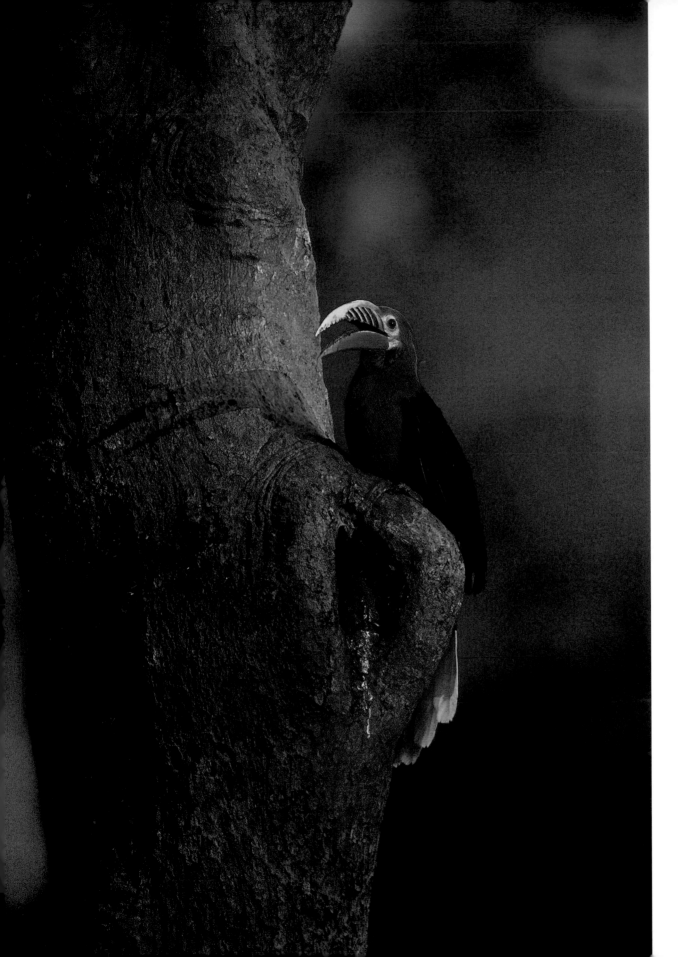

Tim Laman
USA

RUFOUS-NECKED HORNBILL

This male was perched just above his nest opening, inside which his mate had sealed herself. She was to remain entombed there, dependent on the male for provisions through the incubation and chick-rearing period. I took this picture late one afternoon just after the male had made a food delivery. Pausing on his perch, he cast a shadow of his remarkable bill on the tree trunk.

Once found from Nepal to Vietnam, the rufous-necked hornbill is now extinct in parts of its range and barely hanging on in others. One of its remaining strongholds are the mountainous regions of Thailand, such as Huai Kha Khaeng Wildlife Sanctuary, where I worked with researchers from the Thailand Hornbill Project.

Canon EOS 1N with 600mm lens; 1/250 sec at f5.6; Fujichrome Provia 100; tripod; hide.

HIGHLY COMMENDED

Stephen Hogg
UK

PROBOSCIS MONKEYS

Living exclusively on the island of Borneo, these elusive, odd-looking monkeys survive in mangroves along the rivers. On a quest to photograph this endangered primate, my wife and I finally located an oil-palm estate in the Labuk Bay area where sightings were supposedly almost guaranteed. This was because the estate owner had (unusually) kept an area of natural jungle at the edge of the mangroves for a family of proboscis monkeys. After a short wait, we were rewarded with the remarkable sight of the whole family – adults and juveniles – coming to the mangrove edges to feed and play.

Canon EOS-1V HS with 70-200mm lens; 1/30 sec at f5.6; Fujichrome Provia 100; 2x extender; tripod.

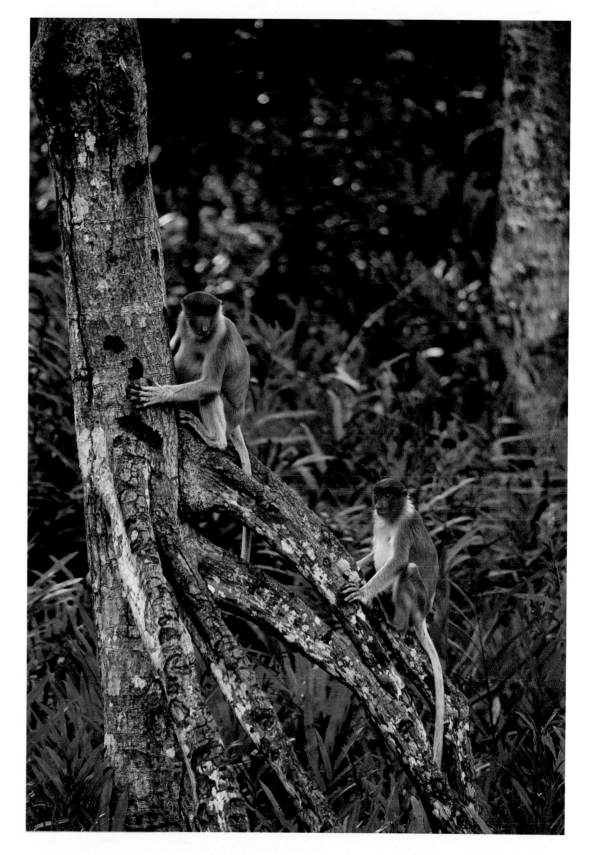

Erik Schlögl
Germany

SAND TIGER SHARK

These endangered sharks congregate at a rock overhang just a few hundred metres off Sydney, Australia. Sand tigers (also called grey nurse sharks) are unusual as they hunt co-operatively, and by swallowing air, they can maintain neutral buoyancy and hover motionless in the water. In 1984, the sand tiger became the first shark to receive official protection – initially in New South Wales, then in other parts of the world. This has failed to halt its drastic decline. Many are still accidentally hooked on fishing gear, and it is now at risk of becoming the first marine species to become locally extinct in Australia. Initiatives to protect at least the key aggregation sites from fishing have so far been rejected by the NSW government catering to the recreational-fishing lobby.

Nikon F801s with 24mm lens; 1/60 sec at f5.6; Fujichrome Sensia 100; underwater housing; flash.

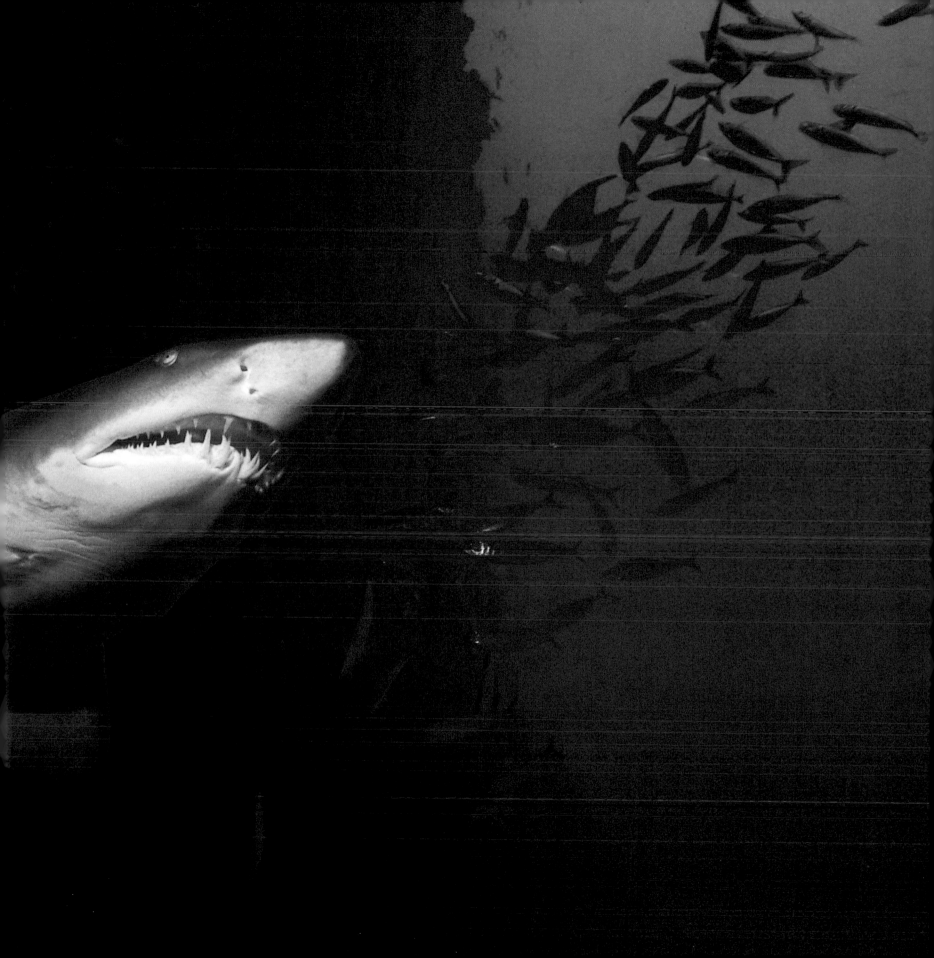

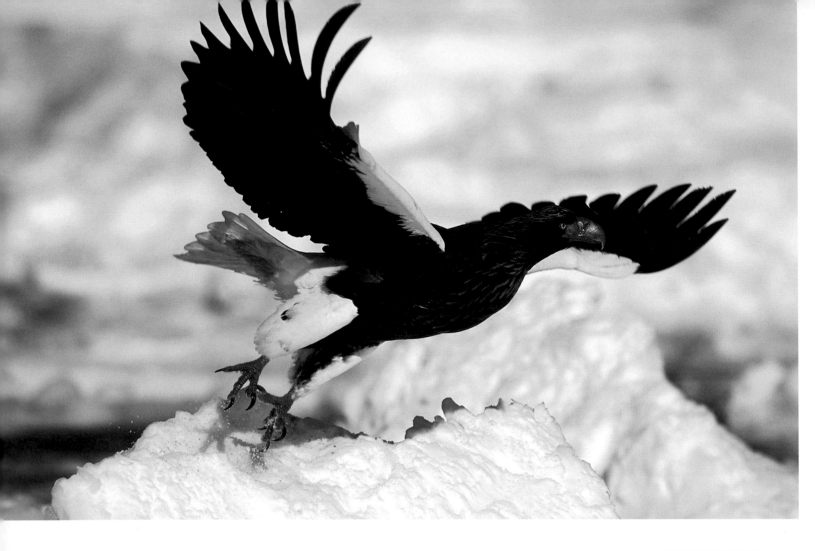

Vincent Munier
France

STELLER'S SEA EAGLE

I photographed this individual by the frozen sea at Okhotsk between the Shiretoko Peninsula, Japan, and Kunashiri Island, Russia. These eagles are stunning birds with wingspans measuring more than two metres, and for years I have dreamt of photographing one. They are found from Kamchatka in Russia to the northern island of Hokkaido, Japan and are threatened by overfishing.

Nikon F5 with 600mm lens; 1/500 sec at f5.6; Fujichrome Provia 100; tripod.

Takako Uno
Japan

GREAT WHITE SHARK

South Africa is a hotspot for the ocean's largest toothed predator, the great white shark. Though visibility is usually quite poor around Dyer Island, on this particular day the water was clear. As I looked up from the shark cage three metres below the surface, shafts of light beamed through the glassy surface as this four-metre-long shark banked sideways and lifted its snout towards the light, striking a rather elegant pose. Surely no other shark could create such an atmosphere of power, ferocity and grace.

Nikonos V with 15mm lens; 1/60 sec at f4; Fujichrome Provia 100.

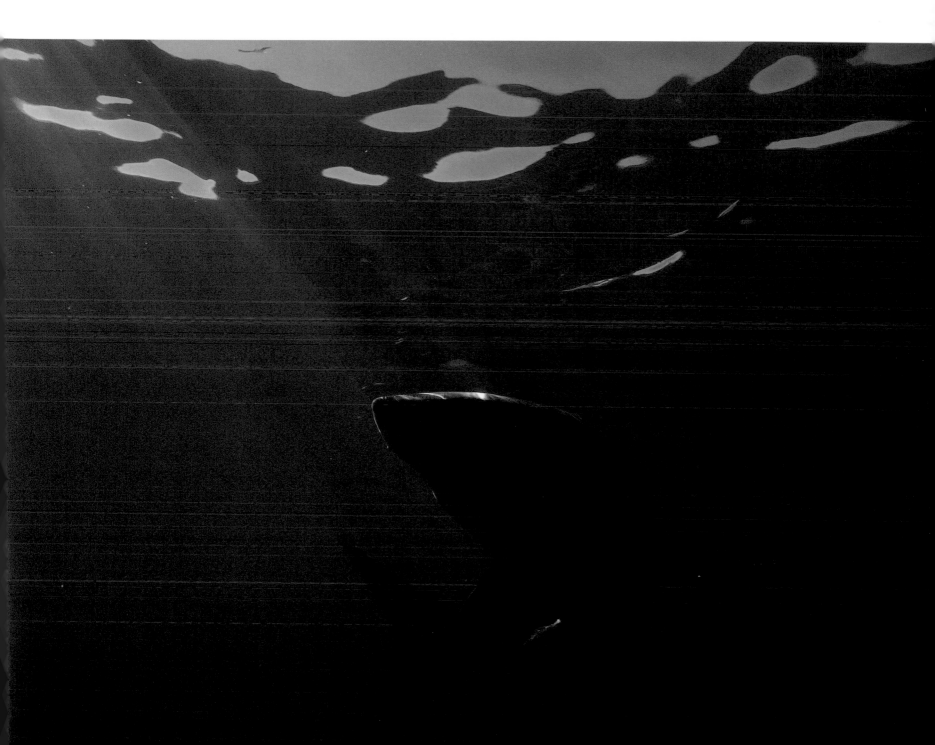

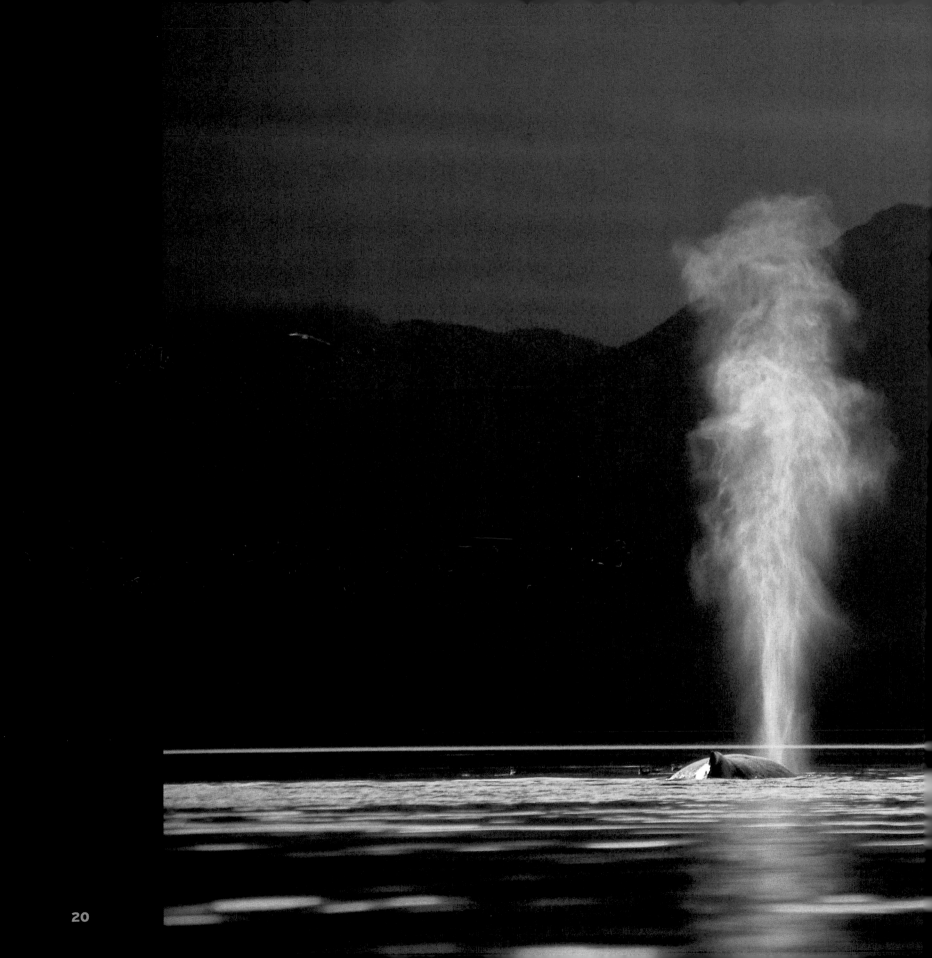

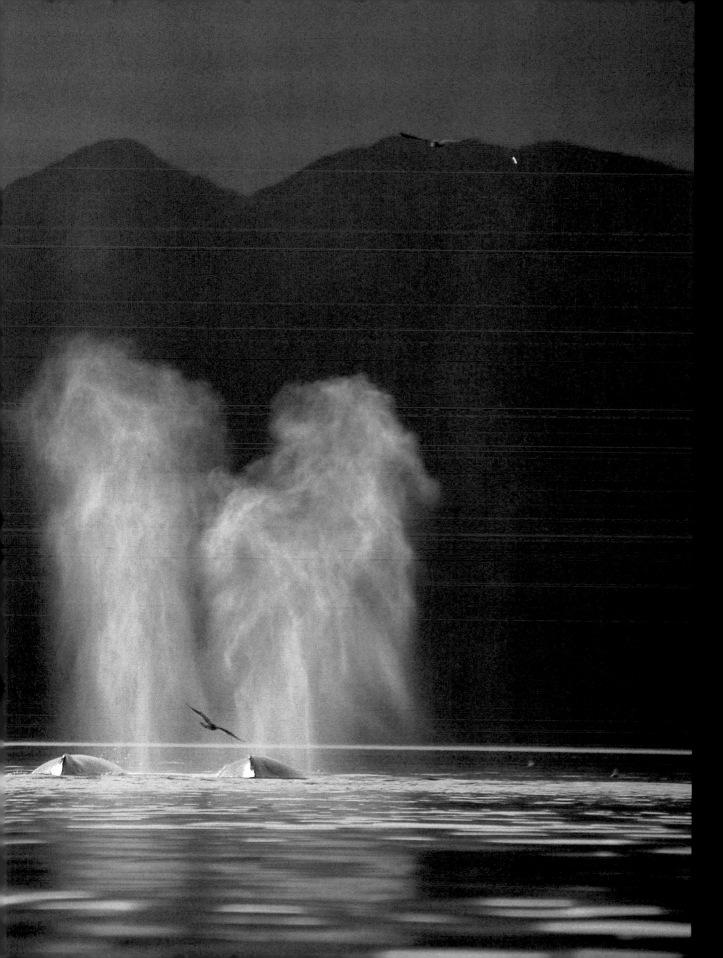

Duncan Murrell
UK

HUMPBACK WHALES BLOWING

South-east Alaska is the perfect backdrop for photographing whales, with its dramatic combination of coastal mountains and dynamic weather. Overcast most of the time, sunlight occasionally penetrates the gloom to make the whales shimmer in their monotone world. If you are downwind when the whales blow, there is no mistaking the content of their gargantuan diet. As well as a foul, fishy odour, their breath contains many pathogens and an emulsion of oil droplets, mucus and a surfactant that leaves an unpleasant, greasy film on exposed skin and camera equipment.

Canon EOS 1N with 75-300mm lens; 1/500 sec at f5.6; Fujichrome Provia 100.

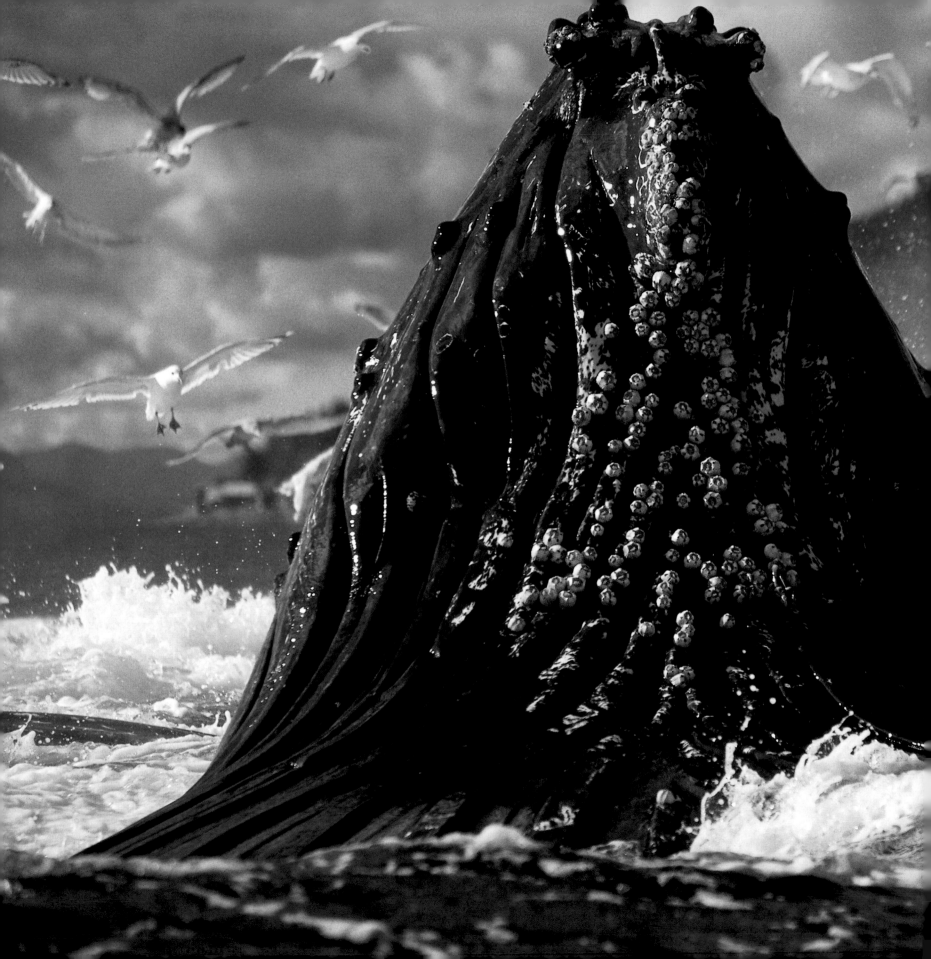

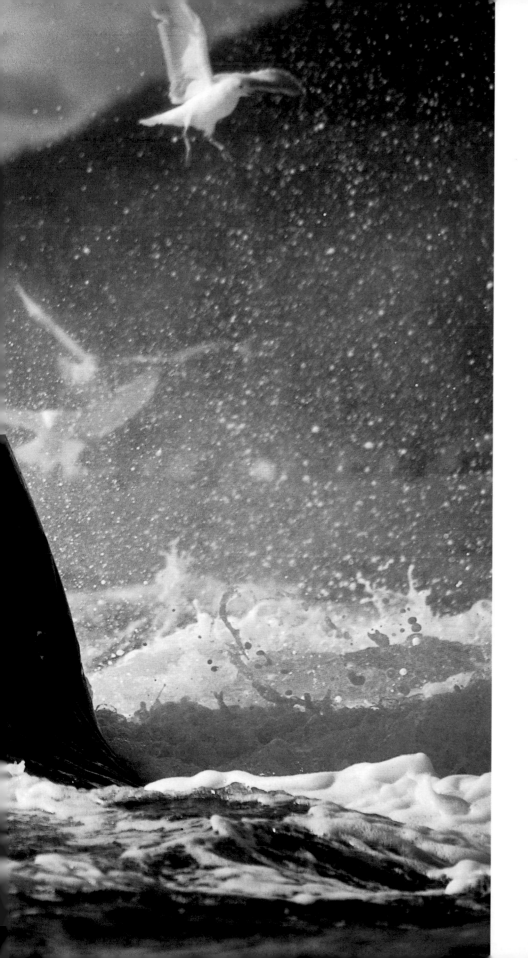

Animal Behaviour
Mammals

These photographs are selected for their interest value as well as their aesthetic appeal, showing familiar as well as seldom-seen behaviour of an active nature.

Duncan Murrell
UK

HUMPBACK WHALE LUNGE-FEEDING

I have spent nearly 20 years photographing humpbacks off South-east Alaska from a kayak. Their co-operative feeding technique, which involves 'bubble-netting', is exhilarating. This involves them spiralling beneath a shoal of fish or krill and one individual exhaling from its blowhole, which causes a net of bubbles of up to 45m across to surround the prey. Mouths agape, the whales then swim up through the centre. As they surge towards the surface, I get myself into position. This is an adrenalin-charged affair, as I have only seconds to exchange paddle for camera or take evasive action if I am caught in the middle of the net. This particular individual burst into view much closer than the rest of the feeding group, and I barely had time to spin around and adjust my zoom lens before it disappeared.

Canon EOS 1N with 75-300mm lens; 1/1000 sec at f5.6; Fujichrome Provia 100.

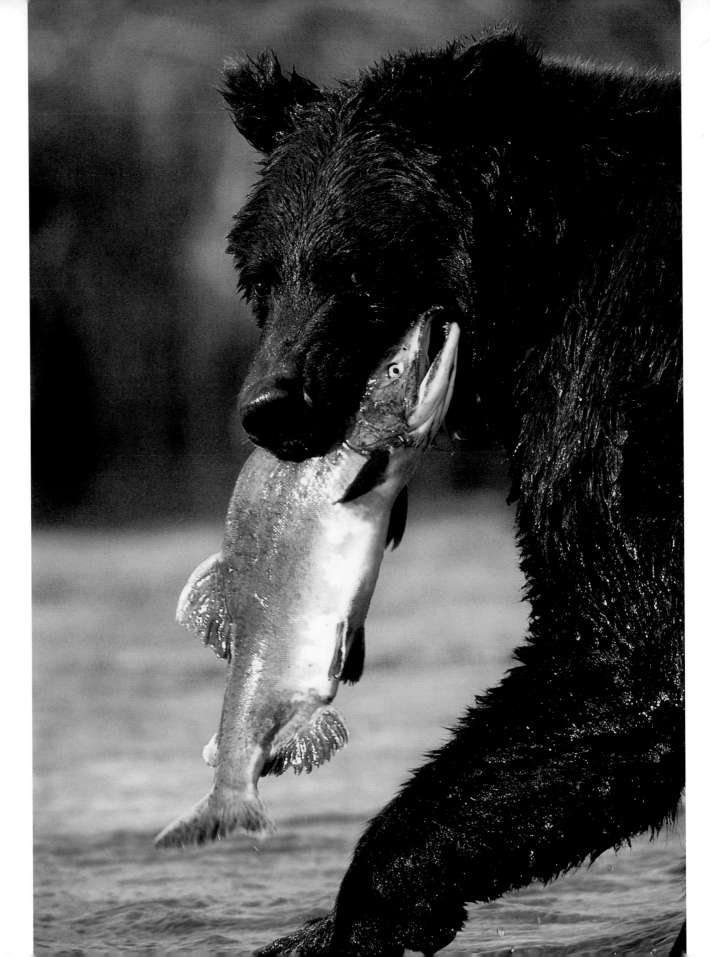

RUNNER-UP

Charles W McRae
USA

**BROWN BEAR WITH
A LIVE SALMON**

The bears in Geographic Bay, in Alaska's coastal Katmai National Park, use a range of fishing techniques, depending on how the tide affects the river. The 'paw slap' is popular when the water is shallow: the bear bounds through a school of fish, trying to flick one out. In deeper water, the bears 'snorkel': they duck their heads under the surface and move in the stream, scanning for salmon. As they come up for breath, water cascades off their heads – a wonderful sight. This bear had just emerged with a salmon and was taking it to shore to eat.

Canon EOS-1V with 600mm lens; 1/640 sec at f5.6; Fujichrome Provia 100; tripod.

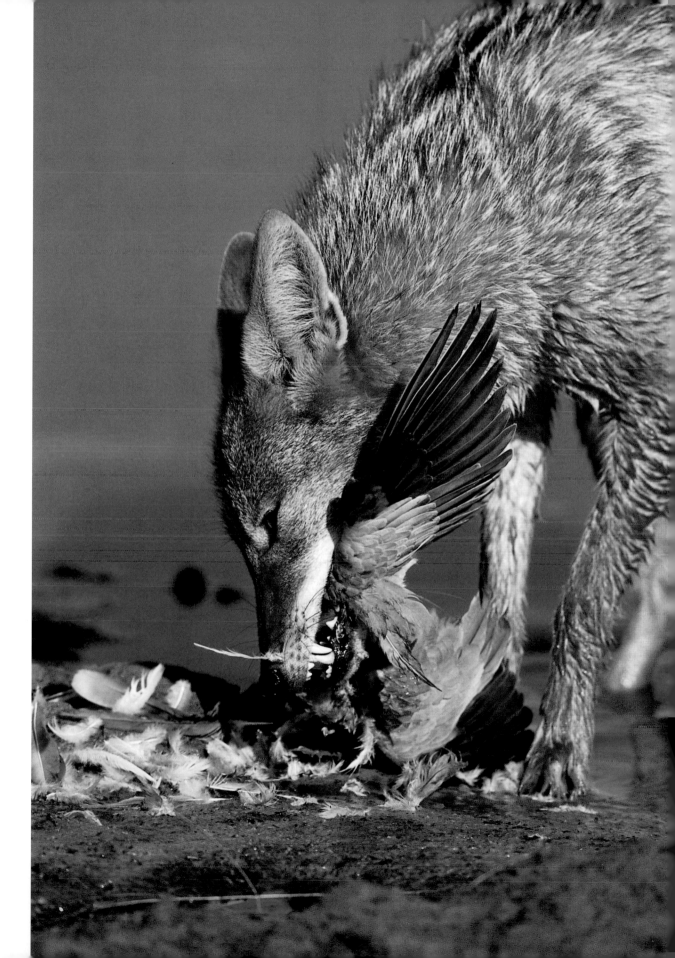

HIGHLY COMMENDED

Martin Harvey
South Africa

BLACK-BACKED JACKAL EATING A DOVE

During the dry season, thousands upon thousands of doves come to drink at waterholes in Etosha National Park, Namibia. Black-backed jackals are opportunistic feeders and make the most of this bounty. They don't seem to have much of a strategy other than to run around the water and take flying leaps at the panicking doves. Most of the time they miss, but occasionally they make a kill. I happened to be close enough to this individual when it struck lucky.

Canon EOS-1V with 600mm lens; 1/250 sec at f8; Fujichrome Velvia 50; beanbag.

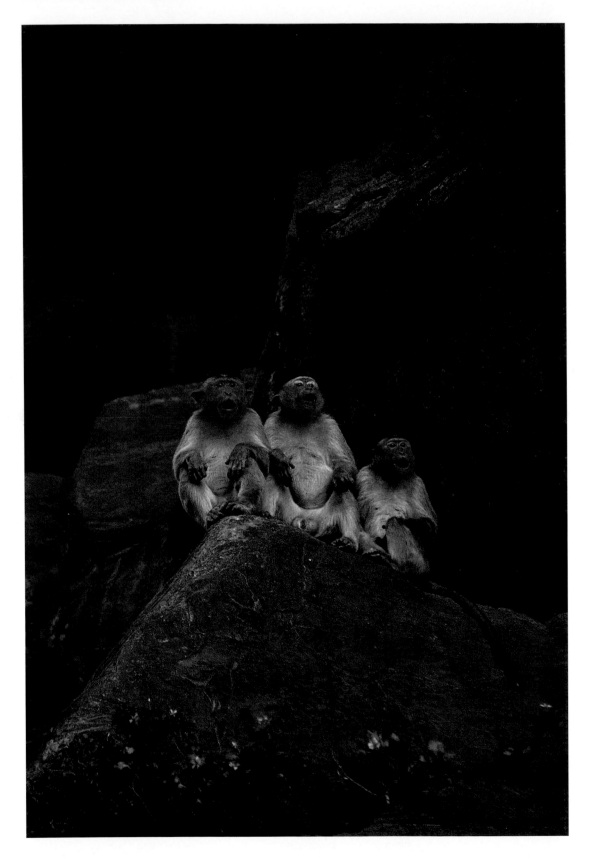

Manoj C Sindhgi
India

BONNET MACAQUE FAMILY

The town of Badami in southern India is famous for the cave temples hewn out of the red sandstone hillside. Once the capital of the sixth-century Chalukya Empire, Badami is now home to large troops of bonnet macaques (named for the cap-like whorl of hair on their heads). Their antics and complex social interactions entertain the tourists who come to explore the temples. When I saw this trio, though, it seemed that the tables had been turned: from their vantage point, the monkeys stared back up at the tourists, mouths agape as though in astonishment at the strange behaviour of their bipedal relatives.

Canon EOS 3 with 28-135mm lens; probably 1/125 sec at f8; Kodak Elite Chrome EBX 100.

Peter Hall
South Africa

LIONS MATING

One rainy morning in South Africa's Kruger National Park, this lion pair emerged from the long grass and lay down on the relatively dry track, near my car. Every 20 or so minutes, the male would get up and approach his mate. Time and again she snarled and slapped him. Eventually, she allowed him to mate. This scene was played out over several days. I focused on the detail that reveals the sexual tension between them – his powerful yet delicate bite.

Canon EOS 3 with 300mm lens; 1/400 sec at f2.8; Fujichrome Velvia 50; tripod.

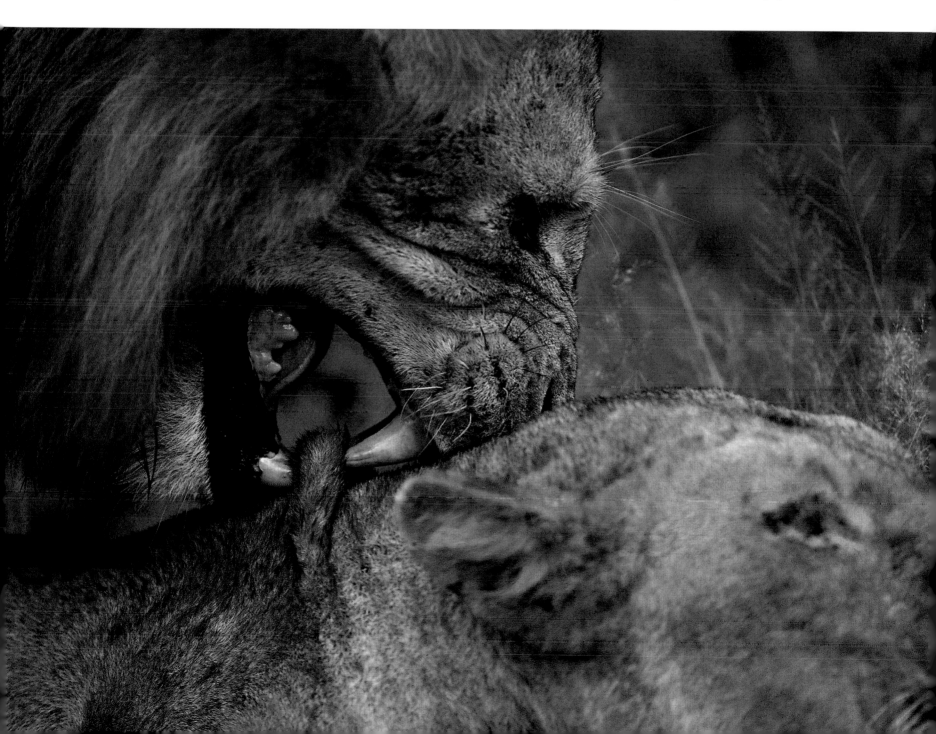

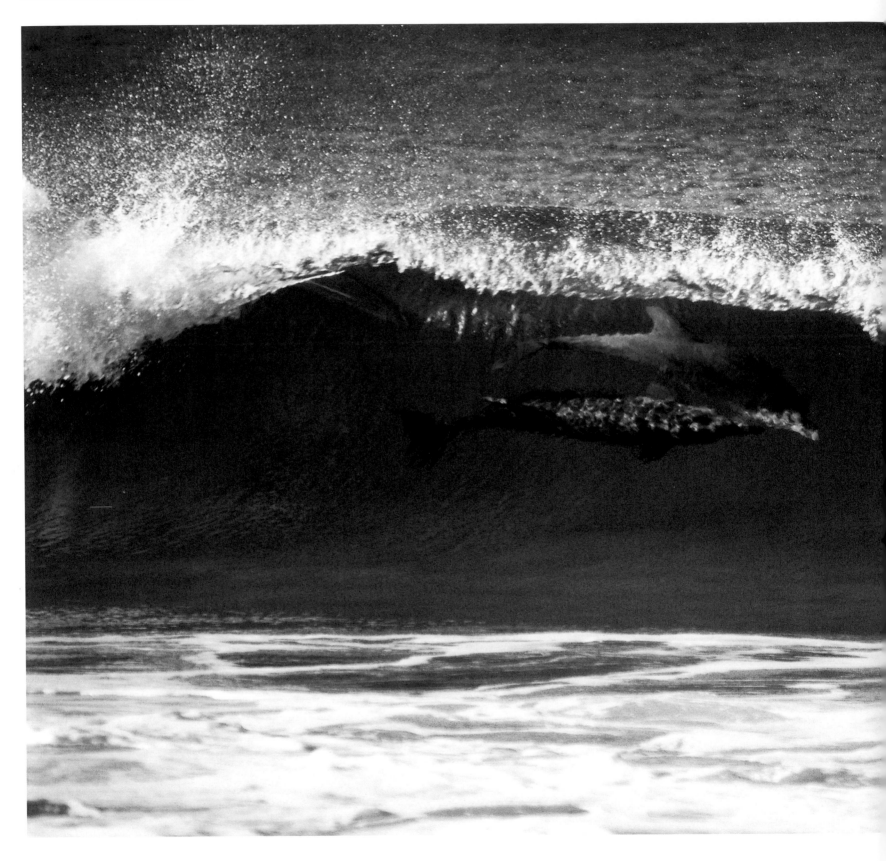

Gavin Parsons
UK

BOTTLENOSE DOLPHINS SURFING

Waves begin building up from quite a long way off the shore of Forster, in New South Wales, Australia. They roll up in sets, with calm periods in between. During one quiet moment, I saw two dolphins playing together, splashing around, flicking their tails in the air and twisting and leaping. Then they started surfing. Both of them missed the first wave. But they turned around, caught the next one in the set and surfed all the way to shore, jumping in and out and veering away just as the wave was about to crash.

Nikon F90x with 75-300mm lens; 1/250 sec at f5.6; Fujichrome Velvia 50.

Animal Behaviour Birds

The pictures in this category can't just be record shots or beautiful images – they must have interest value and action as well as aesthetic appeal.

Bernd Zoller
Germany

TERRITORIAL GREYLAG GOOSE
Last spring, I visited a small lake near Stuttgart, Germany, on which were around 50 greylag geese. Greylags have a reputation for intelligence, devotion and lifelong marital fidelity. They don't tolerate intruders, and in this instance, a furious gander ran across the water to see off another male who was showing interest in a female.
Nikon F5 with 500mm lens; 1/250 sec at 1.4; Fujichrome Velvia 50; tripod.

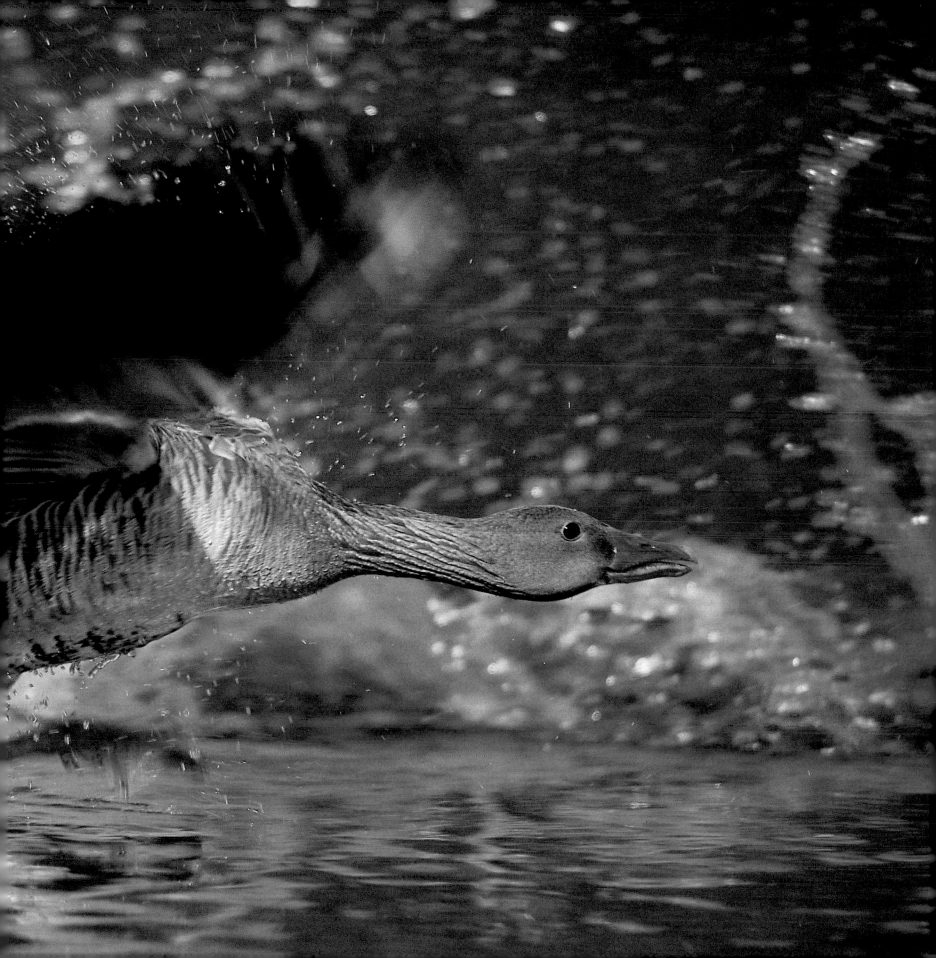

HIGHLY COMMENDED

Chris Hellier
UK

LITTLE EGRETS FIGHTING

Settling into a hide at La Capelière in the Camargue Nature Reserve in southern France early one morning, I began watching a little egret. It was fishing in the shallows, stalking through the water with long, deliberate steps, neck outstretched, ready to lunge at a juicy fish or frog. All was peace and calm. Then, squawking raucously, a second egret flew in to challenge it. But the first egret refused to concede its fishing rights and confronted the intruder, kicking and screeching, and within a short time, managed to evict it.

Nikon F90x with 170-500mm lens; 1/1000 sec at f8; Fujichrome MS 100/1000 (used at 400).

RUNNER-UP

Tim Laman
USA

RHINOCEROS HORNBILL DELIVERING FOOD

This male is delivering a meal of mouse to his mate sealed inside the tree-trunk nest along with her chick. Over the days I observed this nest, the male came once every two or three hours to put food through the small hole left in the seal. He used favoured perches to pause on before the final approach. I knew that, when he landed in a tree just behind and below the nest, he would have to fly towards me and make a banked turn to get to the hole. I pre-focused at the spot where I guessed he would turn and framed this shot.

Canon EOS-1V with 600mm lens; 1/250 sec at f4; Fujichrome Provia 100; tripod; hide.

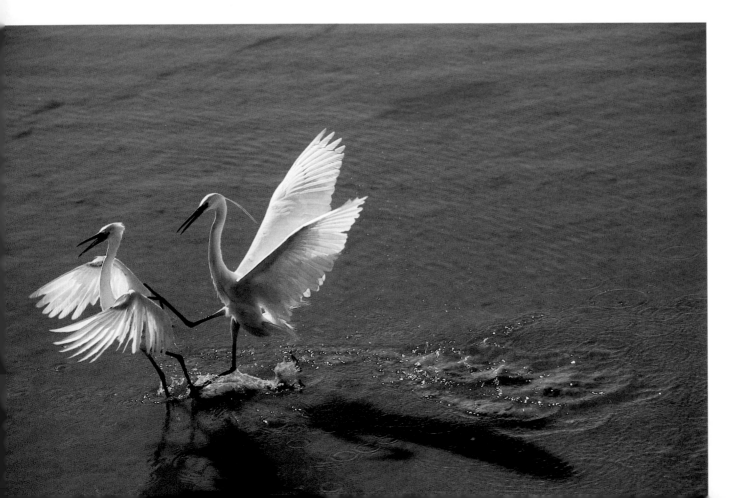

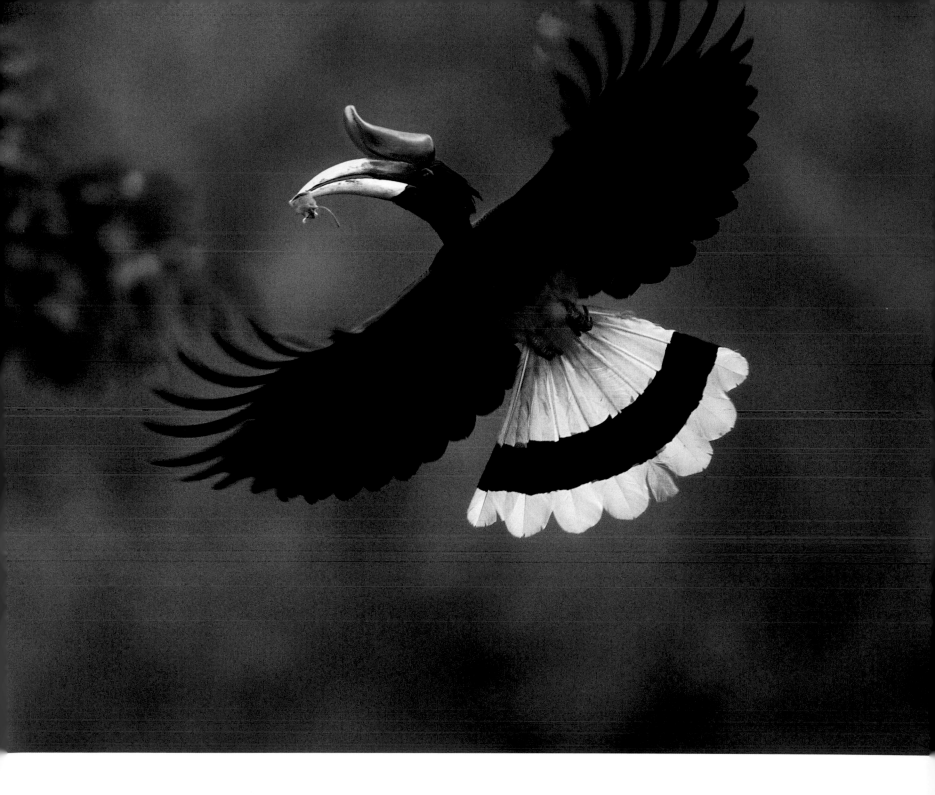

HIGHLY COMMENDED

Anup Shah
UK

MATING OSTRICHES

I guessed that these ostriches in the Masai Mara National Reserve, Kenya, were courting, and so I kept a lookout for signs to confirm my suspicions. After several days, the hen finally took the initiative. First, she stopped grazing and began to preen herself. Then she approached the cock, ruffled her wings and danced and bowed around him. Within minutes, his pale pink neck had turned crimson. As she began to run away, he chased after her. As soon as he caught up, she dropped to the ground. Very gently, he crouched over her, making a parasol with his wings. As they mated, they seemed to fall into a trance, their eyes sometimes open, sometimes shut, necks swaying dreamily from side to side.

Canon EOS-IV with 600mm lens; 1/250 sec at f5.6; Fujichrome Provia 100.

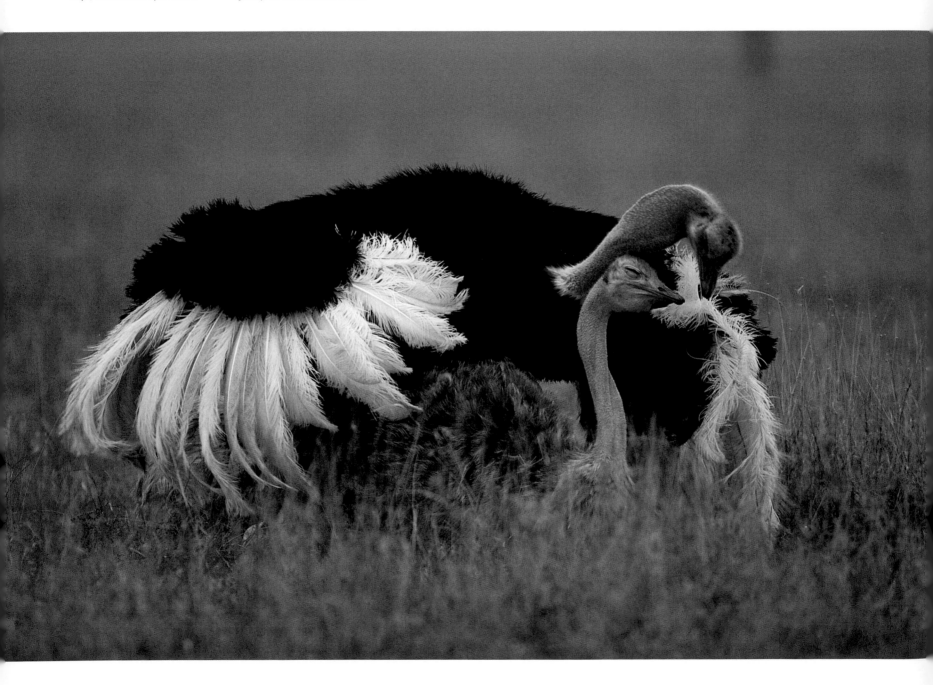

drama's conclusion, though

HIGHLY COMMENDED

Rukshan Jayewardene
Sri Lanka

HAWK-EAGLE GRAPPLING WITH A MONITOR

On my last morning at Yala National Park in South-east Sri Lanka, returning from a rather uneventful game drive, I persuaded our tracker to have one last look at a nearby waterhole. As we approached, I could see a sub-adult crested hawk-eagle on the road. As I got closer, I realised it was fighting with a land monitor. The bird, which was obviously inexperienced, tried to subdue the monitor, but it fought back, biting the eagle's chest each time it was pecked. I didn't witness the drama's conclusion, though I heard later it had ended unhappily for the monitor but with a large meal for the eagle.

Nikon F100 with 300mm lens; 1/500 sec at f2.8; Fujichrome Velvia 100; beanbag.

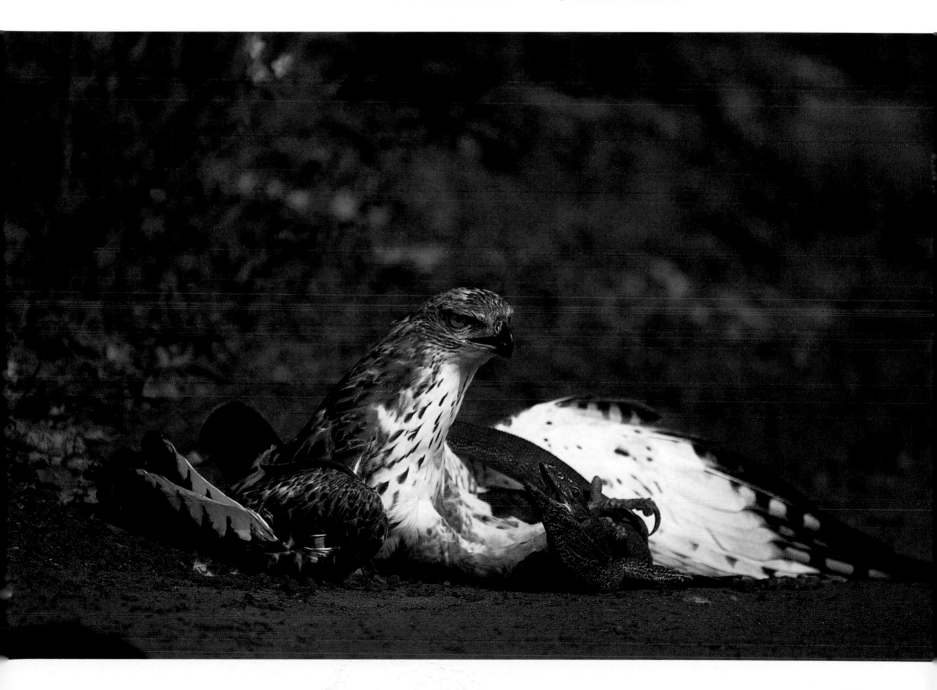

Bernd Römmelt
Germany

GOOSANDER CARRYING HER CHICKS

Each year in May, I head for Nymphenburger Palace gardens, which is a lovely, small wilderness in the heart of Munich. A real highlight for me is when goosander mothers carry their chicks on their backs. Vast numbers of people visit the gardens, and so the goosanders are fairly relaxed and not too difficult to photograph. But to get a clear reflection and clean, black background such as this took hours.

Nikon F100 with 300mm lens; 1/80 sec at f2.8; Kodak Ektachrome 100VS.

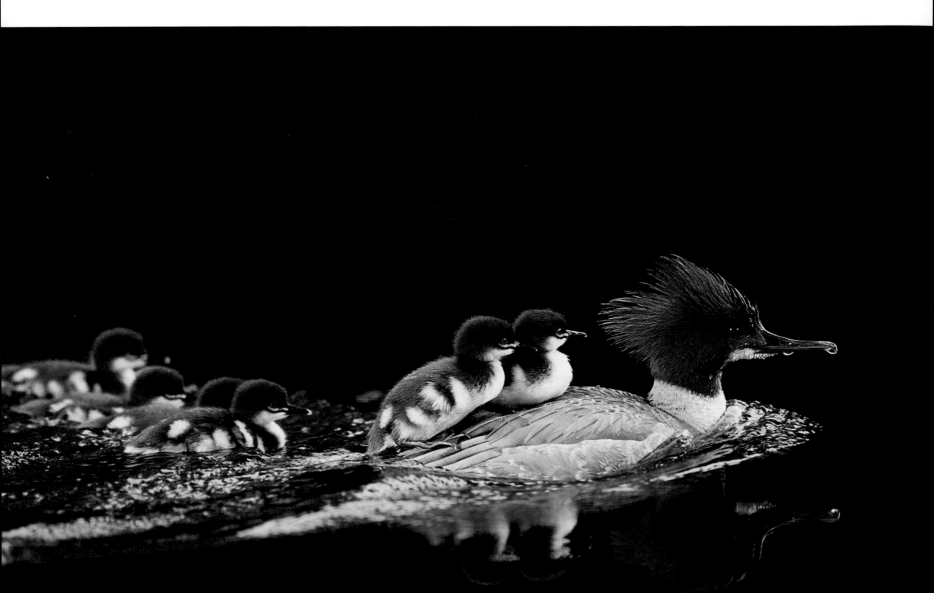

**Marek Kosinski
and Renata
Krzysciak-Kosinska**
Poland

**BLACK-NECKED GREBE
FEEDING ITS YOUNG**
There is a huge complex of
fish-farming ponds near
Krakow, southern Poland.
Some years, the ponds are
overgrown with water weeds.
Many bird species breed
there, which is why it's a
popular spot for birdwatchers.
Last June, black-necked
grebes chose to build their
nests on a shallow pond. This
meant we could easily wade in
with a floating hide, which the
birds soon got used to. Right
after hatching, the chicks (up
to four in a clutch) are difficult
to spot. You can usually see
them only when they emerge
from under a parent's wing to
take food from the other one.
Nikon F90x with 400mm lens;
1/125 sec at f5.6; Fujichrome Provia
100; floating hide; tripod.

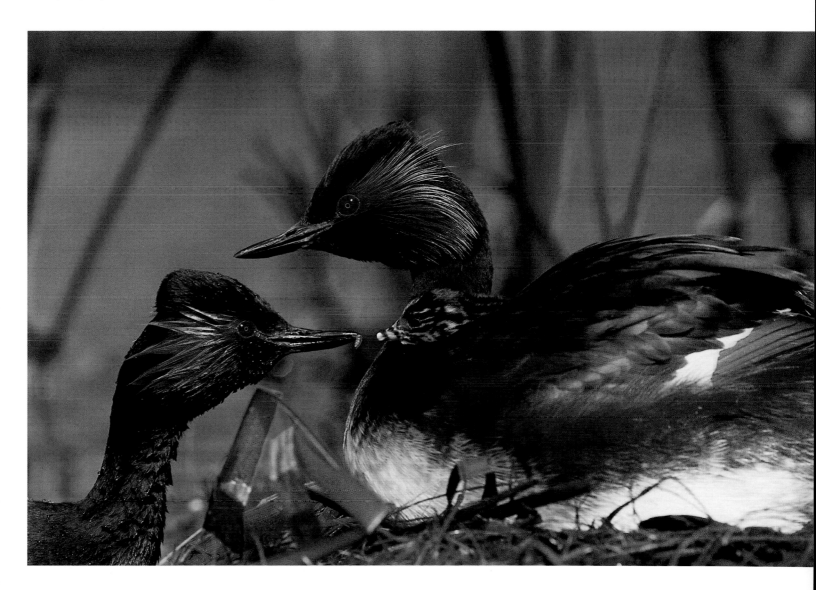

Chris Gomersall
UK

REED WARBLER SINGING

In Britain, reed warblers are at their most vocal just after arriving back in late April, when they are establishing their territories in the reedbeds. On this beautiful, calm morning at Titchwell RSPB Reserve in Norfolk, several ventured out from the lower reedbeds to perch high and sing strongly. As soon as one started its guttural, churring song, its neighbours responded. The birds would drop back down to skulk among the reeds if there was a gust of wind or a marsh harrier drifted by but very soon hopped back up again to sing. Only after I had the film processed did I notice the gossamer thread clinging to this bird's beak.

Nikon F5 with 500mm lens and 1.4x teleconverter; 1/250 sec at f5.6; Fujichrome Provia 100; tripod.

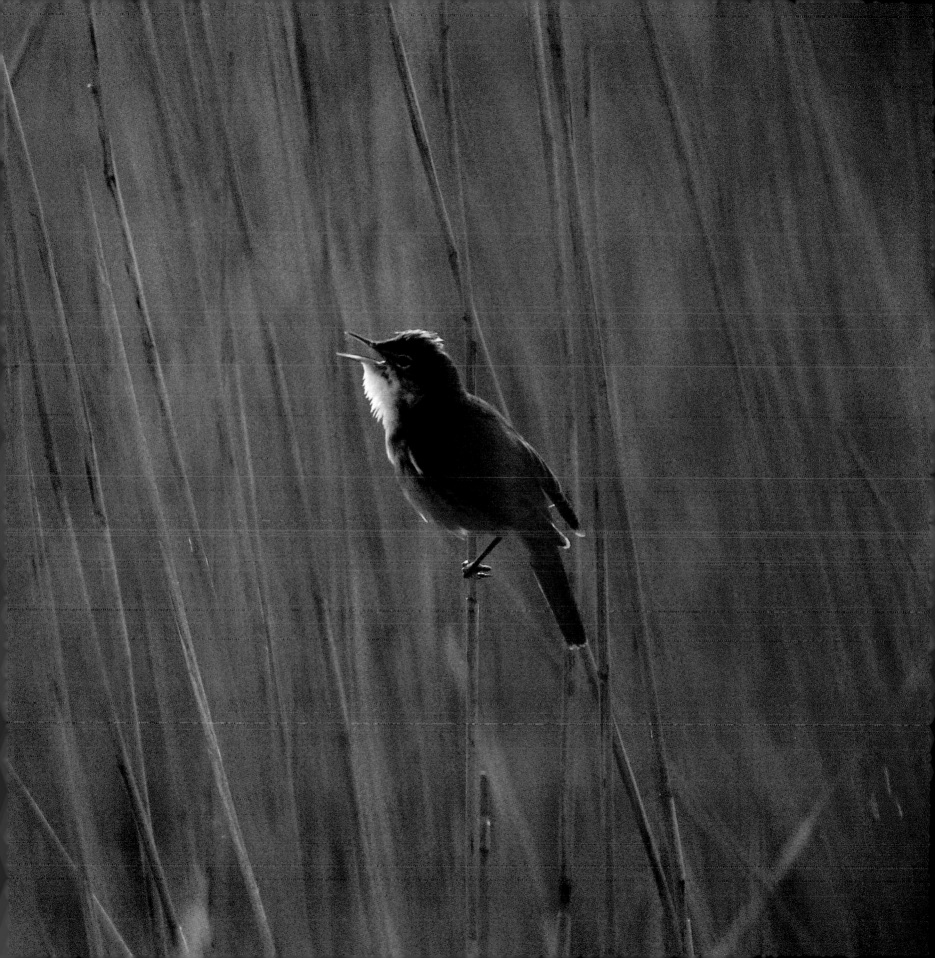

Animal Behaviour
All Other Animals

This category offers plenty of scope for interesting pictures, as the majority of animals are other than mammals and birds, with behaviour that is often little known.

WINNER

Adrian Hepworth
UK

YELLOW-BELLIED SEA SNAKE AND BABY
I found this female yellow-bellied sea snake washed up on a beach in Costa Rica. She appeared to be dead, and so I walked on. On my return, I was astonished to see that not only was she still alive – but in the few minutes I'd been gone, she'd also given birth. Her baby was wriggling frantically in the wet sand, desperately searching for the sea. Sea snakes are highly venomous, and so after photographing them, I carried them on a stick to the water's edge. The youngster shot away instantly, but the female, clearly very weak, swam off much more slowly.
Canon EOS 1 with 20mm lens; 1/60 sec at f11; Fujichrome Provia 100; polarising filter.

Janos Jurka
Sweden

MOUNTAIN ASH SAWFLY LARVAE

One day in late June, I staked out a forest glade, waiting for a moose. My attention was caught by a mountain ash (rowan) tree, the leaves of which were swinging gently in the slight breeze. It took a while for me to realise that they were covered in sawfly larvae. These look like butterfly or moth caterpillars, but sawflies are in fact related to wasps and bees. The larvae feed in large groups, stripping all but the midribs of leaves on a branch before moving on to defoliate the next. The moose never did come, but I was more than satisfied with what I'd seen.

Canon EOS 3 with 180mm macro lens; 1/30 sec at f5.6; Fujichrome Velvia 50; tripod.

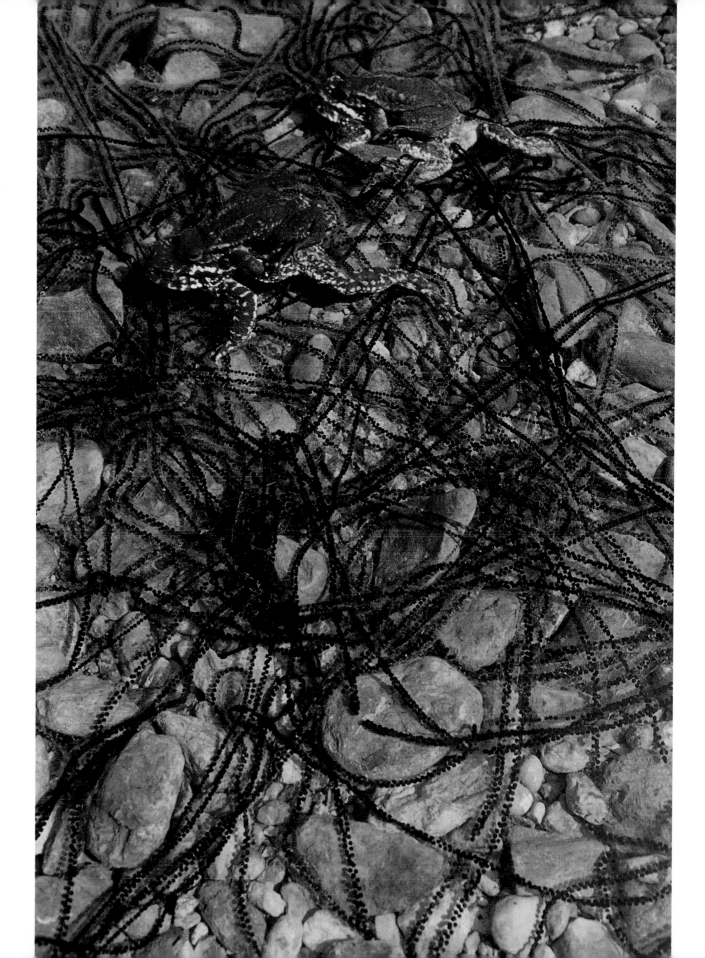

RUNNER-UP

David Vilasís Boix
Spain

COMMON TOADS MATING
At the beginning of May,
I visited an isolated valley in
central Catalonia, North-east
Spain. Around 300 toads
were copulating along a
one-kilometre stretch of a
shallow stream, and after
a few hours, the water
was a stringy tangle of eggs.
The females are larger, their
bodies swollen with mature
eggs, while the males have
developed horny pads on
their thumbs. These help the
male grip the female behind
her forelimbs, and he can be
carried about on her back for
several days. As the female
lays her eggs, the males
produce a sperm-containing
fluid that pours onto them as
they leave the female's body.
**Canon EOS 3 with 17-35mm
lens; 1/60 sec at f11; Kodak
Ektachrome 100VS.**

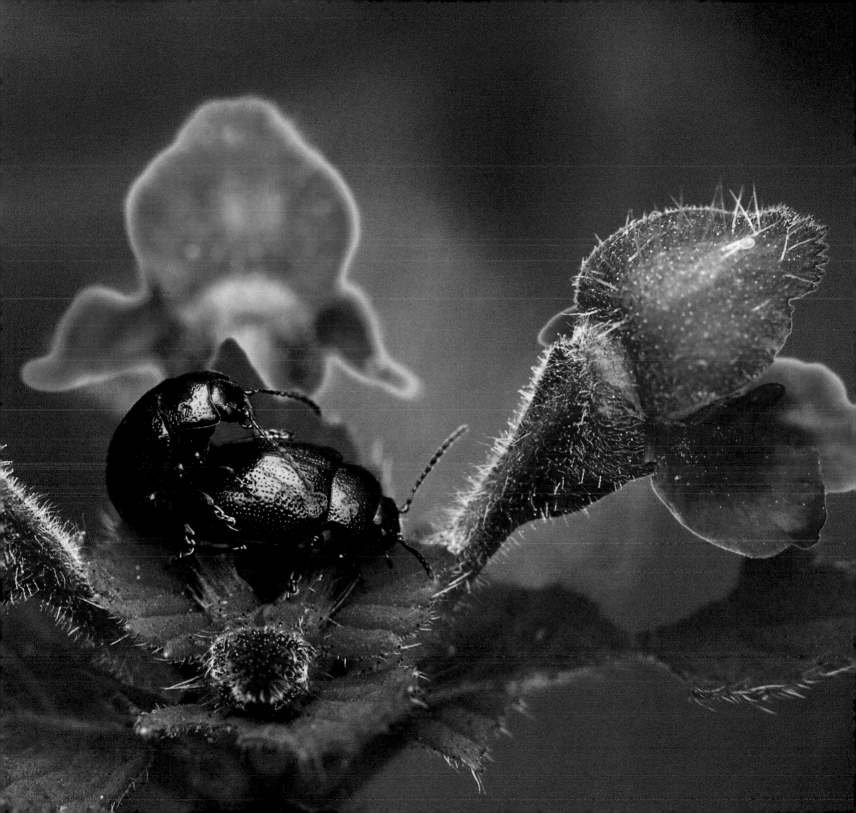

The Underwater World

These photographs can show marine or freshwater animals or plants. The most important criteria are aesthetic, but interest value is also taken into account.

Doug Allan
UK

BELUGAS

These sociable and inquisitive mammals are among the most vocal of the toothed whales. You'll hear their amazing repertoire of squeaks, twitters and clicks even above the surface. The best way to see them (in this case, in Lancaster Sound in the Canadian Arctic) is by snorkelling and singing softly, waiting until you become an object of curiosity. They become aware of you by using echolocation and will eventually come over for a look. They tend to hang beneath you (as in this case), peering up at your silhouette while you appreciate their pristine white against the blue-black depths.

Nikonos V with 20mm lens; 1/125 sec at f5.6; Fujichrome Sensia 200.

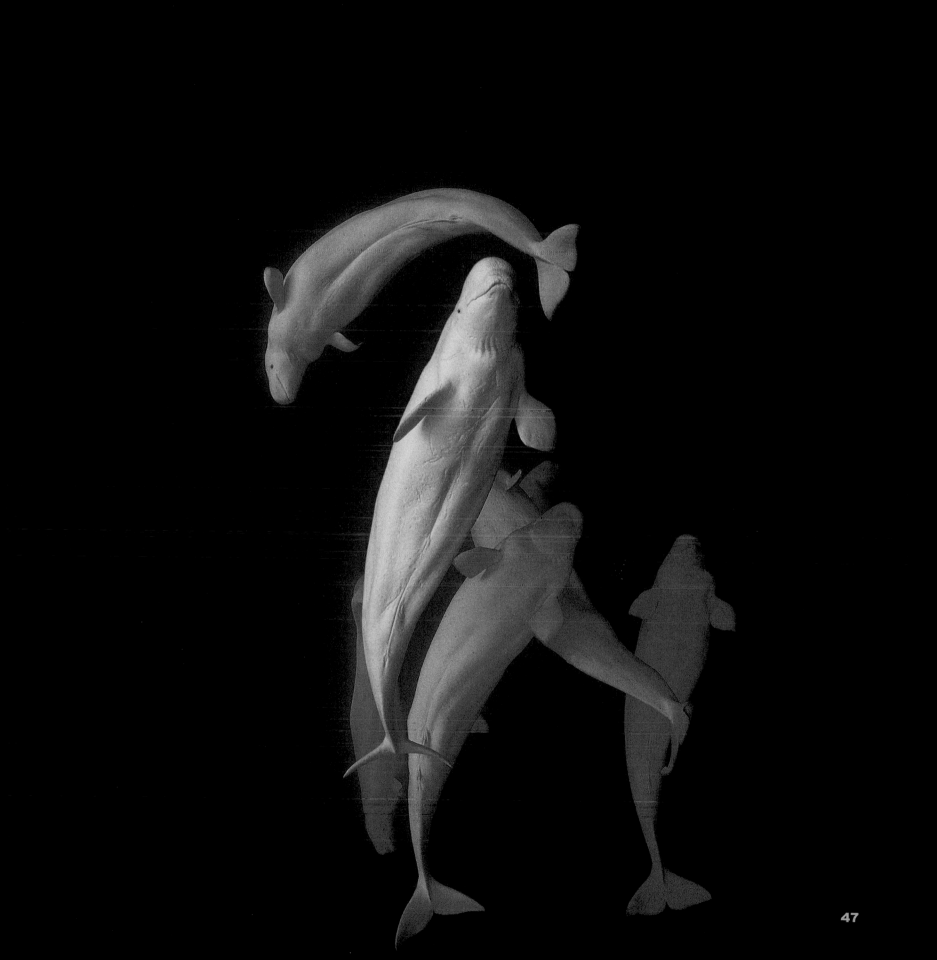

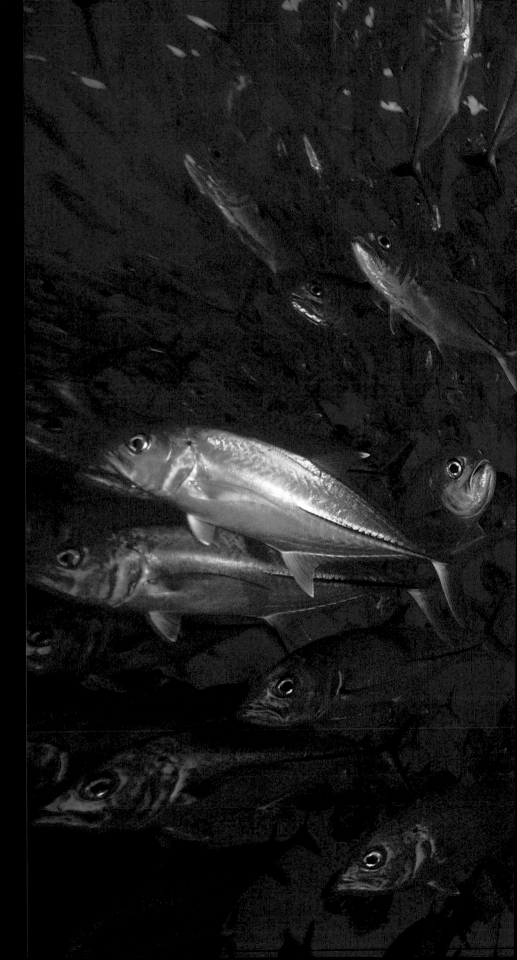

Malcolm Hey
UK

BIGEYE JACKS ON THE MOVE

At night, these predators hunt alone. But during the day, they gather in huge numbers at their favoured spots on the reef. While diving in the Solomon Islands, I found a sea-mount with a resident shoal. After watching for a while, I saw that they were circling the mount in a regular pattern, crossing the same part of the reef each time. I waited for the shoal to pass, then positioned myself in its path. As the fish reappeared, I held my breath to prevent bubbles from spooking them. Then I rose up right in front of them and took several photographs as the shoal parted just inches in front of my camera.

Nikon F90x with 16mm fish-eye lens; 1/80sec at f8; Fujichrome Velvia 50; underwater housing; one strobe.

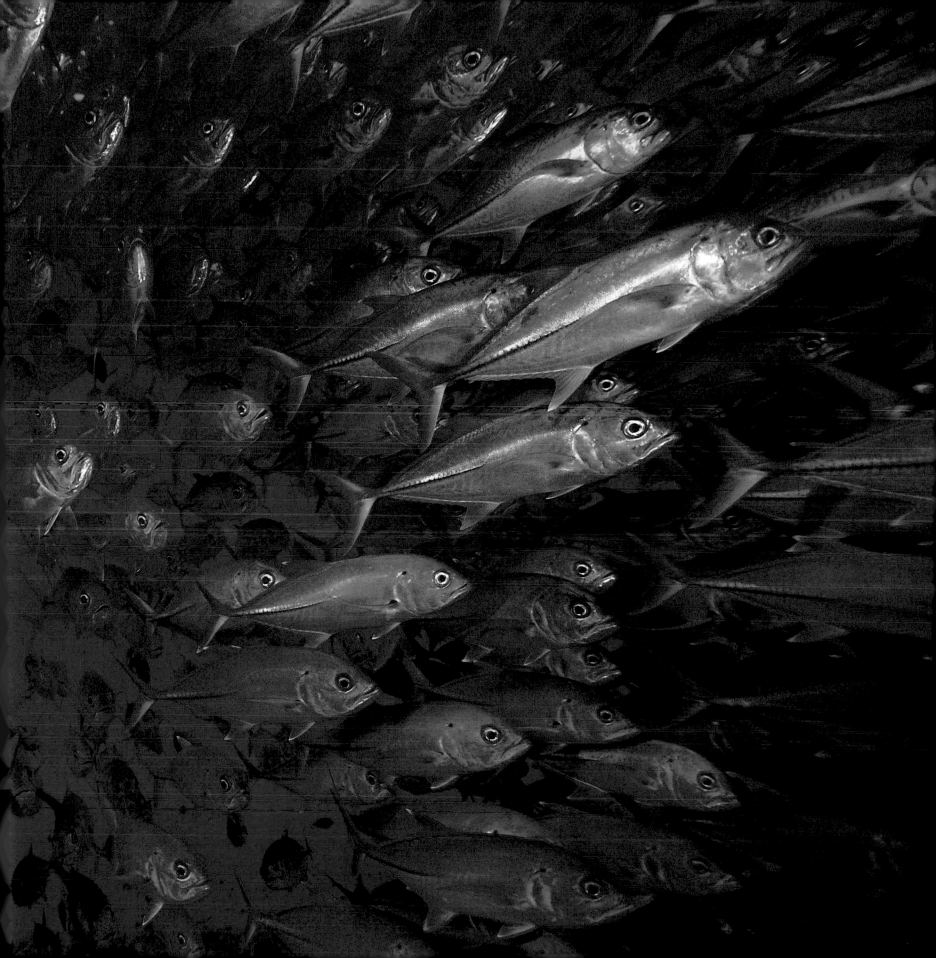

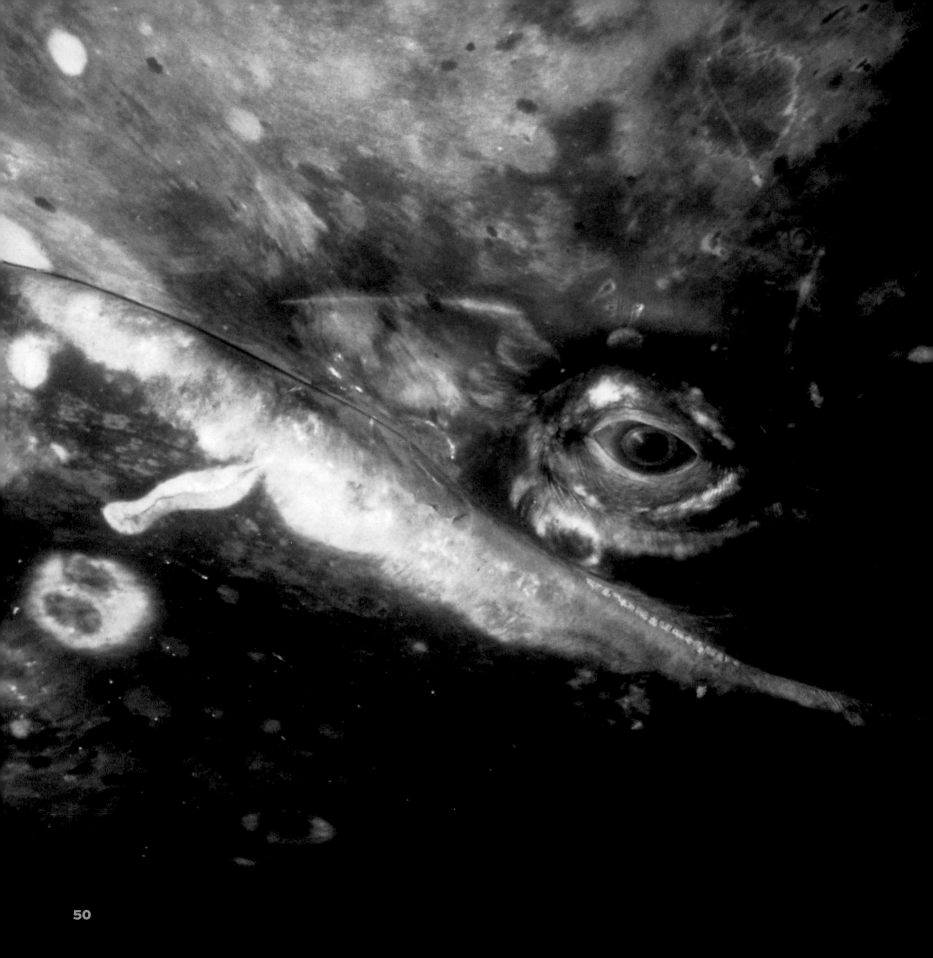

Doc White
USA

GREY WHALE EYE

Grey whales make the longest migration of any marine mammal. They travel more than 9,000 kilometres from feeding grounds in the Arctic to lagoons on the Pacific side of Mexico's Baja Peninsula, where they breed and calve. Some have become so used to boats that they now initiate friendly encounters. They seem to enjoy being patted and stroked, and may even gently nudge the boat. This female had a very young calf with her, but she felt confident about leading it to us. When I leaned over the side and put my head in the water, my camera was just a few inches away from her eye.

Nikon F3 with 16mm lens; Fujichrome 100; underwater housing.

Constantinos Petrinos
Greece

**EMPEROR RED SNAPPERS
SHELTERING
AMONG FIRE URCHINS**
I came across these sea urchins while diving in the Lembeh Strait off North Sulawesi, Indonesia. There is nowhere for them to hide in this sandy substrate, which divers call a 'muck dive site', and so they cluster together to defend themselves. The spine forests become a safe-haven for fish, such as these juvenile emperor red snappers.

Nikonos RS with 13mm lens; 1/60 sec at f8; Fujichrome Provia 100; two flashguns.

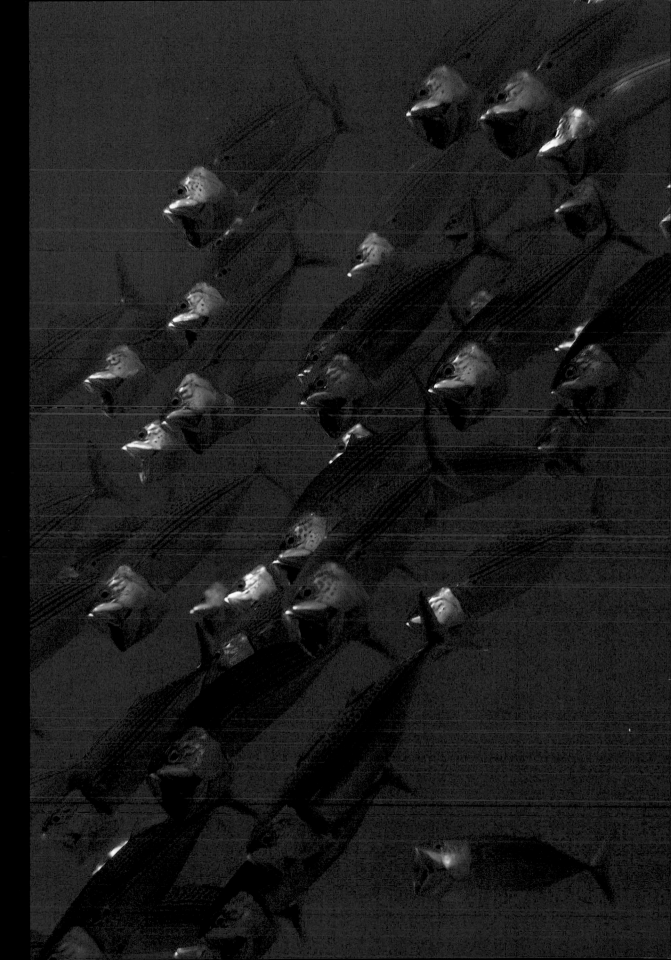

Sally Sharrock
UK

STRIPED MACKEREL FEEDING

There must have been more than 40 mackerel in this shoal. I found them filter-feeding on plankton in the shallows at Marsa Egla in the Red Sea when I was swimming to shore after a dive. They moved in tight, perfectly synchronised formations. I knew how easy it would be to disperse them, and so I waited until there was a gap in the circle, then quickly slipped into the centre of the whirling carousel. The mackerel cruised around me, seemingly oblivious to my presence.

Nikon F90x with 60mm lens; 1/125 sec at f8; Fujichrome Sensia; underwater housing.

Malcolm Hey
UK

PYGMY GOBY RESTING ON STAR CORAL

The pygmy goby is less than two centimetres long, and lives in close association with reef creatures such as corals and sponges. As I drifted alongside a wall on a coral reef at Bunaken Island in North Sulawesi, Indonesia, I spotted several gobies on a star coral. They were easily spooked by the close proximity of my camera lens and the light from my lamp, and so I had to pre-focus on the spot where I anticipated one would alight and then wait patiently for it to settle.

Nikon 801s with 105mm macro lens; 1/100 sec at f22; Fujichrome Velvia 50; underwater housing; two strobes.

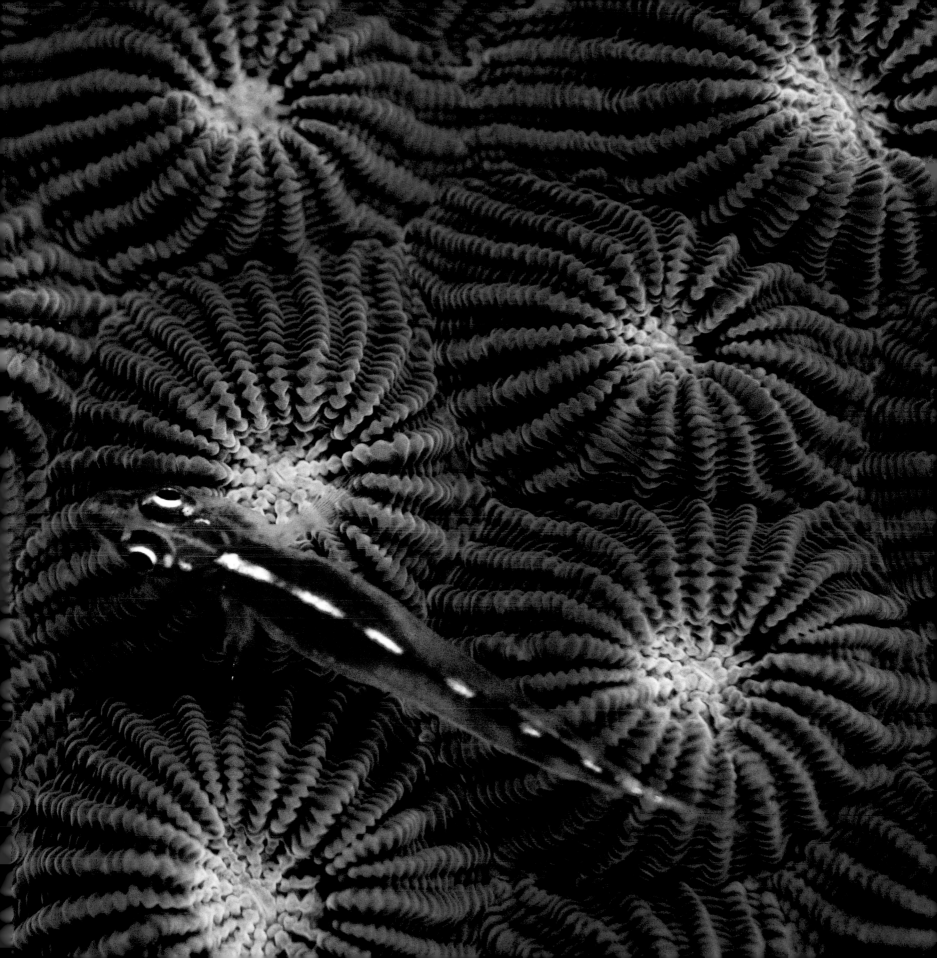

Kelvin Aitken
Australia

SALTWATER CROCODILE ON A CORAL REEF

Λ subordinate saltwater (Indopacific) crocodile which fails to establish a territory may be forced out of the tidal river system by more dominant individuals. It will then scour the coast in search of another rivermouth to settle in. I found this rather undernourished, 1.5m-long crocodile travelling across an inshore coral reef near Popendetta in eastern Papua New Guinea. It swam by sweeping its tail from side to side, swinging gracefully from the hips. For extra power, it would lower its hind legs and 'run' across the seabed. Saltwater crocodiles can, in fact, travel more than 1,000km by sea.

Canon EOS 3 with 20mm lens; 1/60 sec at f5.6; Fujichrome

In Praise of Plants

This category aims to showcase the beauty and importance of flowering and non-flowering plants.

Jeremy Woodhouse
UK

OAK IN A FIELD OF INDIAN PAINTBRUSHES
Spring in Texas is wildflower season, with a dozen related festivals, websites and bluebonnet trails. The Texas Hill Country is well known as the best place in the state for wildflowers. People come from all around to drive along the small, empty country roads and enjoy the flowers. I'm fortunate to live close enough for annual trips to the area. Last year, it was this solitary live oak tree standing amid a field of Indian paintbrush blooms that caught my attention.
Fuji 617 with 105mm lens; 1/15 sec at f32; Kodak Ektachrome 100VS.

Peter Lilja
Sweden

ROSEBAY WILLOWHERBS AND MIDGES
In late summer in Sweden, rosebay willowherb blooms in fields, woodland margins and wasteland alike. This particular vibrant display with its dancing midges especially appealed to me. The mellow background combined with the soft, evening light made the insects sparkle.
Pentax 645N with 600mm lens; 1/45 sec at f5.6; Fujichrome Velvia 50; tripod.

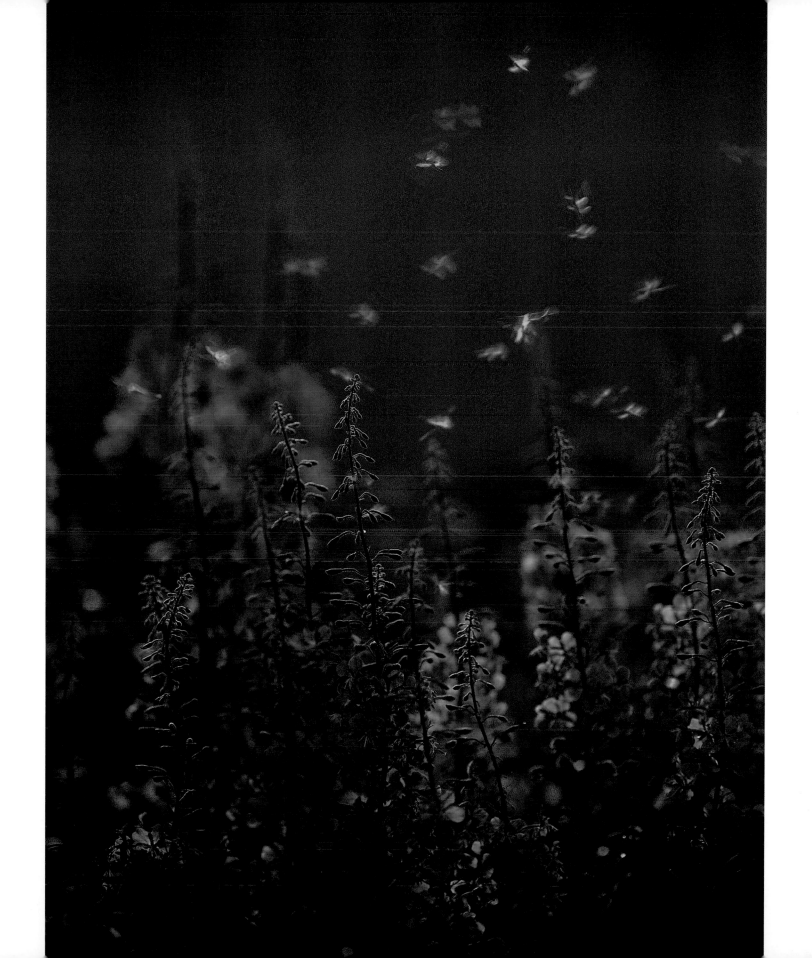

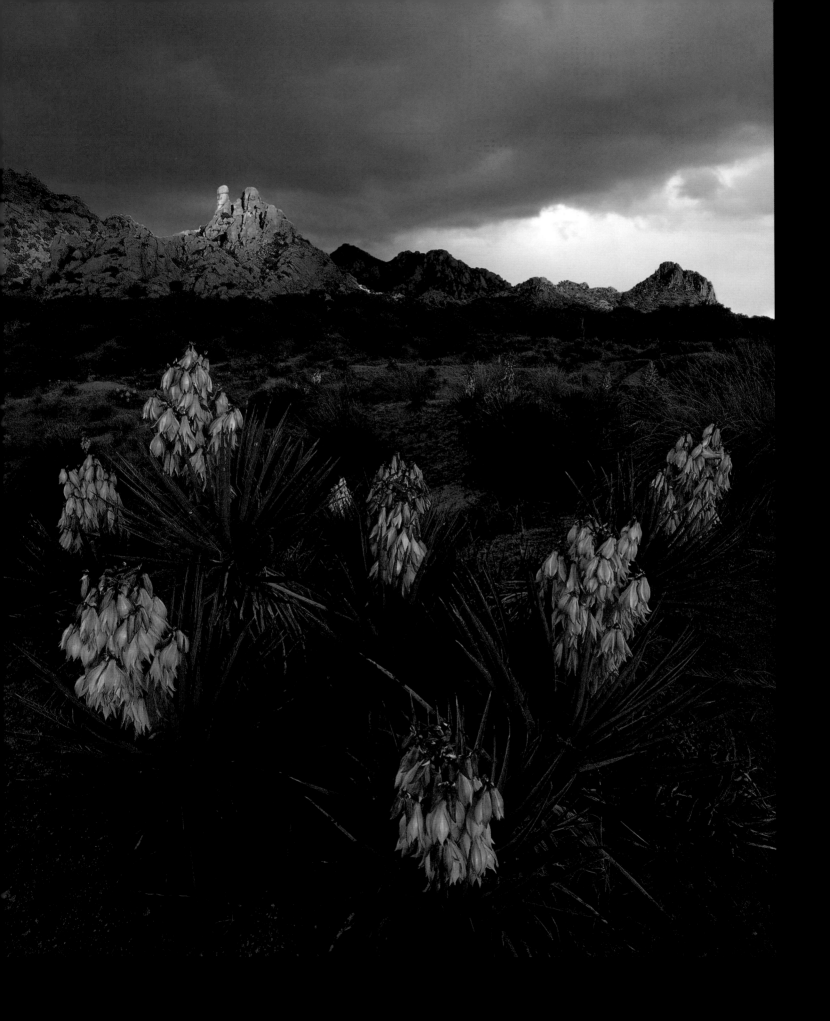

George Stocking
USA

BANANA YUCCAS ON THE DRAGOON MOUNTAINS

Towards the end of March, clusters of banana yuccas flower in the Dragoon Mountains. These rugged mountains, in the Coronado National Forest of south-eastern Arizona, USA, were once a favourite hiding place for the legendary Apache chieftain Cochise and his band as they fled from the US army. The yucca fruits are edible, and so the plant would have been an important food source for the Apaches. The boulder pile in the background illuminated by a passing spring storm is part of an area known as Council Rocks, which is said to have been used as a meeting place for Mogollon Indians about 1,000 years ago.

Bronica GS-1 with 50mm lens; 1/2 sec at f22; Fujichrome Velvia 50.

Klaus Koch
Germany

TEASELS ON WASTELAND

Most urban environments have dozens of patches of wasteland, from long stretches of railway embankments and dumps to small corners of parkland and scrub. Some of our hardiest and most versatile plants soon colonise these habitats. A single teasel, for example, can produce more than 2,000 seeds. To me, these opportunistic 'weeds' are among the most beautiful wild plants around. I discovered this group of common teasels growing on a motorway verge near my home in Frankfurt and took a series of photographs over several weeks. Late afternoon summer sun provided the best light.

Canon EOS 100 with 300mm lens; 1/125 sec at f11; Kodak Elite Chrome Extra Colour 100; tripod.

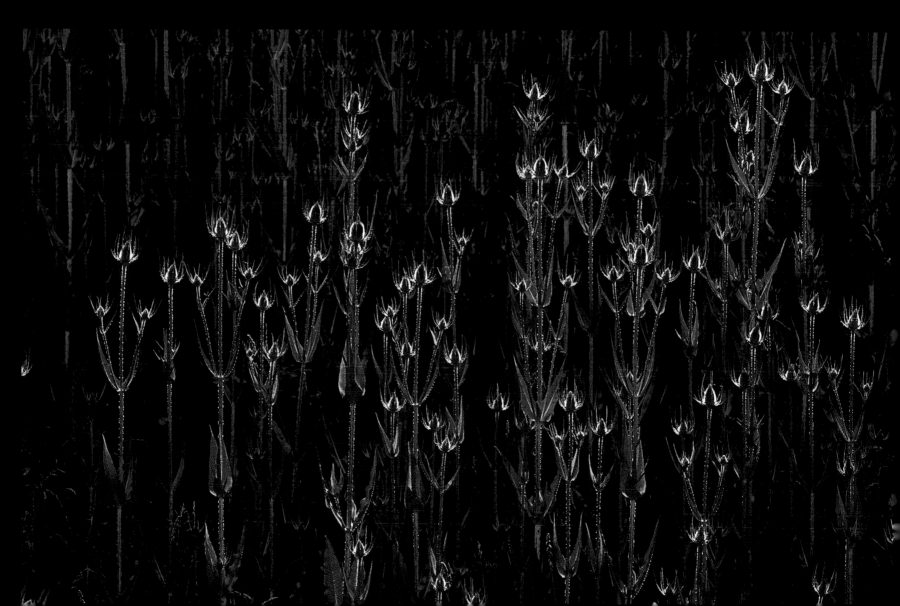

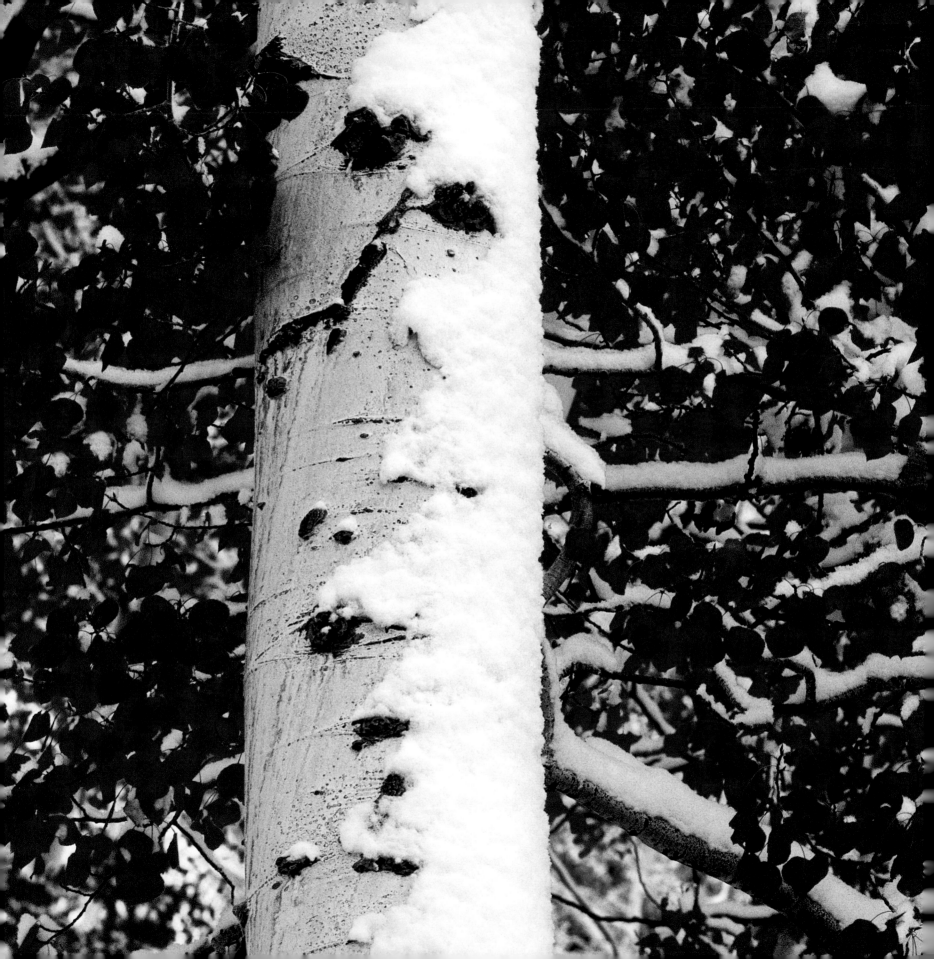

**Wendy Shattil
and Bob Rozinski**
USA

SNOW ON AN
ASPEN TREE

Aspens grow from root-stock
or 'suckers' rather than from
seed. That means all the trees
within a particular grove are
clones. And so, in autumn,
they all follow the same
colour-change pattern.

At any given time, leaves at
the crown may be red, those
in the centre orange, while
the lowest branches may be
yellow. But whatever the
sequence, all the surrounding
aspens will be the same.

We photograph a beautiful
grove in an isolated corner of
southern Colorado, in the US,
every year, and it is always
different. Last autumn, for
the first time in 15 years, the
aspens were covered in a layer
of snow – photographically,
the icing on the cake.

**Canon EOS 3 with 500mm
lens; 1/15 sec at f16; Fujichrome
Velvia 50.**

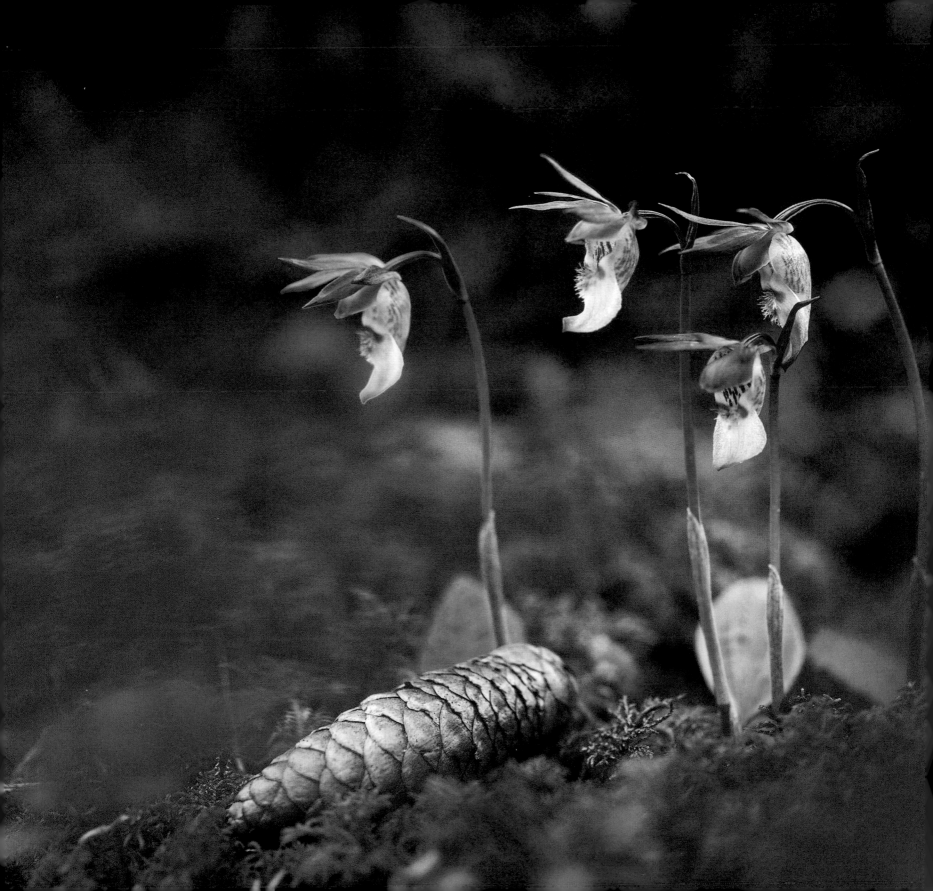

Peter Lilja
Sweden

FAIRY SLIPPER ORCHIDS
In Sweden, the beautiful and mysterious fairy slipper orchid grows in old, mossy spruce forests. Its flowers appear in early June and smell faintly of vanilla. But it's an elusive orchid, because it's small and blooms for a very short time. I couldn't believe my luck, therefore, when I found four specimens together in a protected, coniferous forest.

Pentax 645 with 120mm macro lens; 1/15 sec at f4; Fujichrome Velvia 50; tripod.

Adriano Turcatti
Italy

COTTONGRASS IN A GALE
An afternoon spent in the
Landmannalaugar region
of Iceland involved bracing
myself against a strong
wind. To photograph the
cottongrass being lashed by
the gale, I had to lie flat in the
wet bog. I included the sky
backdrop to emphasise the
atrocious weather conditions.
Canon EOS 3 with 20-35mm
zoom lens; 1/250 sec at f8;
Fujichrome Velvia 50.

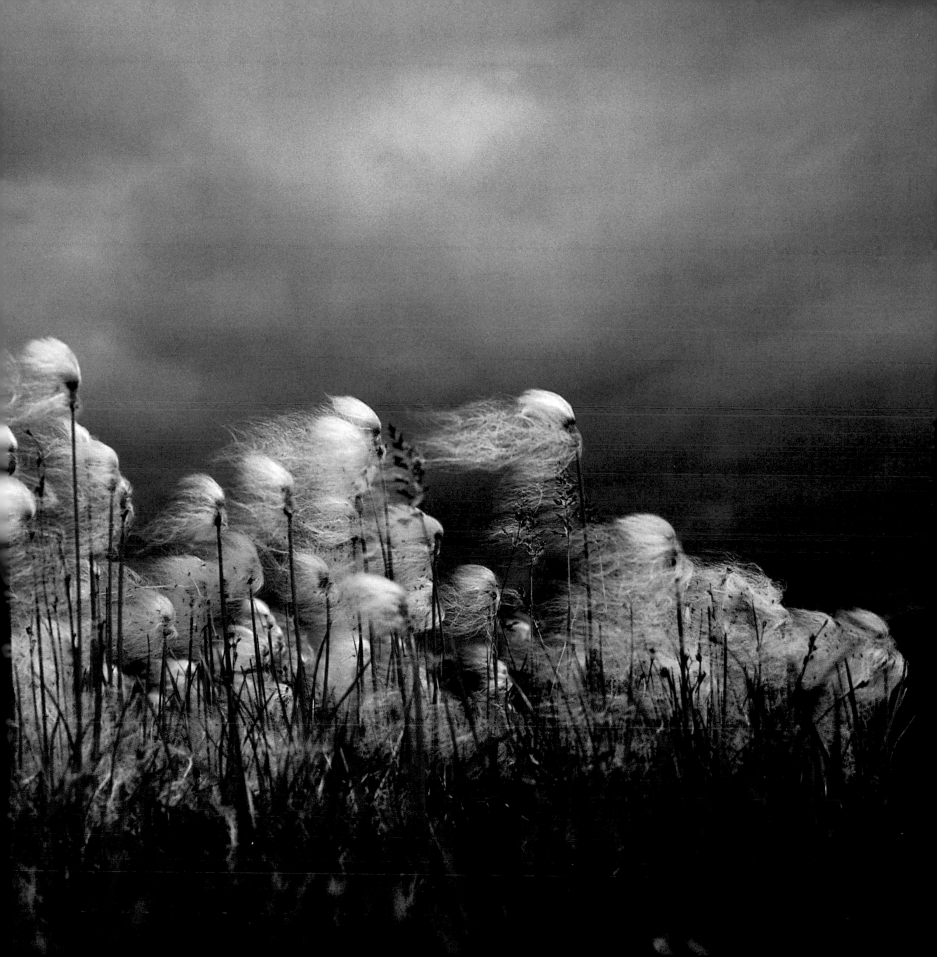

Wild Places

This is a category for landscape photographs, but the pictures must convey a true feeling of wildness and create a sense of awe and wonder. (There are no overall winners.)

HIGHLY COMMENDED

Olivier Grunewald
France

VOLCANO LAVA LAKE
Erta Ale in the Danakil depression of the Great Rift Valley, northern Ethiopia, is an active volcano. I took part in a scientific expedition looking at the volcano's thermal flows. One morning, activity in the lava lake suddenly intensified. Fountains of lava shot more than 15m high, and the solidified surface of the lake cracked apart. The heat of the magma shone crimson on the walls of the 80m-high crater. All I could do was stare in awe, knowing that, within hours, I would be preparing to work... descending into the pit to photograph the volcano's heart.
Nikon F801 with 17-35mm lens; 3 sec at f4; Fujichrome Provia 100; tripod.

Richard Packwood
UK

**DEAD ACACIA TREES
AMONG SAND DUNES**
Desiccated acacias, or
camel-thorn trees, in the
bleached, cracked clay valley
of the Dead Vlei in Namibia's
Namib-Naukluft National
Park, serve as a reminder
of a time when water was
comparatively abundant here.
There's so little moisture in
the valley now that the
acacias decay extremely
slowly – some are thought
to be at least 500 years old.
We arrived in this surreal
landscape before dawn, and
I noticed shadows growing
longer as the sun crept over
the dunes that encircle the
Dead Vlei. Within a couple
of hours, the soaring
temperatures had forced
us away again.
**Nikon F4 with 80-200mm lens;
1/30 sec at f16; Fujichrome
Velvia 50; tripod.**

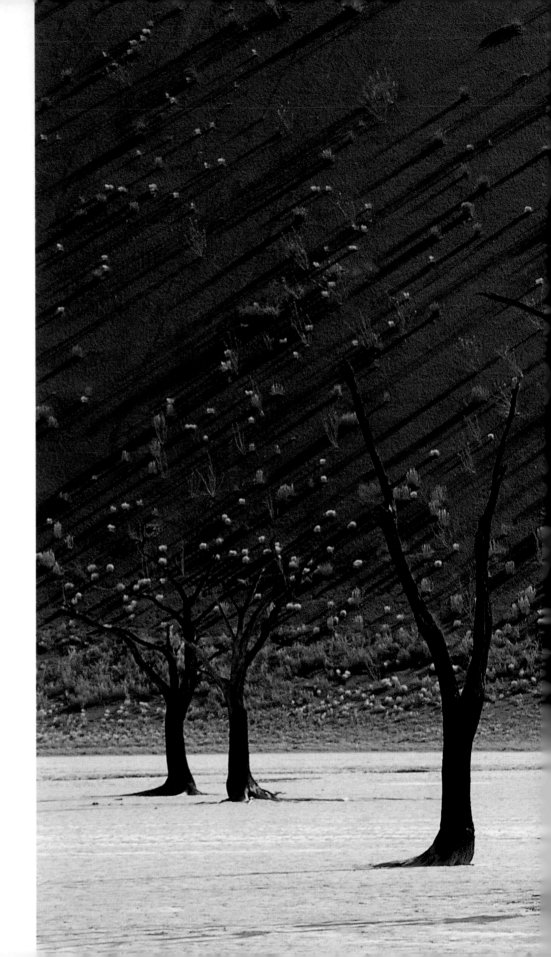

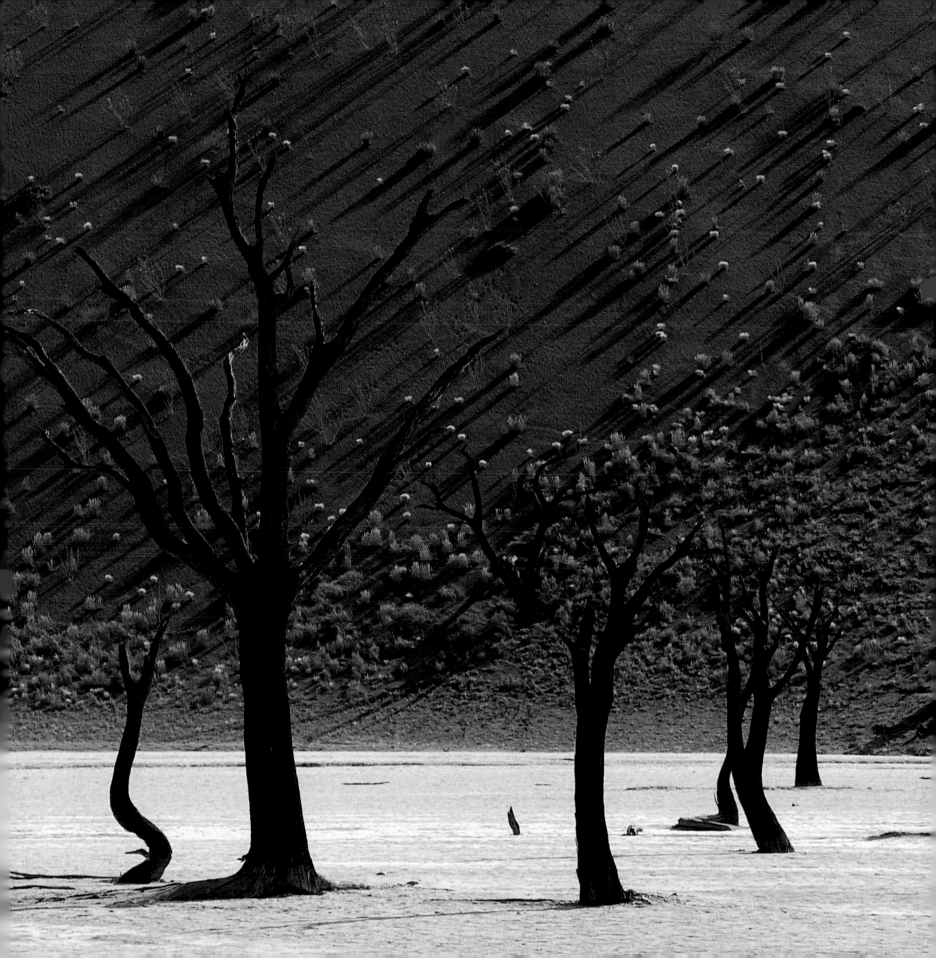

Richard du Toit
South Africa

CHOBE RIVER AT SUNSET
The Chobe River, fed by the Linyanti and Zambezi Rivers, runs along one of the Great Rift Valley's southernmost fault lines. It lies on a large flatland in the Caprivi Strip, on the border of Botswana, twisting and turning through swamps of reed and papyrus beds. Hidden lagoons, fed by the river, teem with birdlife. Every year in April, floodwaters from the Zambezi spill over into the Chobe. The sunsets in this vast, unspoiled Botswana wilderness are the most beautiful I've ever seen. As I watched the setting sun paint the sky with crimson and gold, a family of Egyptian geese swam by.
17-35mm lens; 1/30 sec at f8; beanbag.

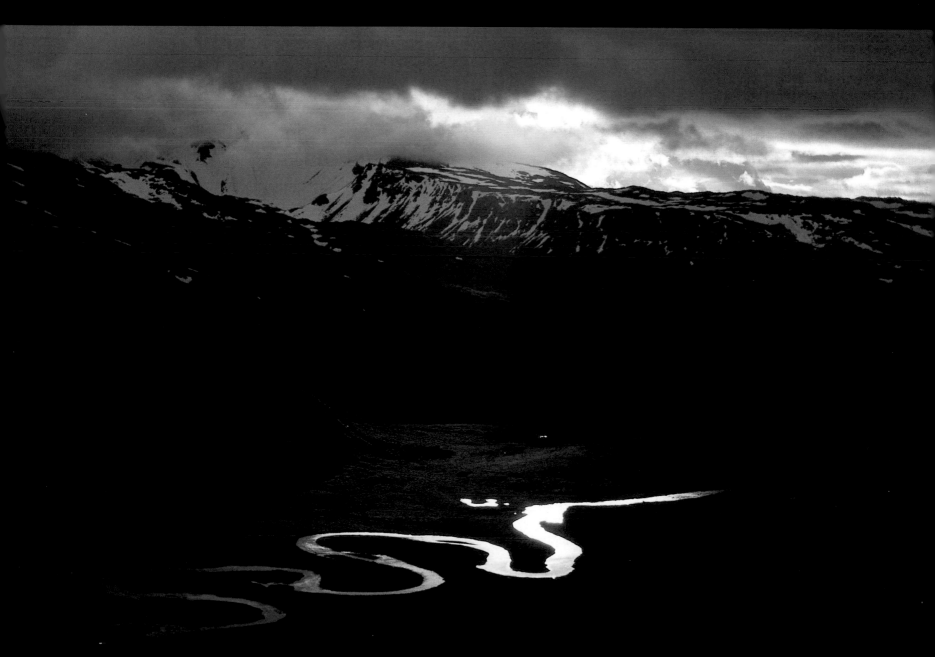

HIGHLY COMMENDED

Beverly Pickford
South Africa

SUMMER NIGHT OVER THE VENTURI RIVER
While on a photographic assignment for a book on fly-fishing, I took many flights in an Otter float plane to some of the remotest rivers in Alaska. One summer's night, we flew from Illiamna in South-central Alaska to Kodiak Island. The plane passed over the Venturi River, world-famous for its wildlife, salmon runs, glaciers and the towering Aleutian Mountains – the views took my breath away.
Nikon F5 with 80-200mm lens; 1/500 sec at f4; Kodachrome 64.

HIGHLY COMMENDED

Tim Laman
USA

GUNUNG PALUNG NATIONAL PARK

Ever since I first saw hornbills high in the canopy in Gunung Palung National Park, in Kalimantan on the island of Borneo, I have dreamt of photographing an overview of the canopy with hornbills in the foreground. After countless hours in dozens of different spots, I eventually used a blind in a very high tree on a steep hillside overlooking the lowlands. These three adult rhinoceros hornbills were part of a group of 10 or so sub-adults – birds that don't yet have breeding territories and travel in loose flocks. They paused here briefly before soaring across the valley.

This national park is under severe pressure from illegal logging, and urgent action is needed to preserve it as one of the few remaining lowland forest sites in Borneo.

Canon EOS 1N with 70-200mm lens; 1/125 sec at f2.8; Fujichrome Provia 100; tripod.

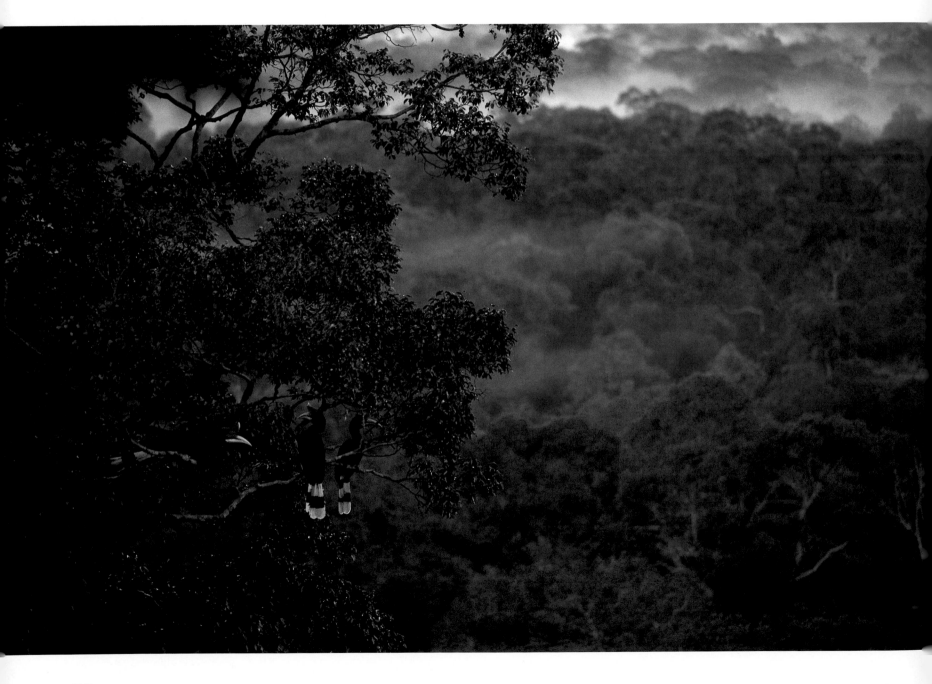

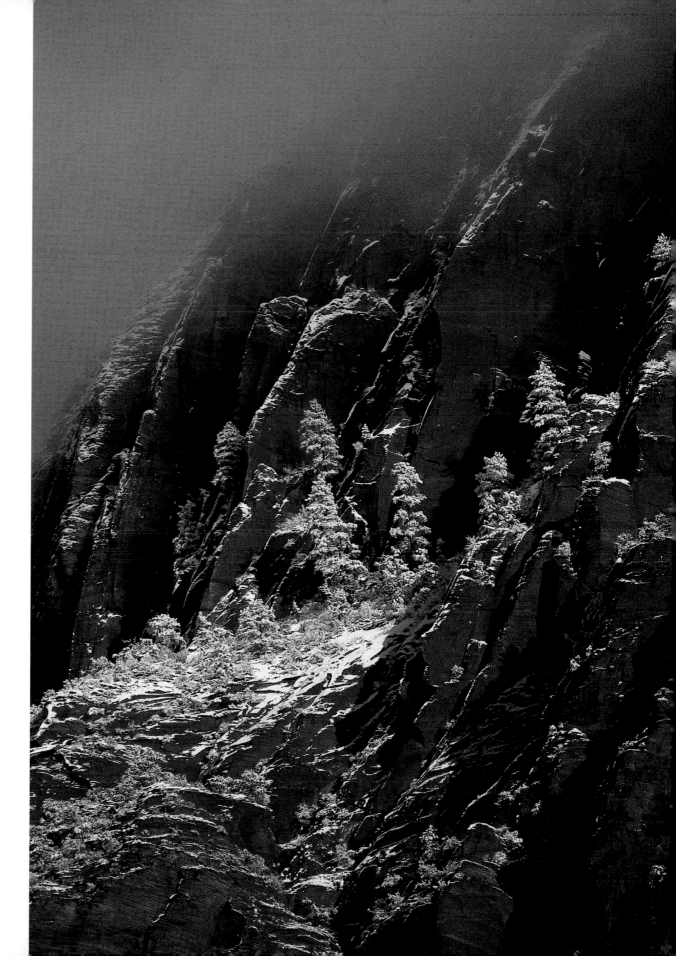

Larry Michael
USA

MOUNTAINSIDE IN ZION NATIONAL PARK

Mormon pioneers arriving in the 1860s in Utah, USA, gave the name 'Zion' – place of refuge – to this area. The park features monumental works of nature, such as the dramatic uprisings of Navajo sandstone in various reddish shades, stained by iron oxides. These sheer rock walls change colour as the sun moves across the sky. In January, I was lucky enough to witness this scene during two days of rare snowstorms.

Nikon F4 with 300mm lens at f5.6; Fujichrome Velvia 50.

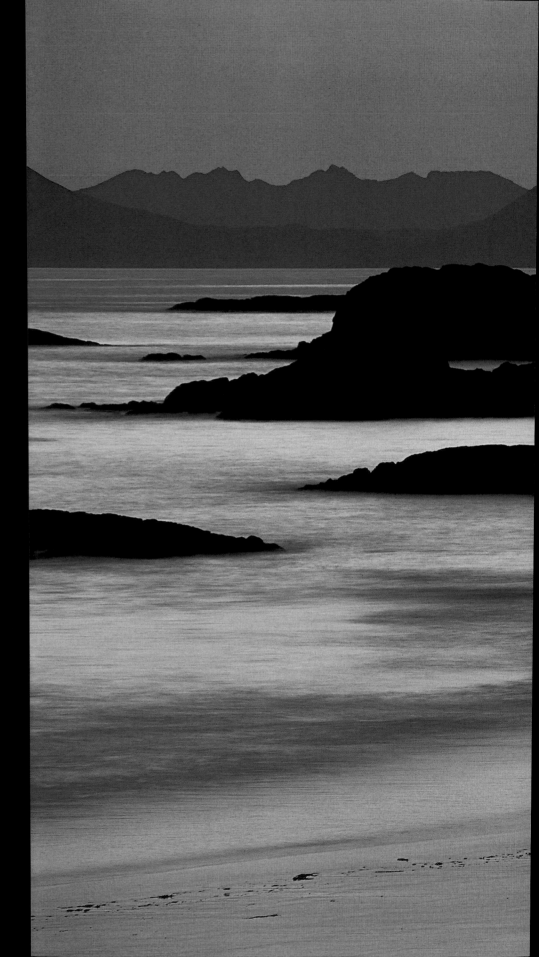

HIGHLY COMMENDED

Lorne Gill
UK

GALLANACH,
ISLE OF COLL

One of Scotland's Inner Hebrides islands, Coll is 21km long and 5km wide in parts, and home to some 150 people. A holiday there gave me the perfect opportunity to slip out of my rented cottage well before dawn to witness the spectacular sunrise at Bàgh an Trailleich. The ebbing of a becalmed sea seemed to be accentuated by the scurrying movements of the gulls as they picked over the cast seaweed on the deserted shore.

Nikon F4 with 80-200mm lens; 90 sec at f8; Fujichrome Velvia 50; tripod.

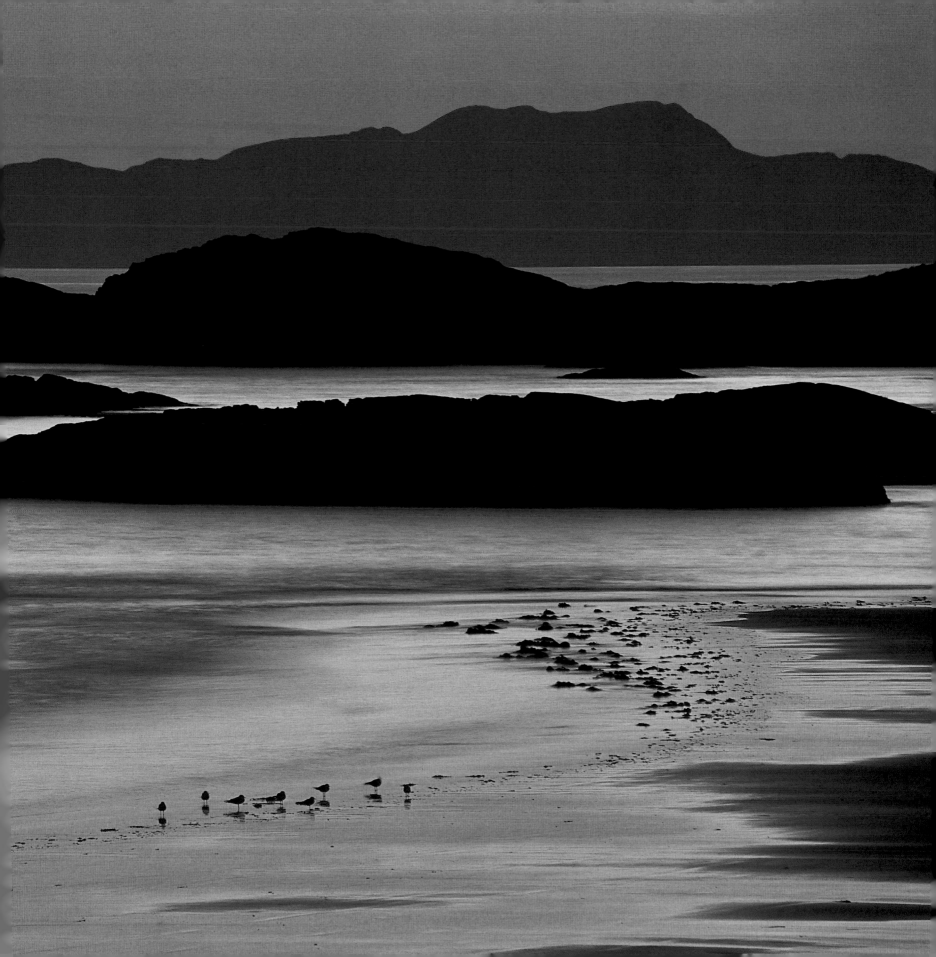

British Wildlife

This category exists both to encourage photographers in the UK to look for subjects closer to home and to show that British plants and animals can be the subjects of beautiful pictures.

Rob Jordan
UK

BLACK-NECKED GREBE FEEDING CHICKS

For the past few years, I've been involved in protecting a colony of black-necked grebes on a private lake in Northumberland, northern England, which was being robbed by egg-collectors almost annually. One evening in late June, after weeks of waiting, I witnessed two walnut-sized chicks hatch, the colony's first of the season. (I was standing chest-deep in freezing water, wearing a diver's dry-suit and camouflaged by my floating hide.) After less than an hour, an attending adult grebe delicately fed insects to the chicks while they nestled on the back of the other grebe (probably the female, though it's difficult to tell the sexes apart). It was almost 11pm, and I could only find enough light to take an image by lining the birds up with the reflection of the setting sun behind them. In Britain, black-necked grebes are nationally very rare and at the extreme north-western edge of their European range.

Nikon F4s with 500mm lens; 1/125 sec at f4; Fujichrome Provia 100; floating hide, beanbag.

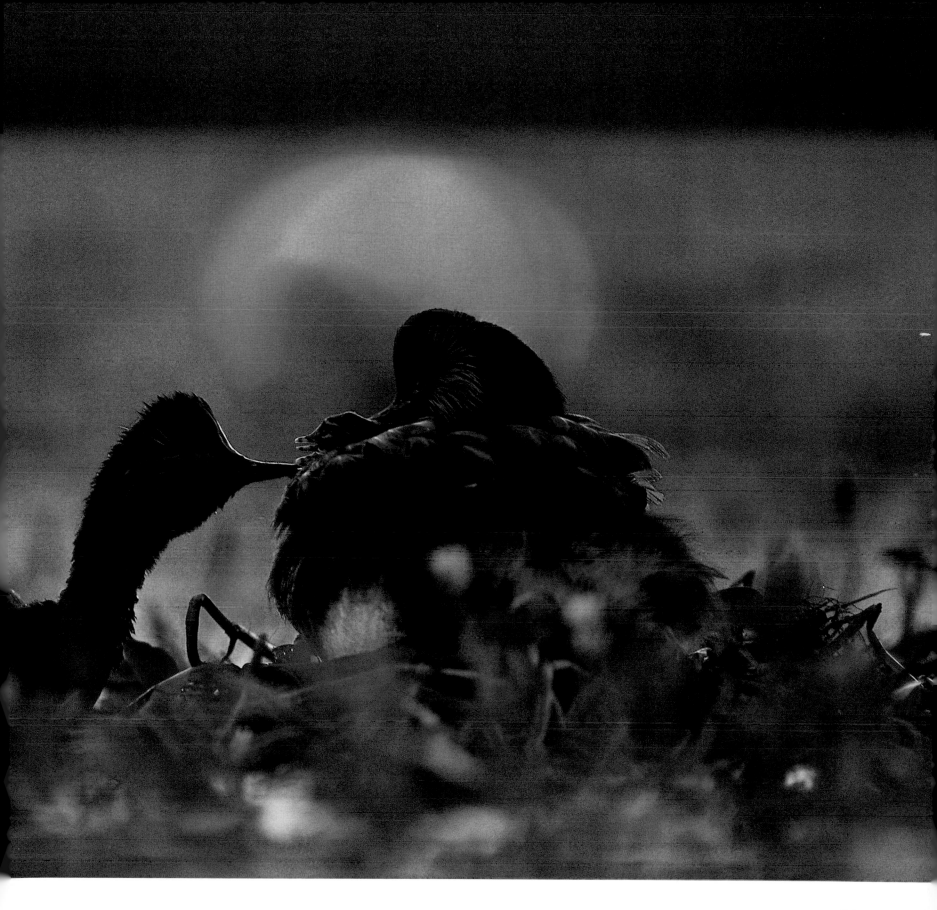

Mike Hill
UK

WISTMAN'S WOOD, DARTMOOR

According to local folklore, a pack of headless, jet-black Yeth hounds (said to be the spirits of unbaptised children) haunt this patch of ancient oak woodland. On a warm summer's day, with plenty of people around, it was an enchanting place. I happily explored the jumbled mass of boulders that has long protected the site, in Devon, in the UK, from browsing animals and wood-cutters. But the best time for photography is when the colours are saturated. So, one wet, stormy morning, I returned. This time, the stunted, mangled, lichen-covered trunks seemed menacing and grotesque. I left as soon as I could, before the wailing Yeth hounds could hunt down my soul. . .

Fuji GX617 with 90mm lens; 1 sec at f16; Fujichrome Velvia 50; tripod.

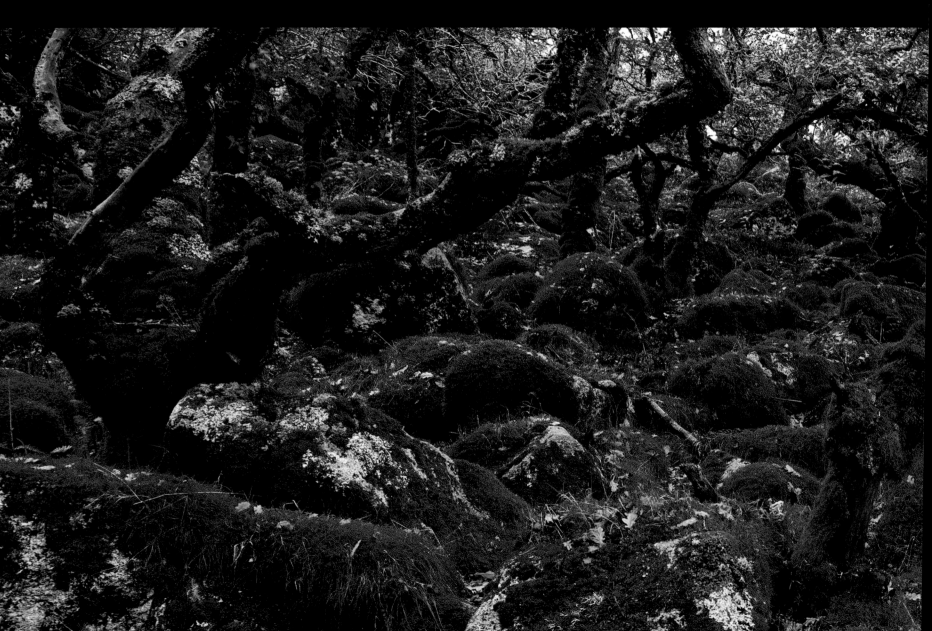

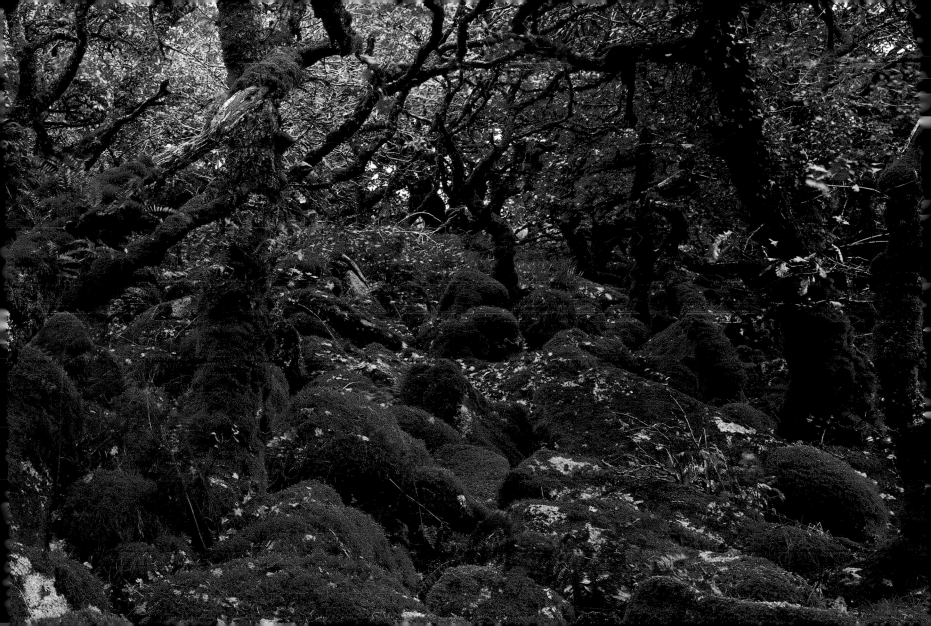

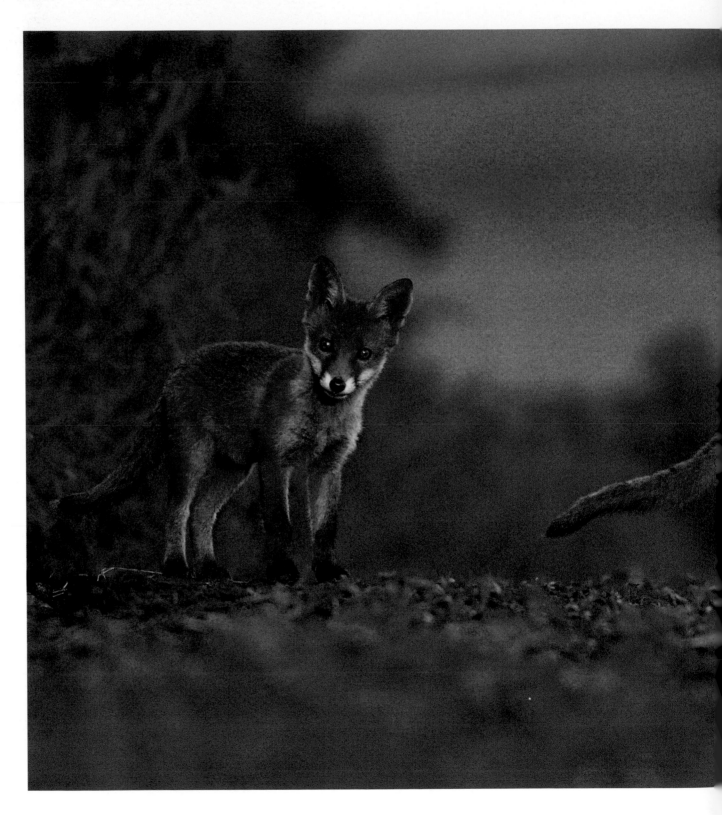

Mark Hamblin
UK

RED FOX FAMILY

I erected a small canvas hide 15 metres from one of the entrances to a fox's earth on the outskirts of Sheffield, northern England, and visited it regularly over several weeks. One morning, soon after daybreak, I spotted the vixen heading towards the earth. Five cubs ran out to greet her and immediately began to suckle. Soon after, the mother regurgitated some food, which the cubs quickly ate. In this picture, two of the cubs are hoping for a second helping, while a third looks briefly in my direction. This was the only occasion that the vixen appeared in light good enough for me to take a photograph.

Canon EOS 3 with 500mm lens; 1/250 sec at f5.6; Kodak Ektachrome 100VS; hide.

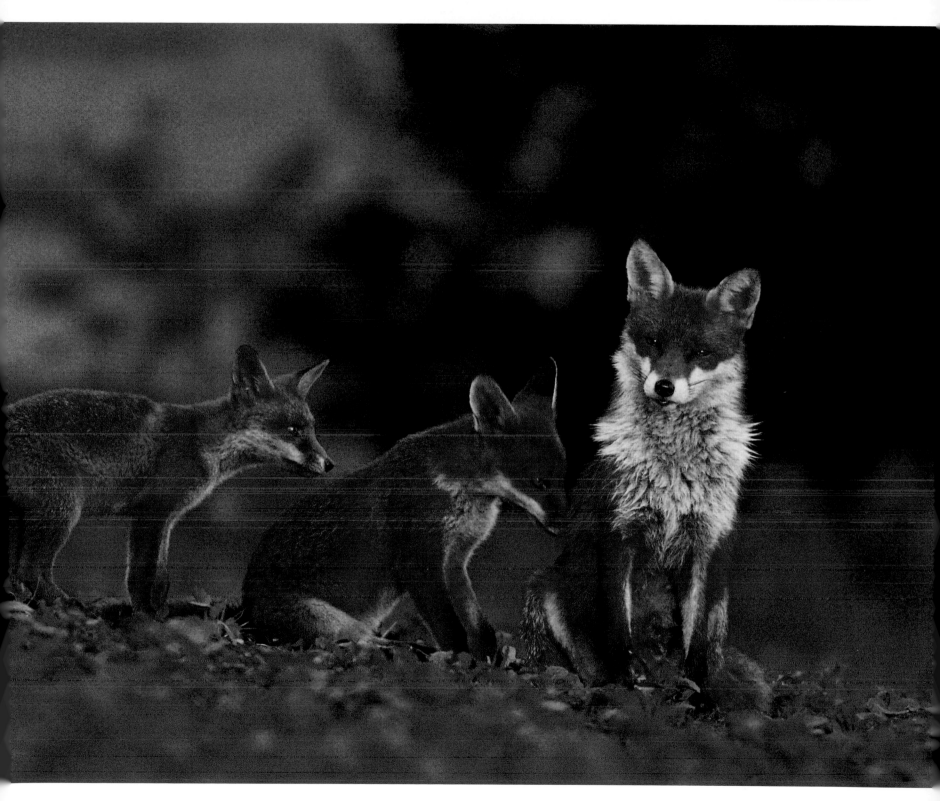

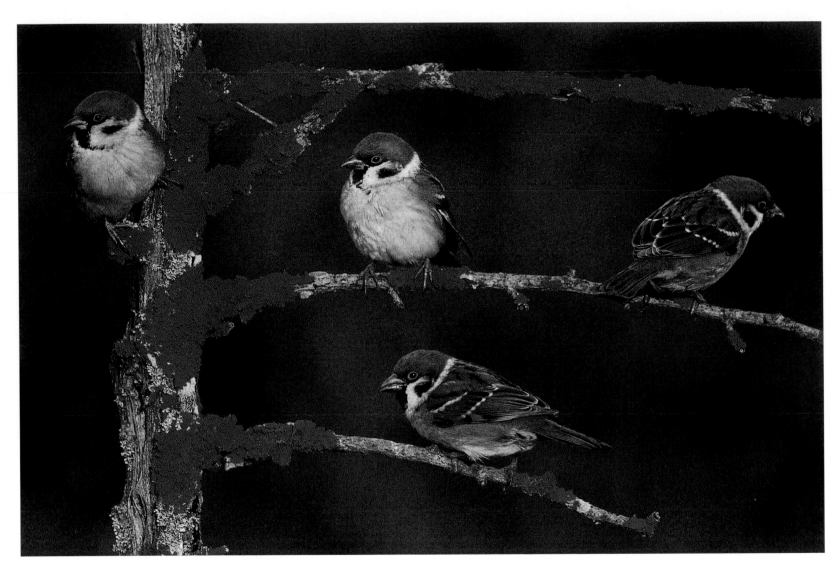

Mike Wilkes
UK

TREE SPARROWS
Ten years ago, I began putting out food in the corner of a field in Warwickshire to attract birds. The farmer fenced off an acre of land for me, and soon it was thick with blackberry bushes, wild roses, willows and other plants. Today, dozens of different birds stop by, from goldfinches, tits and sparrowhawks to ducks, doves and pheasants. Tree sparrows have declined by nearly 90 per cent in UK farmland areas in the past three decades, but at my feeding station, numbers have soared. In winter, up to 30 may gather here at any one time. They're a delight to watch as they feed, display, chirrup and squabble.
Canon EOS 3 with 500mm lens; 1/250 sec at f5.6; Fujichrome Sensia 100; beanbag.

HIGHLY COMMENDED

Mark Hamblin
UK

RED DEER

Photographing red deer in the Scottish Highlands requires fieldcraft skills and a sound knowledge of where and when to find your subject. I lacked this knowledge when, one October, I made a trip to the Highlands, and so I decided to visit the Highland Wildlife Park near Kincraig. Having sought special permission to enter the park early one morning, I spent three successive dawns trying to photograph the red deer. I'd hoped to photograph stags roaring, but when I spotted these five hinds silhouetted against the stormy sky, I knew this was the image I was after. **Canon EOS 1N with 300mm lens; 1/500 sec at f5.6; Fujichrome Sensia 100; beanbag.**

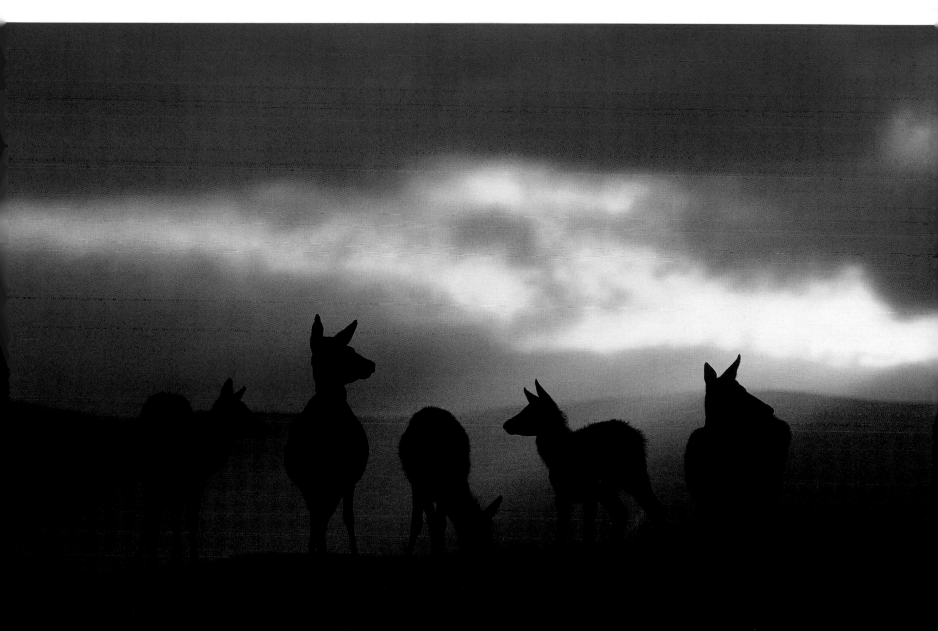

Steve Smithson
UK

CURIOUS GREY SEAL

I spotted a few grey seals playing in the sea off the Isle of Man. I watched them repeatedly swim down a gully, and so I positioned myself at the exit. Gradually, the younger ones became more inquisitive and came closer. They enjoyed watching their reflections in my camera's underwater housing. The UK is an important area for grey seals, with 40 per cent (about 110,000 animals) of the world population.

Nikon F90x with 16mm lens; 1/125 sec at f8; Fujichrome Provia 100; underwater housing; two strobes.

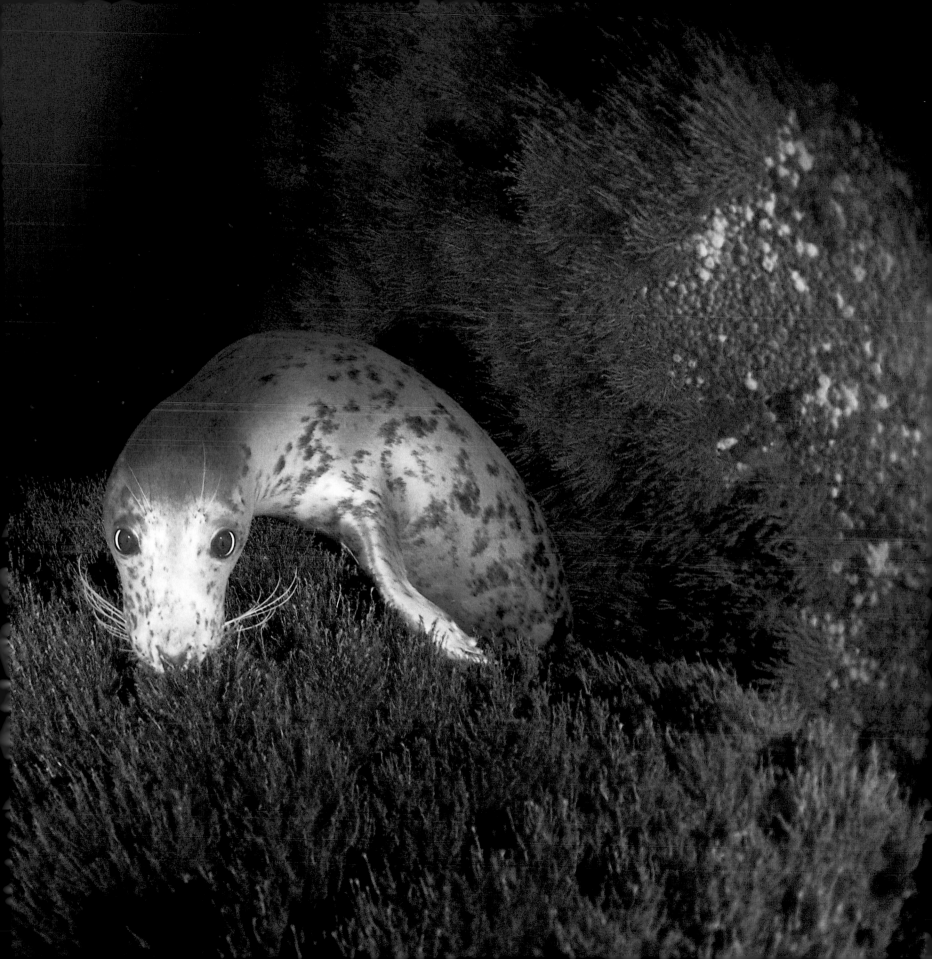

Urban and
Garden Wildlife

This is another category that aims to encourage photographers to take pictures of wildlife close to home – in a garden or an obviously urban or suburban setting. It offers great scope for originality and innovation, but there are always surprisingly few entries. (Once again, there were no overall winners.)

HIGHLY COMMENDED

Janice Ann Godwin
UK

YOUNG RATS DRINKING FROM A WATER BUTT
Rats need to drink frequently, and so when a colony of up to 25 common rats set up home in my neighbour's stables, they chose a spot with the nearest accessible water, which was in a butt in a secluded corner of my garden. I set up a hide, and it wasn't long before I could recognise the rats individually. At first, the water level was low, and the youngsters struggled to reach it. I filled it up, which created lovely reflections when they leaned over to sip. After hanging on with their little front legs for as long as they could, the young rats would eventually drop off, then scramble back up the pile of bricks at the back of the butt again.
Nikon F4s with 500mm lens; 1/60 sec at f8; Fujichrome Sensia 100; flash unit; tripod.

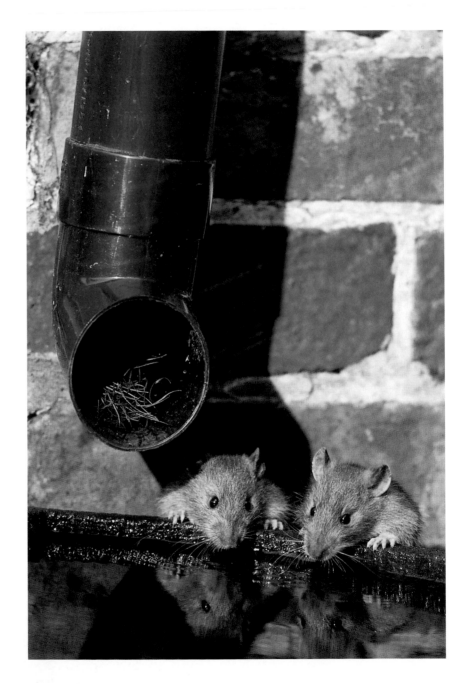

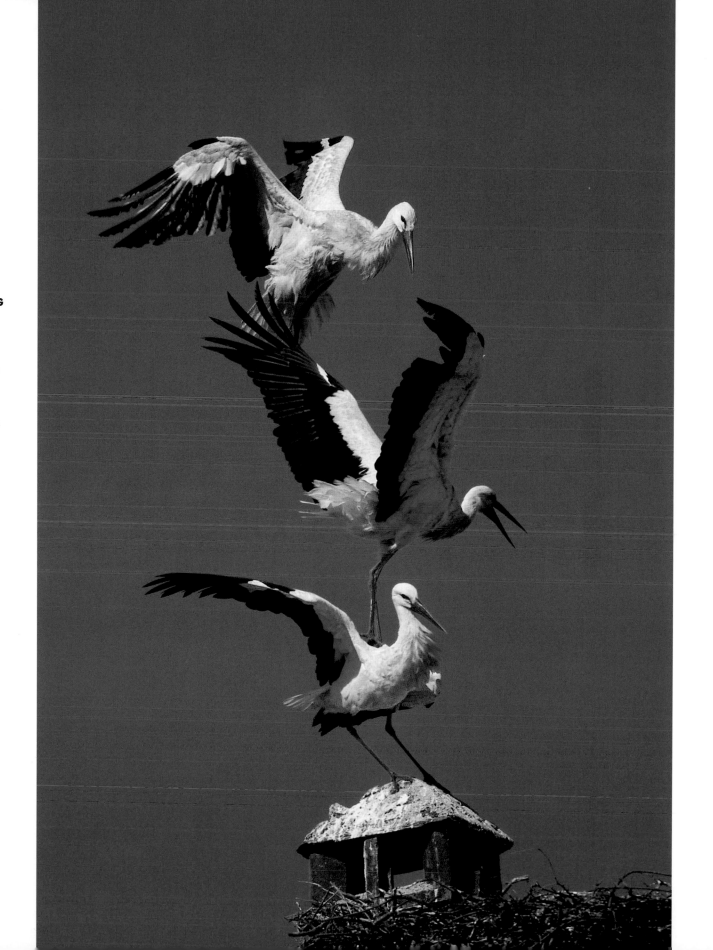

HIGHLY COMMENDED

Rainer Müller
Germany

WHITE STORKS FIGHTING FOR CHIMNEY SPACE

For 15 years, I've regularly visited an old farmhouse 5 kilometres from Cáceres, in Extremadura, Spain. White storks have always nested there, but now their population seems to be larger than ever – last spring, there were at least 50 pairs breeding on the roofs of the building. Space is at a premium, the most sought-after resting places being the chimneys. Here, a mating pair is being attacked by a neighbour.

Canon EOS 3 with 500mm lens; 1/1000 sec at f5; Fujichrome Sensia 100.

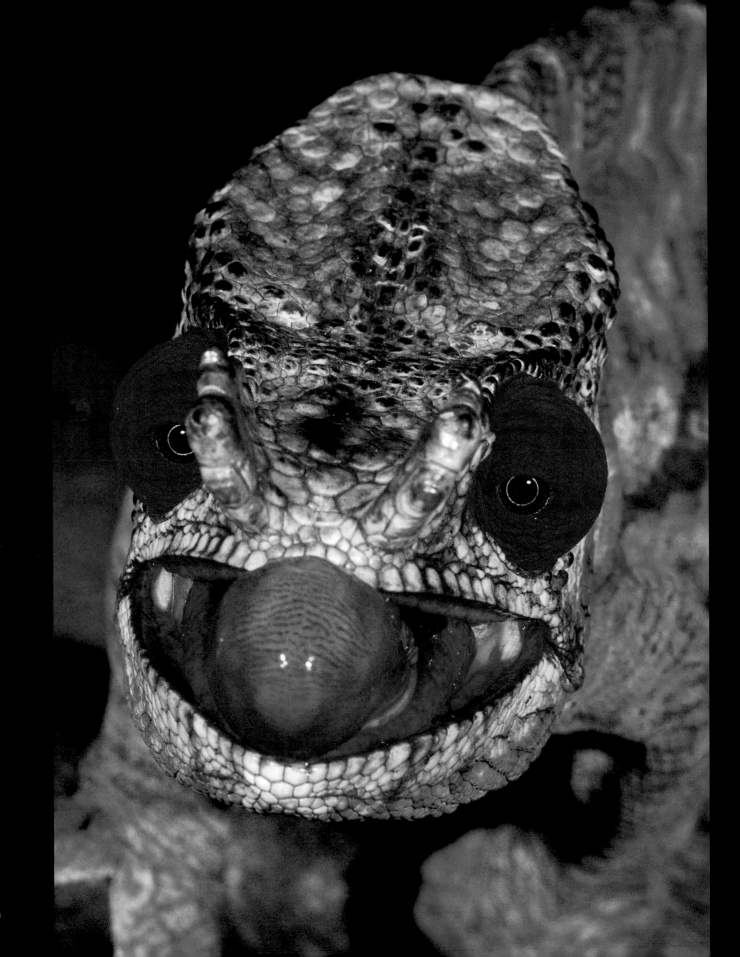

This is one of the most popular categories. It invites entries that are true portraits, showing an animal in full- or centre-frame, which convey the spirit of the subject.

WINNER

Martin Harvey
South Africa

PARSON'S CHAMELEON ABOUT TO CATCH A FLY

This large chameleon lurked in the bushes around the hotel I stayed at in Madagascar and was consequently used to people. I decided to get an insect's perspective of it, and so I took this picture in the instant before the chameleon's tongue – which was at least as long as its body – shot out to grab a meal. This is the view an insect would have in its final moments.
This species is one of the largest chameleons in the world and can grow up to 50cm in length – this individual was around 40cm.
Canon A2E with 180mm lens; 1/125 sec at f22; Fujichrome Velvia 50; two flashes.

Christof Wermter
Germany

PHEASANT

A cloudy, early morning in April on the island of Texel in the Netherlands didn't hold much promise for any decent pictures, but I hoped to spot a pheasant, and after an hour, I saw this individual in the grass near the road. The sun suddenly lit up the scene, which gave me enough time to take some pictures before dull-grey conditions returned.
Nikon F5 with 500mm lens and 1.4x converter; 1/250 sec at f5.6; Fujichrome Sensia 200; beanbag.

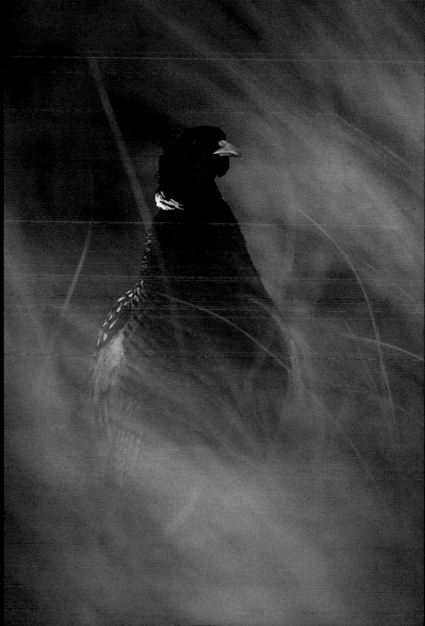

Torbjörn Lilja
Sweden

COURTING BLACK-LEGGED KITTIWAKES

Ekkerøy, on the north coast of Varangerfjord, Norway, is home to one of the world's largest colonies of kittiwakes. These birds are highly skilled at landing in strong winds on the narrow ledges where they build their nests. When I visited at the beginning of April, there were still some weeks to go until they began laying eggs, and the birds were busy pairing up. After the nest is ready, up to three eggs are laid, and both parents share egg-incubating and chick-rearing.

Pentax 645N with 600mm lens; 1/125 sec at f5.6; Fujichrome Velvia 50; tripod.

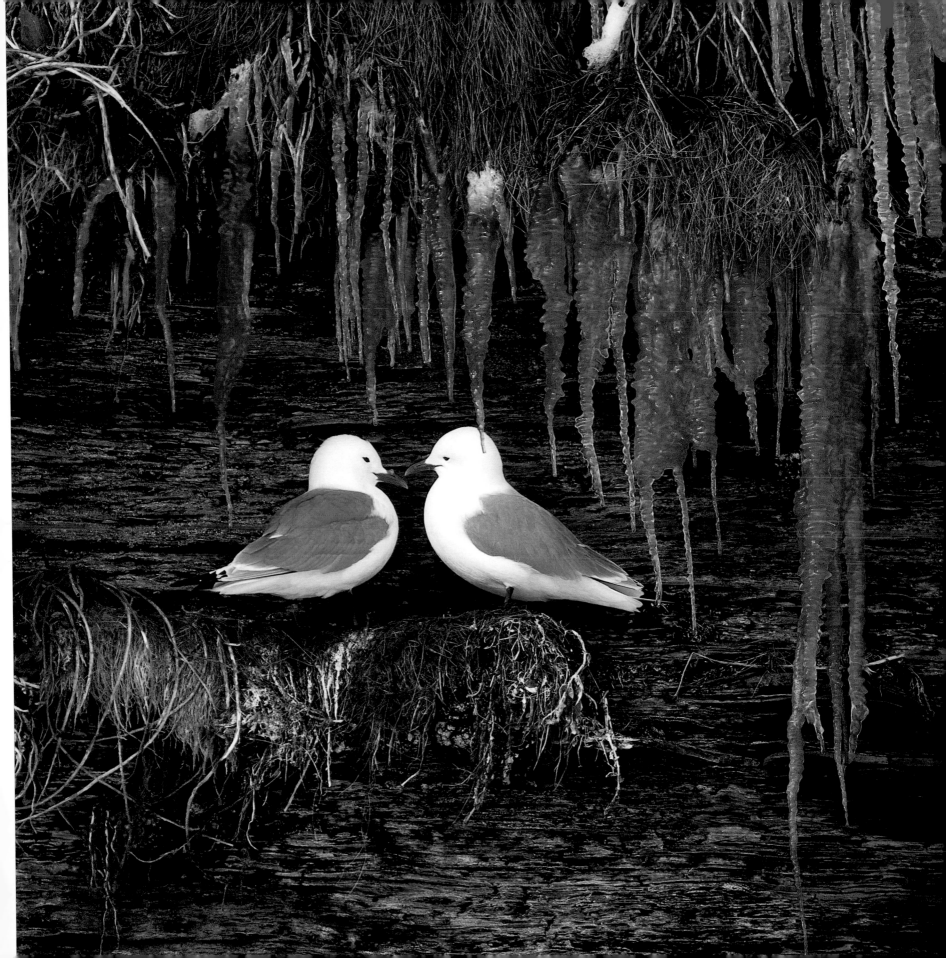

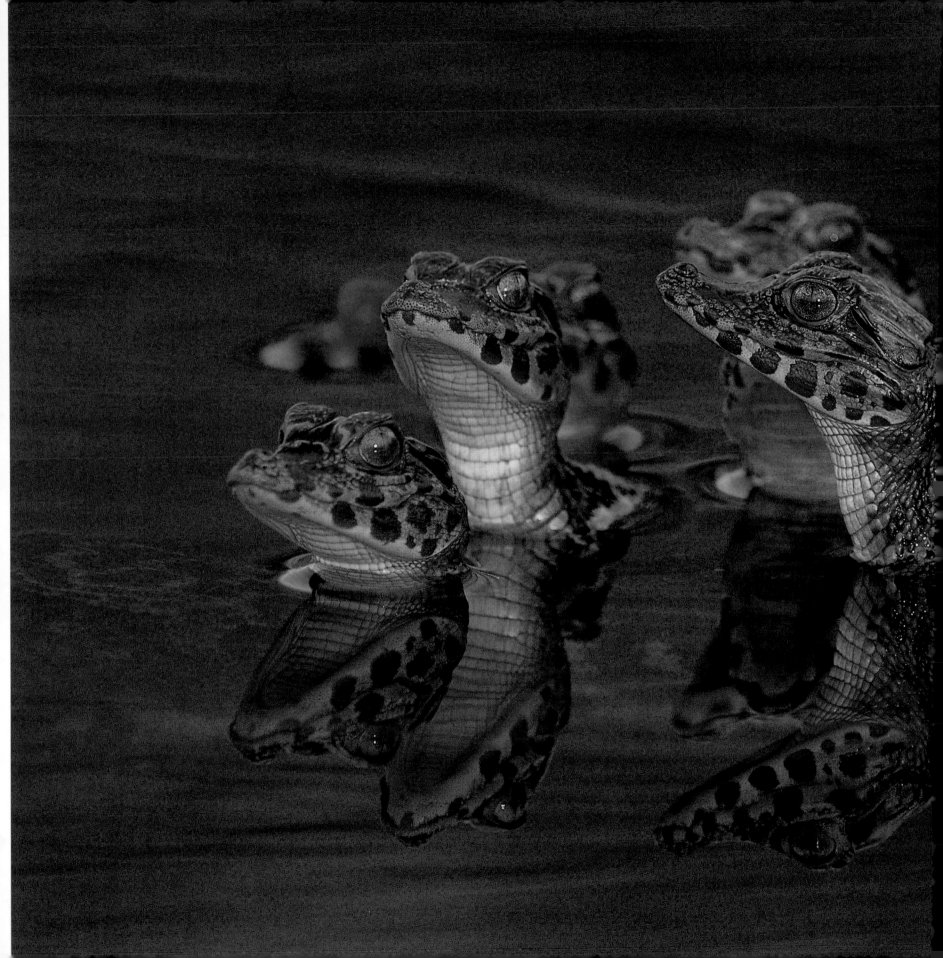

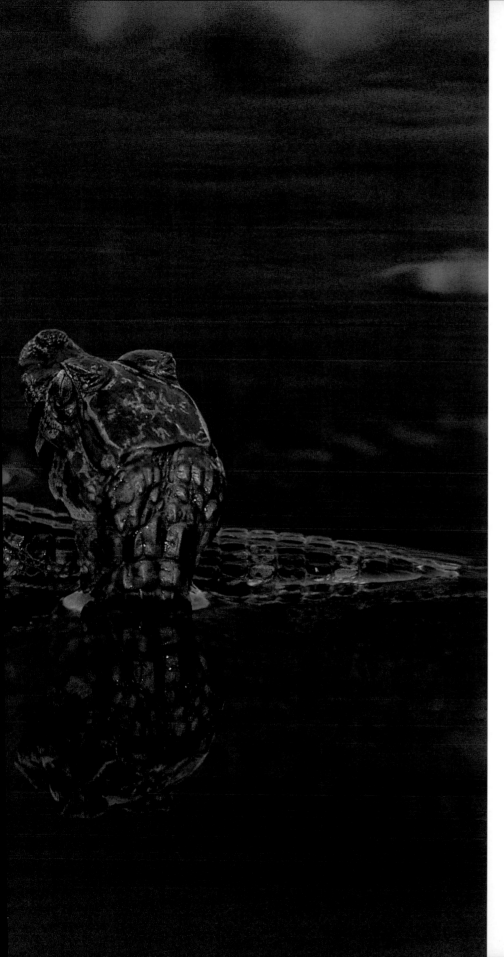

Theo Allofs
Germany

YACARE CAIMAN CRÈCHE
I discovered this group of baby yacare caimans huddled together in shallow water near the shore of a lagoon in the Brazilian Pantanal. Their mother was hovering protectively nearby. I fully expected the youngsters to disappear at any moment but decided to get my camera ready nonetheless. Amazingly, the little caimans sat quite still, soaking up the sun, their near-perfect reflections shimmering slightly in the water. Of the six species of caiman in South America, the yacare caiman is one of the most widely distributed, from the rivers of Central Brazil down to Argentina, Bolivia and Paraguay.
Nikon F5 with 300mm lens;
Fujichrome Provia 100.

Thomas Dressler
Germany

PERINGUEY'S ADDER BURYING ITSELF

There is precious little natural cover on the bare dunes of Namibia's Namib Desert. So the Peringuey's adder, or sidewinder, sinks into the sand to keep cool and hide. When it's fully buried, the only parts of its body that will remain exposed are its eyes, which are on top of its head, and the black tip of its tail, which twitches to lure prey closer.

Canon EOS 5 with 28-105mm lens at f6.7; Fujichrome Velvia 50.

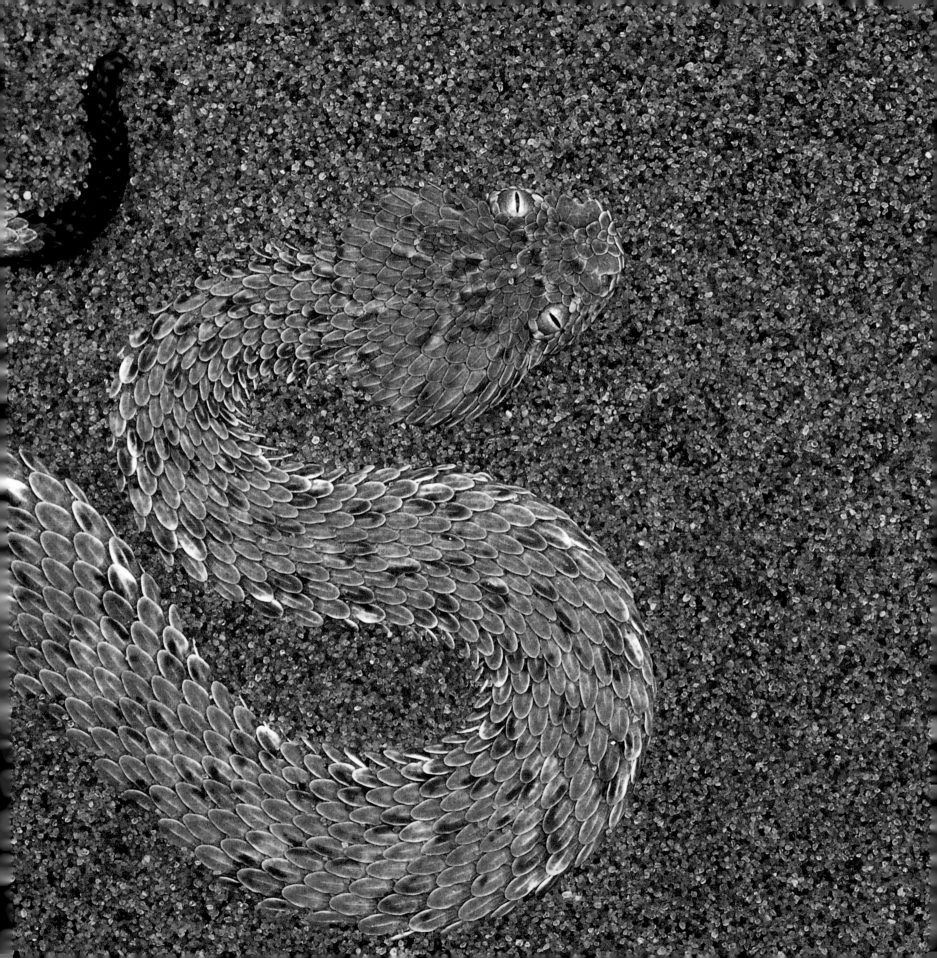

The World in Our Hands

These pictures illustrate, whether symbolically or graphically, our dependence on the natural world or our capability for damaging it.

Michael Nichols
USA

BUSHMEAT KILL
To feed his family, this man set out from his home on the Motaba River in Northern Congo with a shotgun and a couple of shells. He returned with a moustached monkey, abundant in local forests. Every year, between 1 and 3.4 million tonnes of bushmeat is taken in Central Africa. Some animals, as in this case, are caught for local consumption. In terms of the bushmeat crisis, this man is not the problem. The greatest threat comes from the professionals, the hunters who use snares indiscriminately and export the meat to cities regionally or overseas. If that trade continues at current levels, some conservationists believe that many species, including our closest relatives, the great apes, could be extinct in the wild within the next 10 to 15 years.
Canon EOS 3 with 17-35mm lens; 1/8 sec at f5.6; Kodak 100SW; one strobe off to the left.

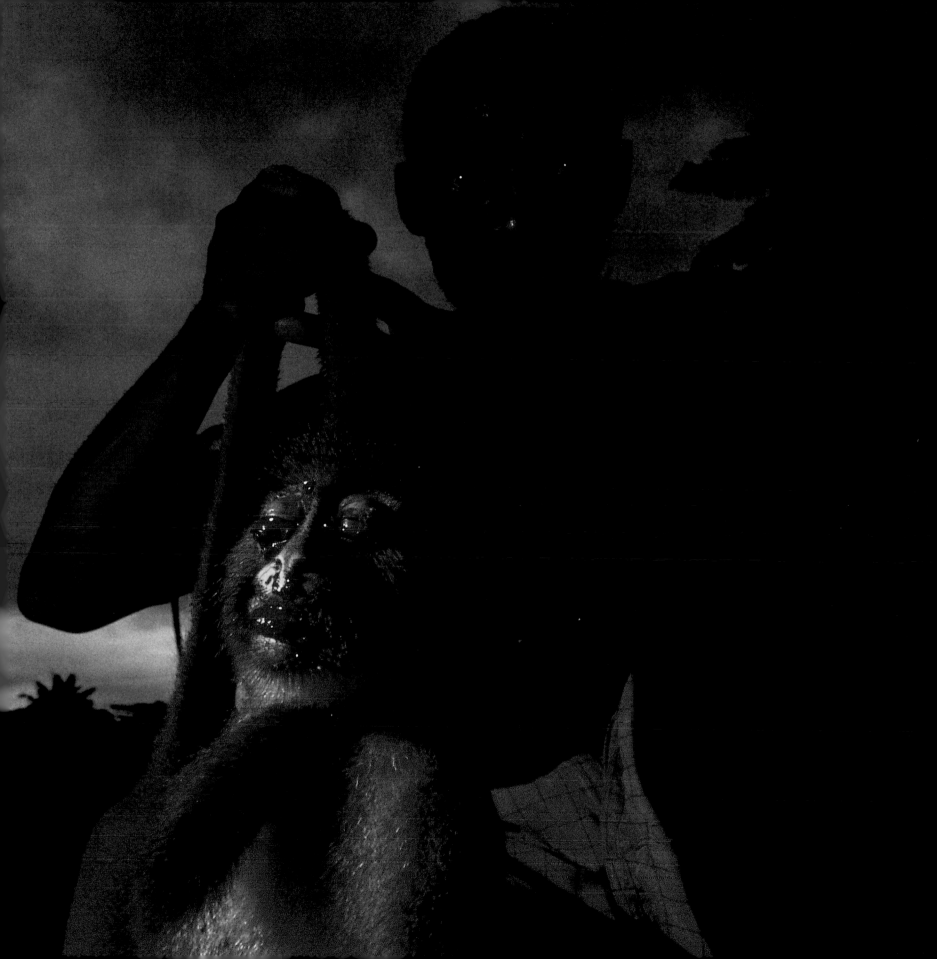

Axel Gomille
Germany

TIGER DISTURBED BY TOURISTS

Our local guides spotted this tiger about to cross a road in Bandhavgarh National Park, Madhya Pradesh, India. When it paused, uncertain of what to do, other vehicles were called up so more tourist tips could be brought in, resulting in a 'tiger jam'. The tiger snarled, finally deciding to bolt through the only gap in the roadblock. There are only about 3,000 tigers left in India – under pressure from poaching, habitat loss and lack of prey.

Nikon F801s with 70-210mm lens; 1/30 sec at f5.6; Fujichrome Sensia 100; shoulderpod.

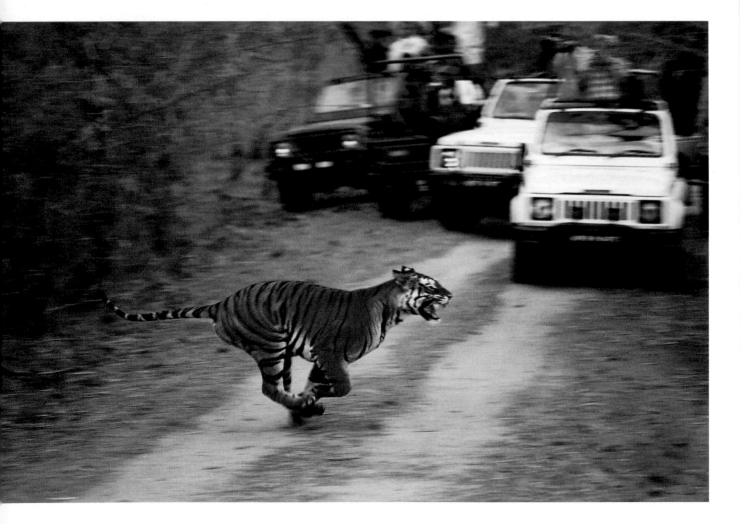

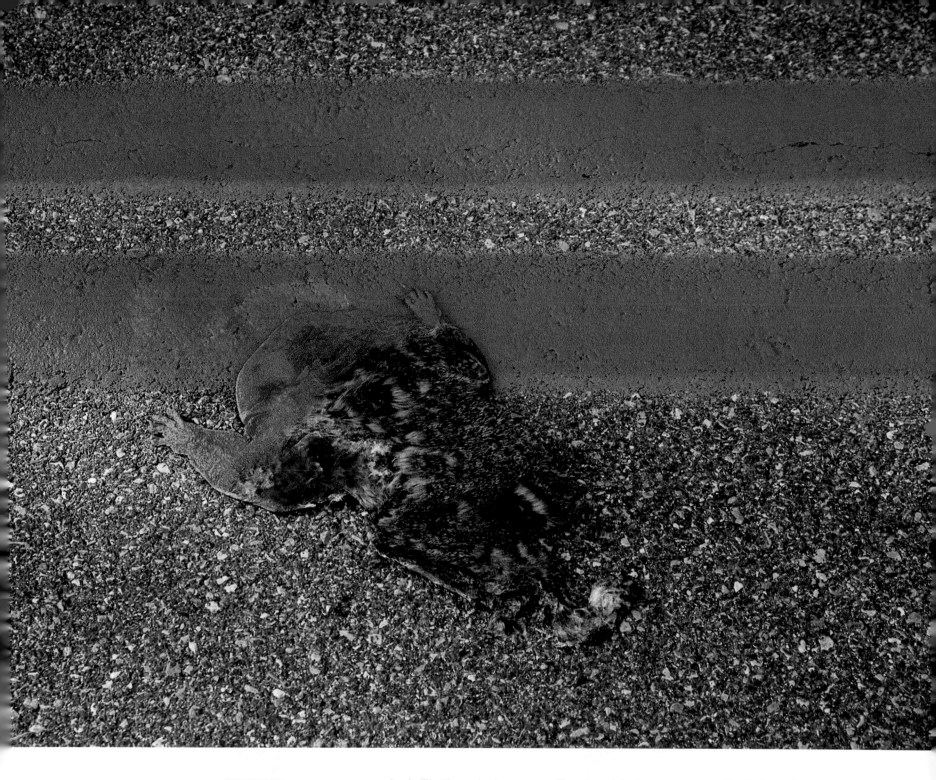

RUNNER-UP

Stephen McDaniel
USA

**GREY SQUIRREL
ROAD-KILL VICTIM**
Every day, the bodies of animals struck by cars and trucks litter the roads where we live in Maryland in the US. This daily slaughter amounts to a horrendous toll – probably a million or more animals a year in our state alone, sometimes including endangered species.

Though most deaths are accidental, I have seen drivers deliberately run animals down, particularly those considered 'pests', such as grey squirrels. This one met its end just a kilometre from my home. To photograph it, I had to be careful not to become a road-kill myself, as cars fly down the road at sometimes twice the legal speed limit.

**Canon A2E with 28-105mm lens;
1/125 sec at f8; Fujichrome
Sensia 100.**

Pete Oxford
UK

CHAINED TIGER AND 'BRAVE' TOURIST

When we visited Primitive Forest Park near Jinghong, Yunnan Province, China, we were unsure what to expect but thought it would be a sort of 'eco' park. It turned out to be a display of severely mistreated animals. As well as a lion, a wolf, a bear and lots of monkeys, there was a tiger, whose permanent home was a cage scarcely bigger than the animal itself. It was only allowed out to 'perform' for visitors. This Chinese tourist sat on the tiger, which was chained to the table. The tiger's keepers, meanwhile, were close at hand with stout, steel bars to curb any misbehaviour (from the tiger, of course). The tourist struck a pose in a show of macho bravado for his friends to get their snapshots.

Nikon F5 with 80-200mm lens; 1/60 sec at f5.6; Fujichrome Velvia 50; flash.

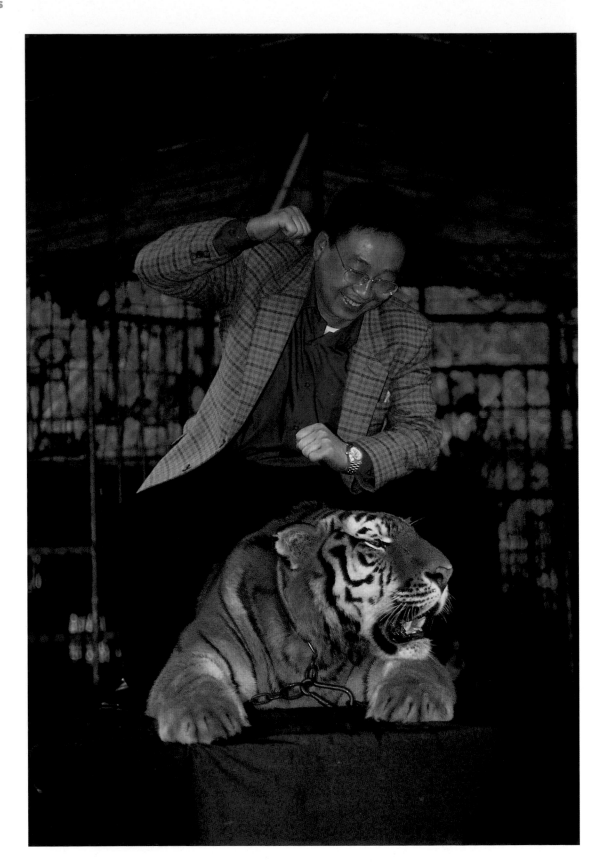

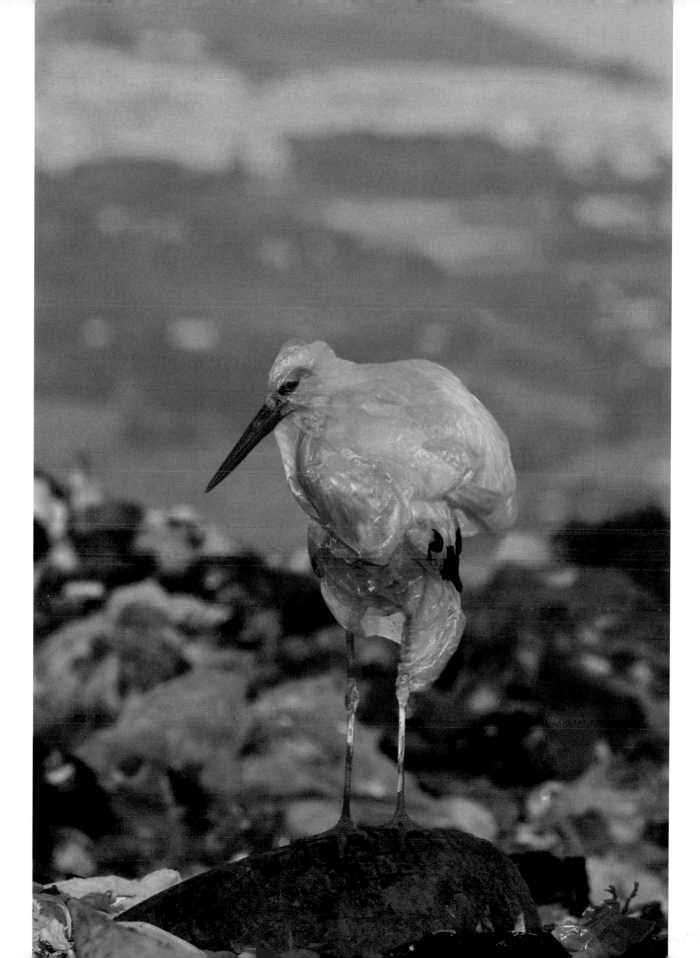

SPECIALLY COMMENDED

John Cancalosi
USA

WHITE STORK TRAPPED IN PLASTIC BAG

Though rubbish poses a threat to individual white storks such as this one, tips are rich foraging sites. In Spain, they contributed greatly to the recovery of the white stork population, from just 6,753 pairs in 1984 to more than 20,000 pairs now. Threat looms, though. An EU Directive has mandated that local authorities clear up tips by covering them and separating components for recycling and disposal. This could cut off a valuable food source for white storks. After taking this photo, I managed to wade through the rubbish and set the bird free. The sight of the stork soaring to freedom will live with me forever, as will the aroma of the rubbish. The open portion of the tip was due to close a few days after I took the photo.

Canon EOS-1V with 500mm lens; probably 1/500 sec at f8; Fujichrome Provia 100; beanbag.

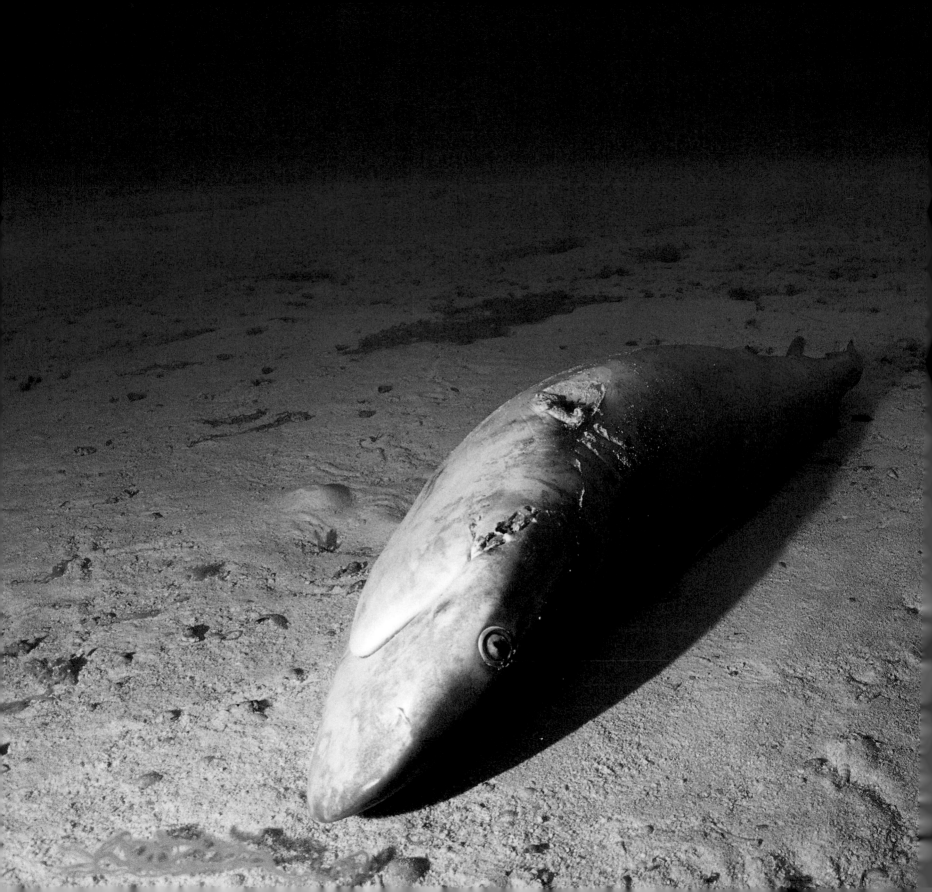

From Dusk to Dawn

The criterion for this category is strict: the wildlife must be photographed between sunset and sunrise. The sun may be on but not above the horizon.

Daniel Magnin
France

**RED DEER DOE
AND FAWN**
I had come to the forest
of Châtillon, in the Côte-d'Or
region of France, to
photograph the red deer rut.
One evening, as I was walking
out of the forest, this doe and
her fawn suddenly appeared
on the track a long way
ahead. I knew that, if I could
get close enough, I might
be able to photograph them in
silhouette. So I memorised
the exposure I would need
and then, keeping near the
trees at the edge of the track
so that they wouldn't see me,
edged closer to them until
I had the perfect picture with
them outlined against the
dusky sky like Chinese
shadow puppets. The pair
remained a minute or two
before melting back into the
dark forest.
**Canon EOS 50 with 300mm lens;
1/60 sec at f4; Fujichrome Sensia**

Chris Gomersall
UK

**BROWN PELICANS
DIVE-FISHING**
At Sanibel Island, Florida, small groups of brown pelicans come inshore at dusk for a period of intense feeding. They fly low over the sea, alternately gliding and flapping. When a pelican sees a fish, it folds its wings and plummets into the water, bobbing up again like a cork to float for a while on the surface. No other pelicans plunge-dive like this – other species feed from the surface. What fascinated me was the way that the pelicans seemed to dive in synchrony – as soon as one plunged into the midst of a shoal of fish, the others would follow, one after the other in rapid succession, bombing down just a fraction of a second apart.
Nikon F5 with 300mm lens; 1/800 sec at f2.8; Fujichrome Sensia 100; tripod.

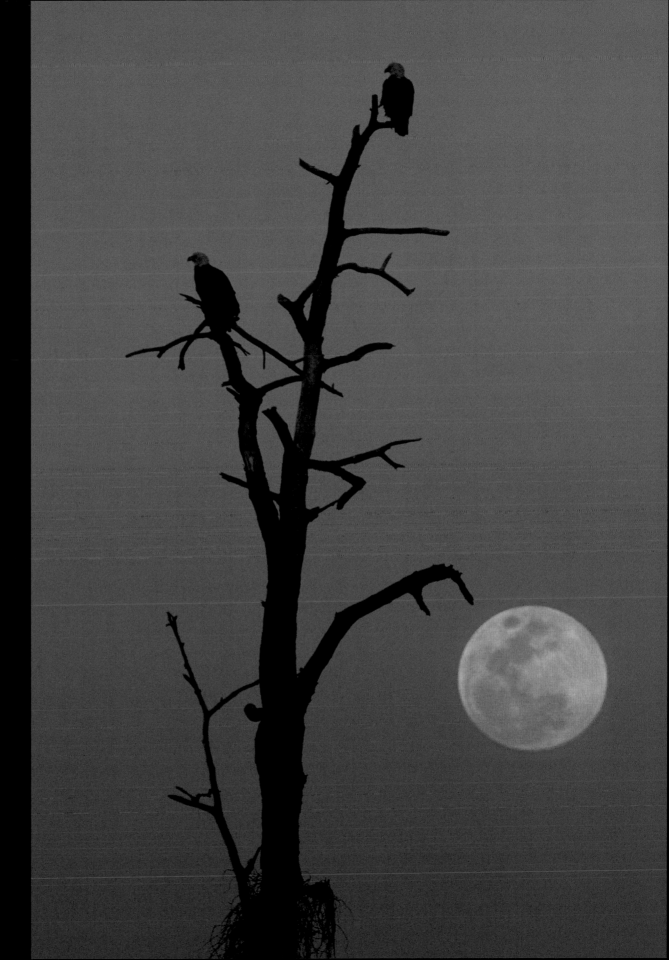

Ellen B Goff
USA

BALD EAGLES WITH A FULL MOON

The bald eagles at this site in Cape Coral, Florida, seemed to use this dead tree as a landing strip and lookout post – and perhaps to get a break from the demanding chick in their nest in a neighbouring tree. Bald eagles are protected, and so we had to stay about 30 metres away. As the light waned, the moon rose, taking us by surprise. Just after I took this photograph, one of the birds flew off – returning just three minutes later with a huge fish. But by then it was too dark to take any more pictures.

Nikon F5 with 600mm lens; 1/125 sec at f11; Fujichrome Provia 100; tripod.

Vincent Munier
France

WHOOPER SWANS ON A FROZEN LAKE

One evening last February, at Lake Kussharo on the northern island of Hokkaido, Japan, a strong blizzard of fine snow concealed six whooper swans that had gathered on the lake's ice. I could barely hear these noisiest of all wildfowl because of the wind. There was a sudden lull in the storm for a few moments when I was able to grab this atmospheric scene, which is engraved on my memory as well as on film.

Nikon F5 with 300mm lens; 1/60 sec at f4; Fujichrome Provia 100; tripod.

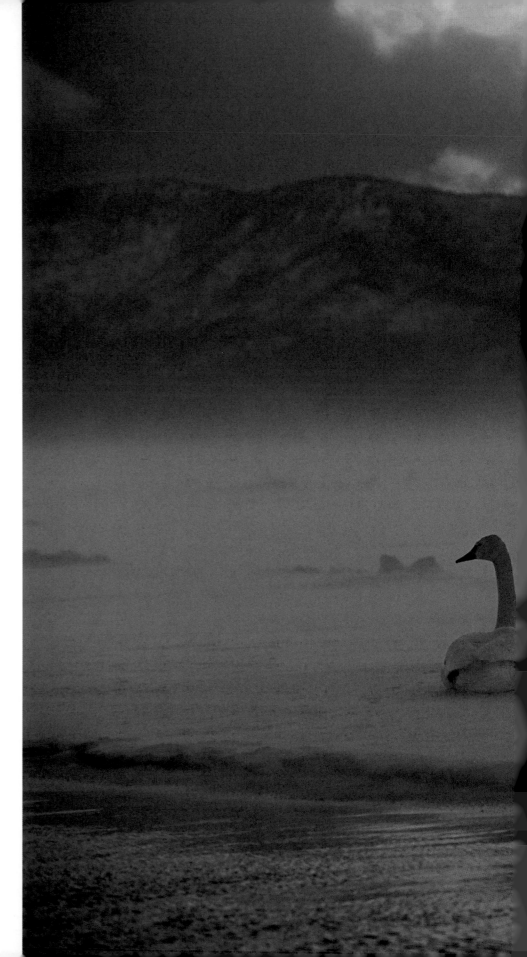

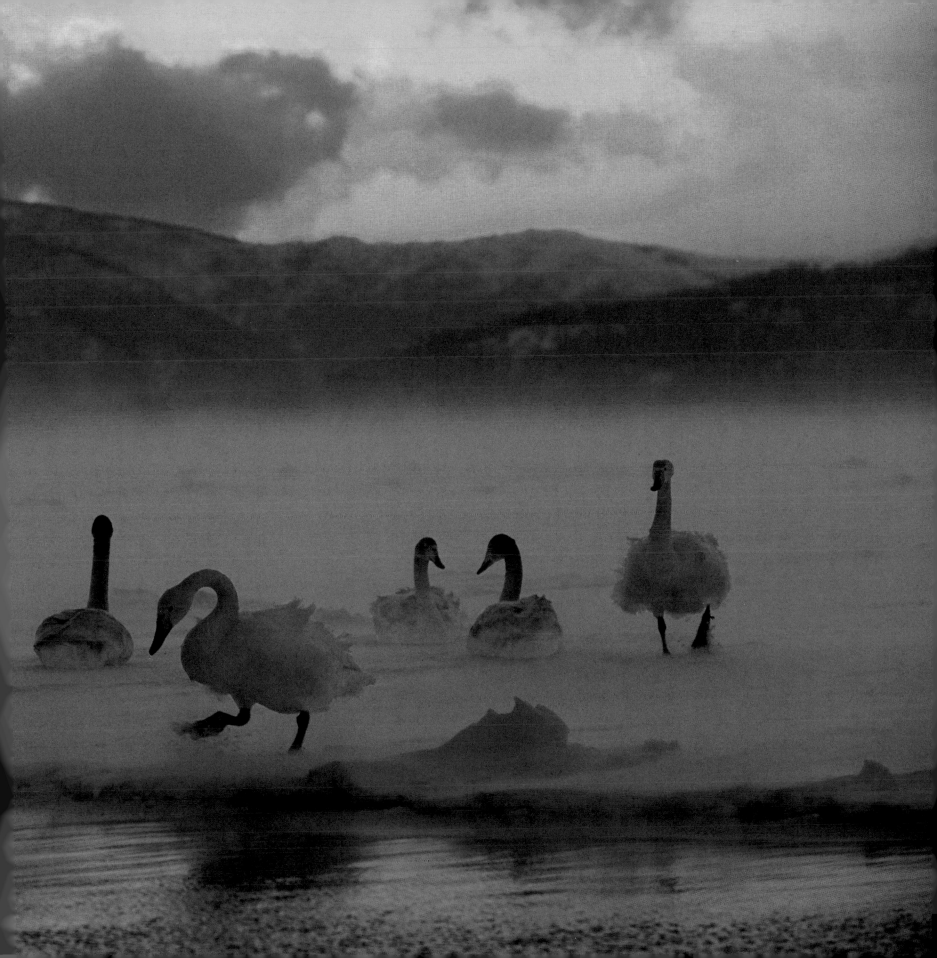

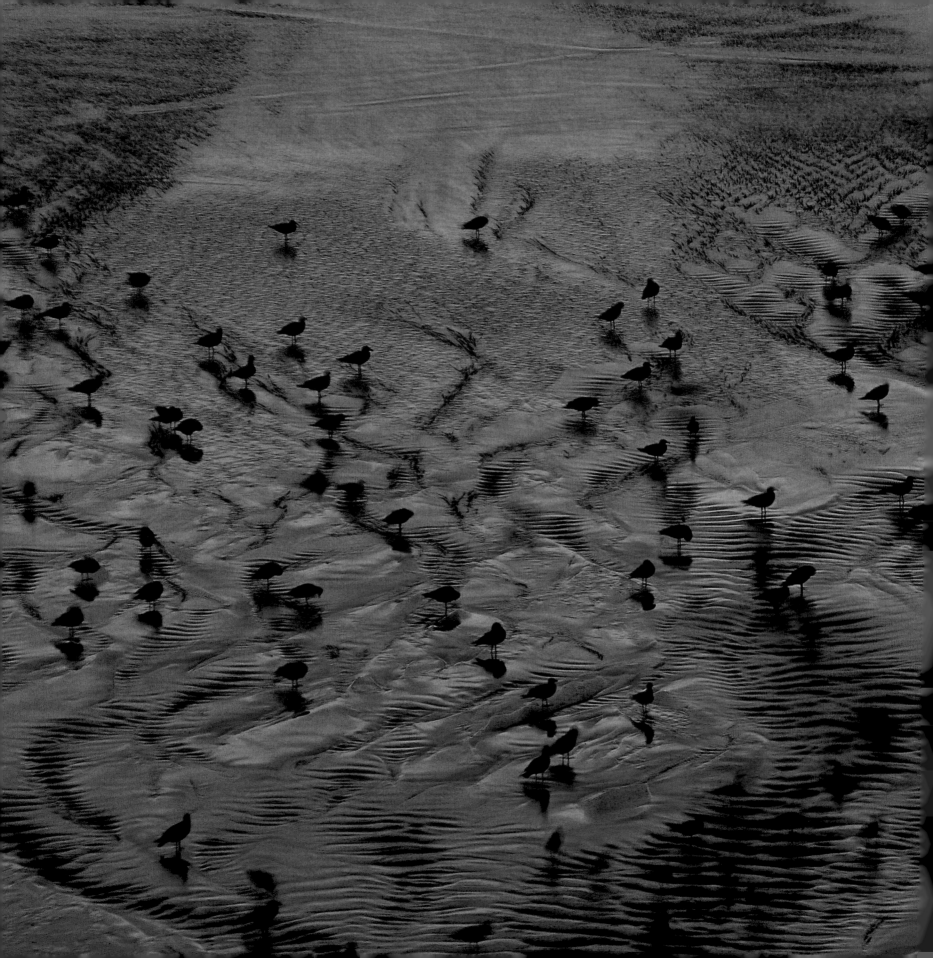

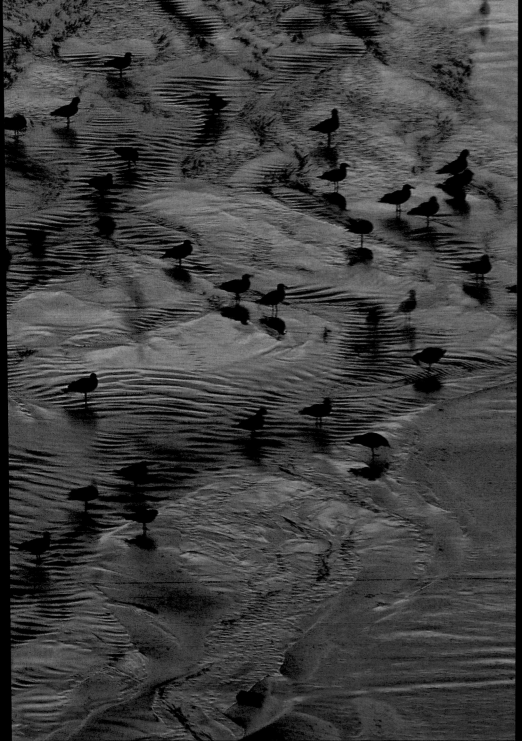

Carol Polich
USA

GULLS AT SUNSET

As I was driving along the Oregon coast one September evening, the beautiful colours created by the sunset over the Pacific caught my eye. I pulled off the road and took several photographs. I was so busy concentrating on the broader scene that I nearly missed the abstract and creative image of gulls silhouetted in the pink waters below. I had just a few moments left before the light faded completely to capture this tranquil fragment

Canon EOS 3 with 75-300mm lens; Fujichrome Velvia 50; tripod.

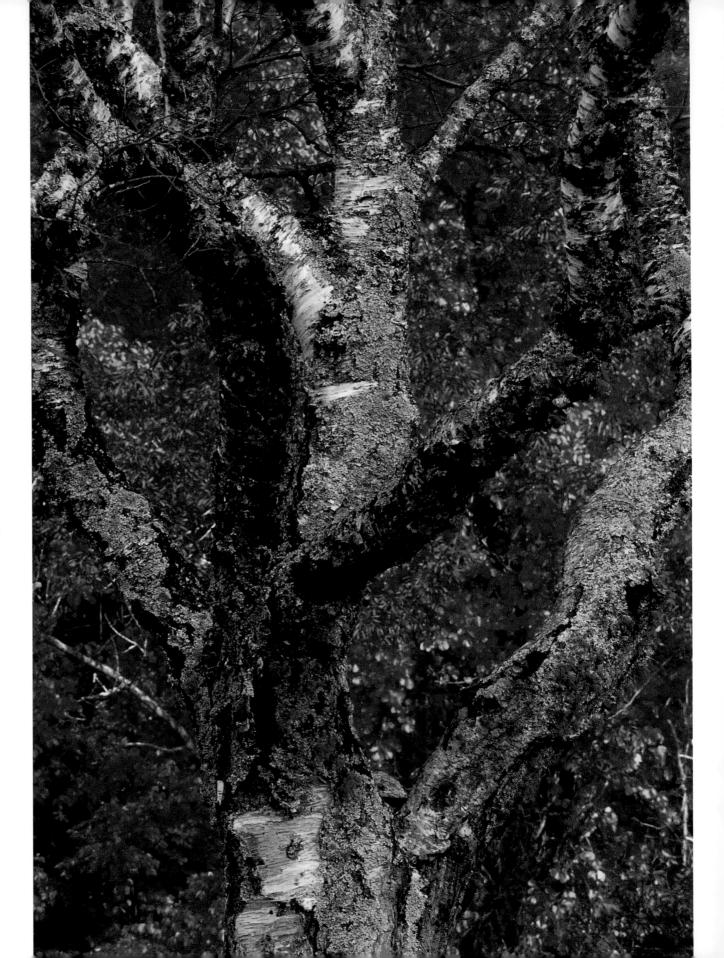

Ellen B Goff
USA

BIRCH, LICHEN AND LEAVES

For centuries, evergreens such as spruce and balsam firs filled Acadia National Park in Maine. But these species burn easily and regenerate slowly, and when a fire broke out in 1947, many were destroyed. A deciduous forest of birch, maple and aspen emerged in the evergreens' place. In the autumn, I visited the park to photograph the glorious kaleidoscope of colour.
I noticed the textured lichen-covered bark of this old birch tree. The brilliant colour of the background leaves bisected by the birch trunk and branches was reminiscent of a stained-glass window.

Nikon F5 with 24-120mm lens; 1/10 sec at f22; Fujichrome Velvia 50; tripod.

Composition and Form

Here, realism takes a back seat, and the focus is totally on the aesthetic appeal of the pictures, which must illustrate natural subjects in abstract ways.

HIGHLY COMMENDED

Jan Töve
Sweden

SILVER BIRCH AND REFLECTION

We often become so familiar with our own neighbourhoods that we become blind to the possibilities that exist right in front of our eyes. For years I have taken strolls around a lake near my home in Västergötland, Sweden, passing this silver birch tree every time without stopping to look at it properly. Then, one day in March, during that seasonal no-man's land after winter is over but before spring has arrived, I suddenly became aware of the tree's shimmering reflection. I 'saw' this image for the first time, even though I'd looked at it many times before.

Linhof Technikardan 6x9 with 210mm lens; probably 1/8 sec at f22; Kodak Ektachrome 100VS.

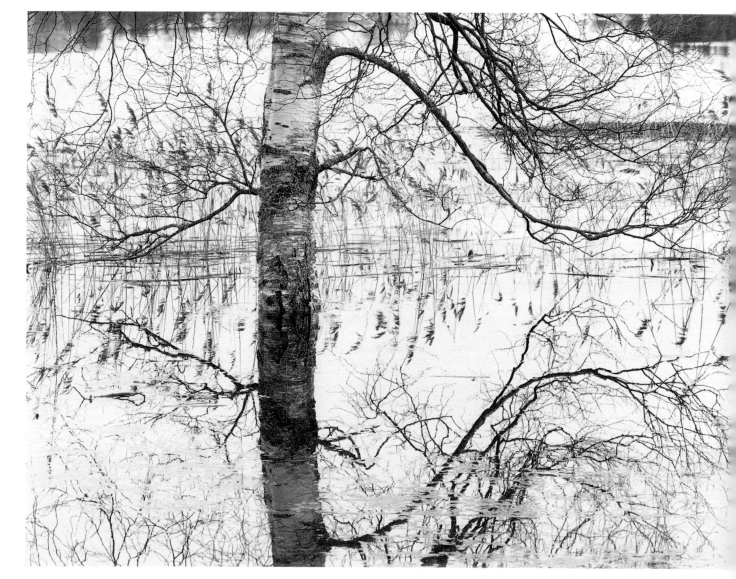

Claudio Contreras Koob
Mexico

MILITARY MACAWS
A major highlight of my time working on a project to promote awareness and support for the Tehuacan-Cuicatlan Biosphere Reserve in Mexico was when a military macaw colony was discovered. Sitting at the edge of the canyon they inhabited, I could enjoy the sight of at least 15 different pairs flying between the canyon walls. Switching to a low shutter-speed, I attempted to convey a sense of speed with the delicate flow of macaw wing beats.

Minolta 9 with 300mm lens and 2x teleconverter; 1/20 sec at f27; Kodak Ektachrome 100VS; tripod.

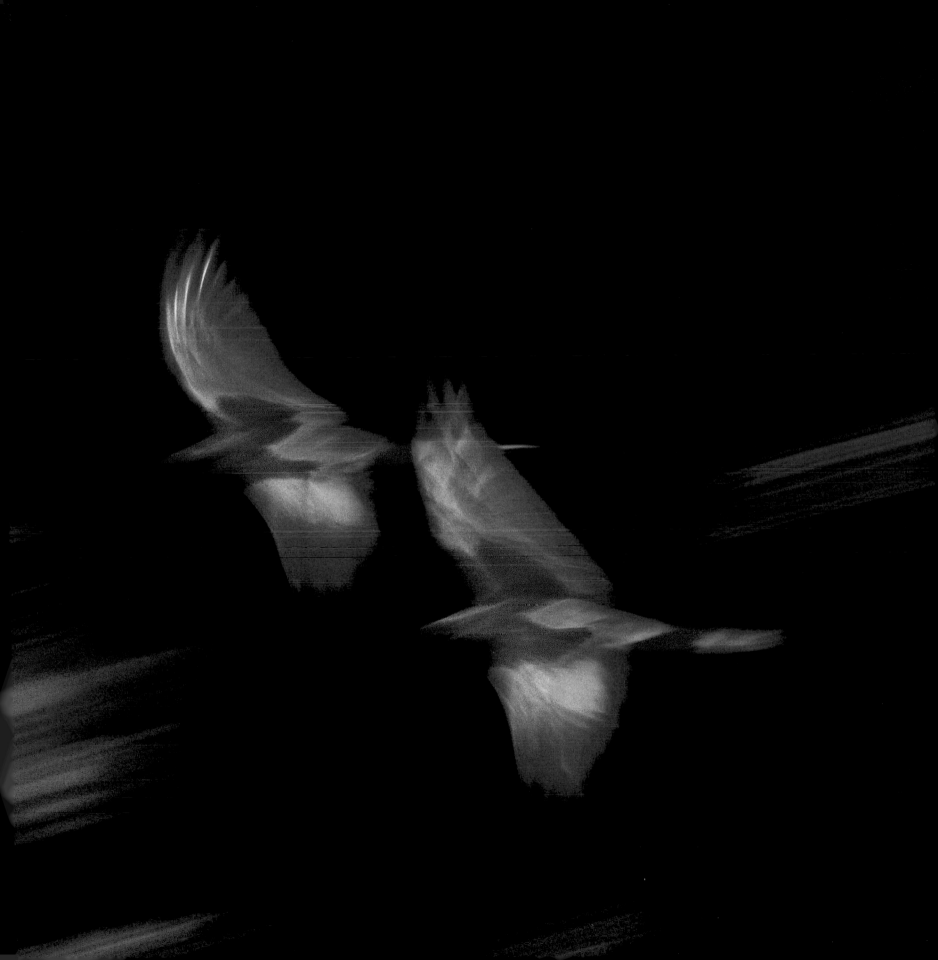

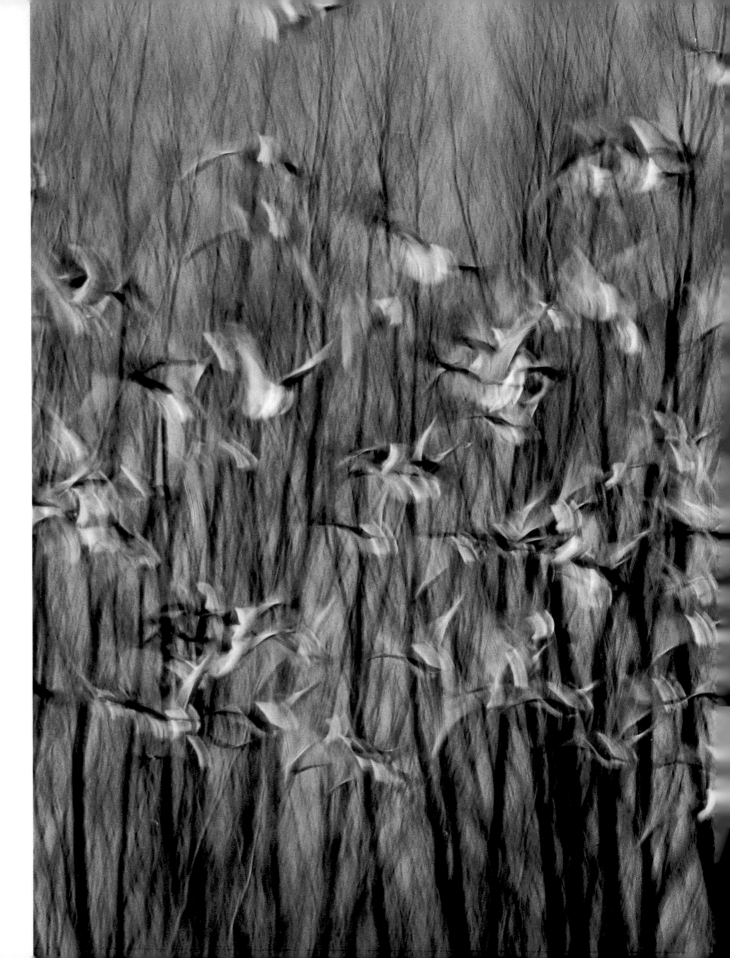

HIGHLY COMMENDED

Armin Paul-Proessler
Germany

WHITE-FRONTED GEESE IN FLIGHT

In the Netherlands, where the River Rhine splits into the Lek and the Waal, a vast wetland of flooded meadows stretches along the rivers. This valley, near Nijmegen, provides rich winter feeding grounds for the 600,000 wildfowl that migrate here from the Arctic every winter, including more than 100,000 wild geese.
I spent a day in the valley photographing white-fronted geese, whooper swans, goosanders and wading birds feeding in the meadows and on cultivated fields. At dusk, the birds take off in great, noisy flocks and head towards their roosts. I used the cover of a small dam to get close to this flock of white-fronted geese, ready for the moment they took off.

Minolta Dynax 7 with 400mm lens with a 1.4 extension; 1/15 sec; Kodak Ektachrome 100VS; monopod.

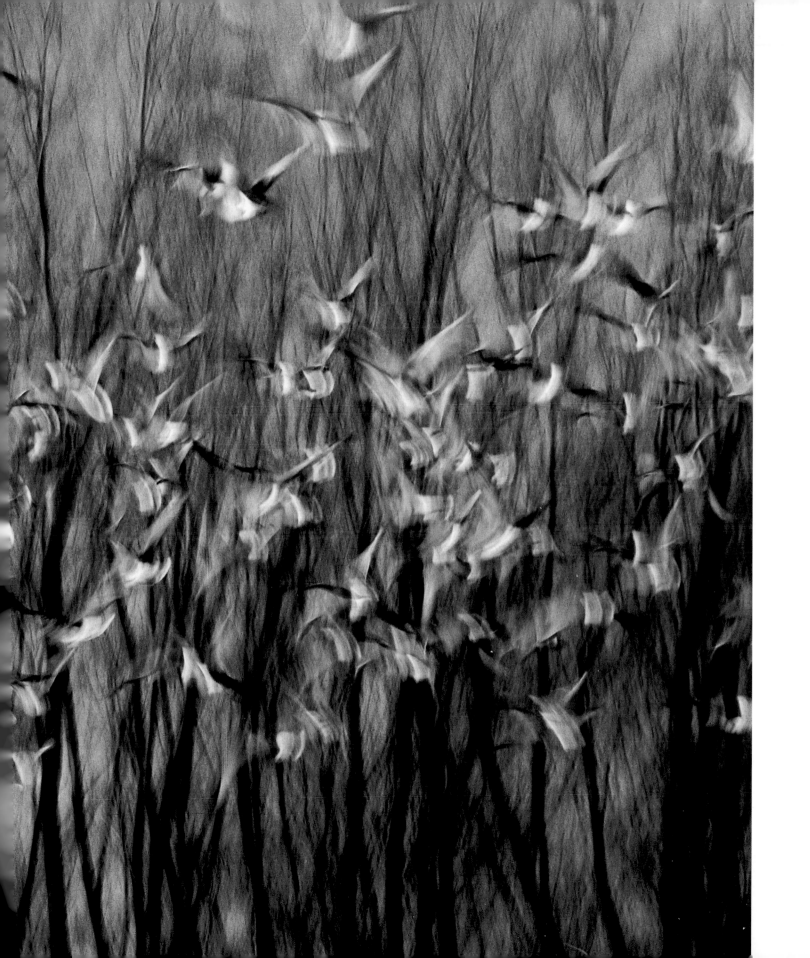

Johannes Lahti
Finland

LAKE WITH REEDS

I find seeking out artistic representations within the natural world more of a challenge than looking for animals. I try to assess my surroundings with a fresh perspective, always on the lookout for a detail that could be interpreted in an alternative way. In this instance, I was attracted by the light and form of this lake on a midsummer's dawn.

Canon EOS 1N RS with a 35-350mm lens at f22.

122

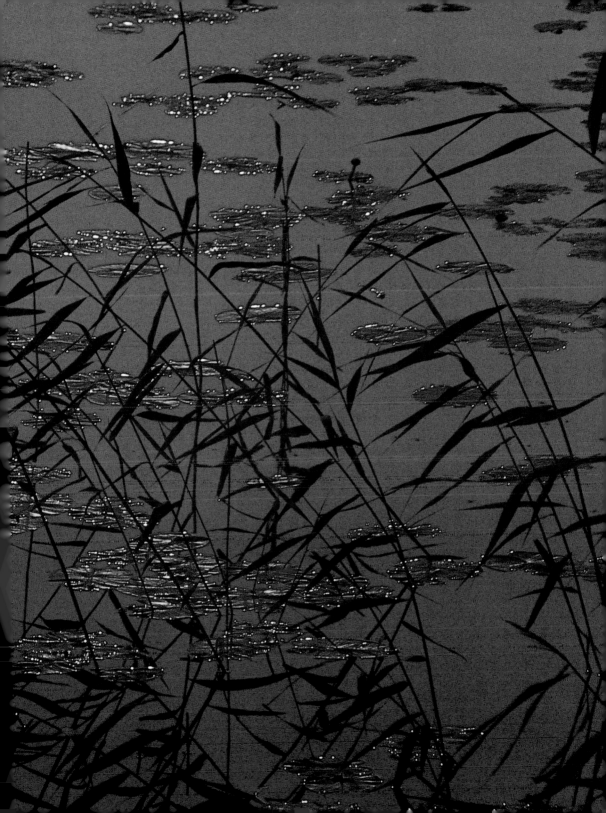

HIGHLY COMMENDED

Richard Herrmann
USA

PELAGIC TUNICATE
Salps often occur in long chains of many individuals. Though they look like jellyfish, they are taxonomically closer to humans. Last year, there was a big episode of Pegea salp chains off the San Diego coast in California, feeding on the plankton. One day, when there was no wind, we took a small boat about 20 kilometres out to sea. Then, using scuba gear, we dived to two or three metres below the surface and drifted with the salps. Each salp chain differs – some short, some long, some curled up in tight wheels, others floating loosely. They offer great opportunities for close-up photography.
Nikon N90s with 60mm macro lens; 1/125 sec at f16; Kodak Ektachrome 100VS; underwater housing; strobe.

HIGHLY COMMENDED

Tore Hagman
Sweden

QUIVER TREE AFTER SUNSET
The quiver tree (or kokerboom) is indigenous to the hot, dry southern part of Namibia. It is a succulent, which has adapted to the extreme environmental conditions by storing water in its distinctive trunk, and it can reach a height of nine metres. I set out one day to photograph quivers to the north of Keetmanshoop. Just after sunset, I found this individual lit by the setting sun's afterglow, which enhanced its leatherlike bark. By showing just part of the tree, I produced the strong image I was after.
Hasselblad 205 FCC with 250mm lens; 1 sec at f16; Fujichrome Velvia 50; tripod.

Kevin Schafer
USA

SPECTRUM ON SEASHELL
This was a felicitous event for me – I travel all over the globe chasing rare images, but this opportunity presented itself on a lazy afternoon in my studio. Light passing through bevelled glass in the window split the natural daylight into its constituent colours and sent a spectrum down on to the floor. I simply put a shell in the path of the beam of light and played with the rainbow colours and textures.
Nikon F100 with 60mm macro lens; 1/80 sec at f11; Fujichrome Velvia 50.

Innovation Award
Per-Olov Eriksson

This award exists to encourage innovative ways of looking at nature. It is given for the photograph that best illustrates originality of both composition and execution.

Per-Olov Eriksson lives in southern Sweden about 200 kilometres west of Stockholm and works as a part-time electrician and the rest of the time as a nature photographer. He has been fascinated with nature from an early age. It took a long time for him to be able to afford the camera that he really wanted — a Pentax 6x7 with enough lenses to allow him to photograph a variety of topics and start to earn money from his work. Nowadays he finds artistic nature photography the most satisfying. He is currently vice-chairman of the Association of Swedish Nature Photographers and has held exhibitions of his work in Sweden and Finland.

SUNBEAM ON A MUSHROOM
In autumn, you can always find a few destroying angel mushrooms among the thick mosses that carpet the floor of the ancient pine forest of Sveafallen Nature Reserve in County Närke, Sweden. On this particularly gloomy day, a shaft of sunlight suddenly pierced through the clouds and dense canopy, landing just a few metres from a single destroying angel. I realised that the narrow shaft of light would, in time, trace a path across the forest floor. And so I waited to see which way it would travel. To my delight, the sunbeam crept towards the mushroom. Nearly an hour later, it finally shone directly on the destroying angel: a celestial spotlight on a stage of soft, damp, dark green.
Pentax 6x7 with 90mm lens; 16 sec at f22; Fujichrome Velvia 50; soft filter.

The Eric Hosking Award
Vincent Munier

This award aims to encourage young and aspiring photographers to develop their skills in wildlife photography and give them the opportunity to showcase their work. It was introduced in 1991 in memory of Eric Hosking – Britain's most famous bird photographer – and goes to the best portfolio of six images taken by a photographer aged 26 or under.

Having worked as a photo-journalist for a French regional newspaper, taking time off when he could to photograph wildlife, Vincent Munier has recently decided to become a full-time wildlife photographer, spurred on by the fact that this is the third time he has won the Eric Hosking Award. He is also a conservationist and hopes that, through the power of his images, he will be able to make people aware not only of the richness and value of the natural world but also the need to care for it.

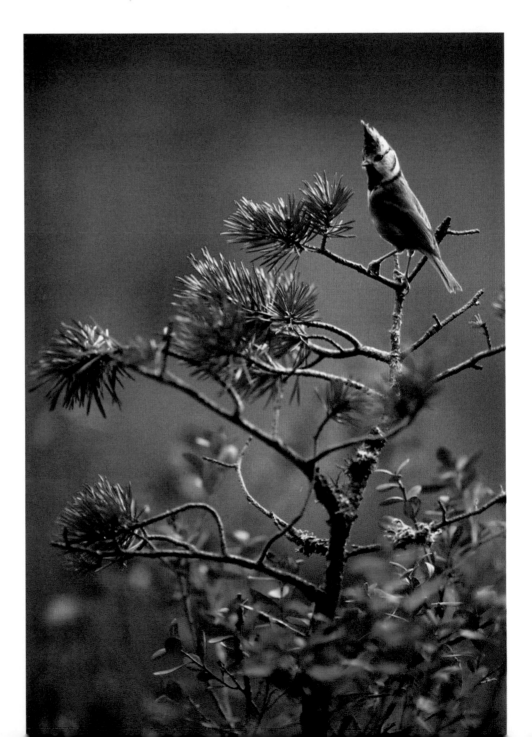

INQUISITIVE CRESTED TIT
Camera poised, I waited in my hide beneath a pine on the edge of a peat bog in the Vosges Mountains of eastern France. I hoped to photograph coal tits, and the autumn light and colours were in my favour. Lurking nearby, I noticed a crested tit – a much less gregarious cousin of the coal tit. It kept its distance, intrigued by my camera lens and the shutter noise. With a sudden burst of confidence, it approached, crest erect, for a closer inspection.
Nikon F5 with 300mm lens and 1.4x converter; 1/125 sec at f4; Fujichrome Velvia 50; tripod; hide.

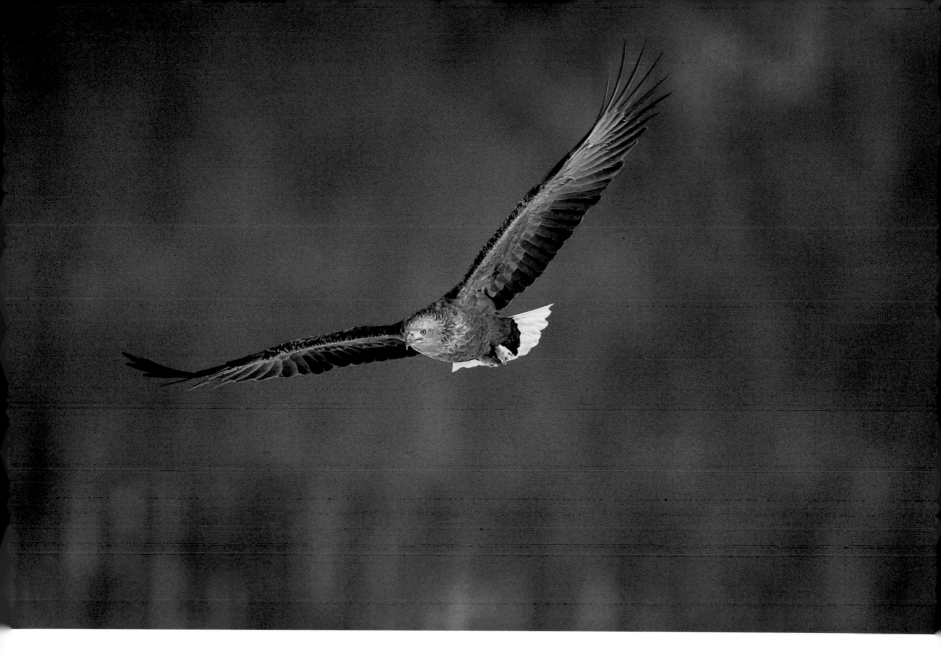

WHITE-TAILED EAGLE
While visiting the island of Hokkaido in Japan, I saw several white-tailed eagles flying towards Lake Furen. Being February, the lake was frozen and the raptors were unable to fish. Instead, they were scavenging on fish remains that the fishermen had discarded near holes in the lake ice. The reflected snow gave this adult's under-wings a warm glow.

Nikon F5 with 600mm lens; 1/400 sec at f5.6; Fujichrome Provia 100; tripod; hide.

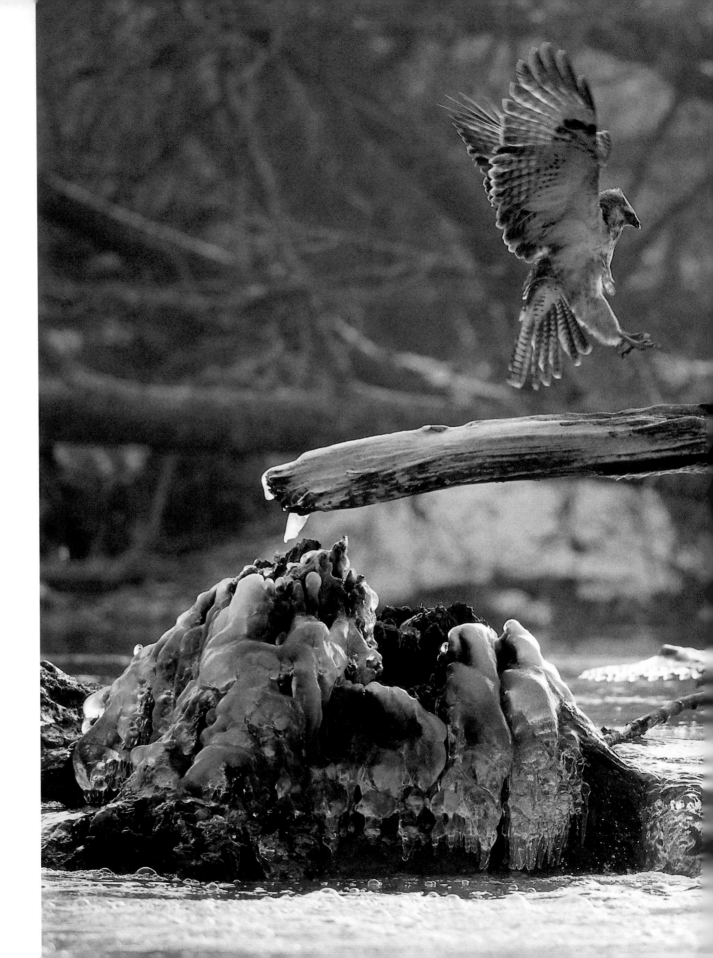

BUZZARD AND GREY HERON FIGHTING

For several days last January, in the Vosges Mountains of eastern France, temperatures plummeted to -20ºC. One morning, I noticed a common buzzard settling down on a riverbank with a coot it had just killed, and so I quickly set up my hide to photograph it feeding. Suddenly, a grey heron burst on to the scene, obviously very hungry because of the severe cold. It tried its hardest to steal the buzzard's prey, but the buzzard held its own. When I took this photograph, the buzzard had left the coot behind the tree stump so that it could give its full attention to the persistent heron.

Nikon F5 with 300mm lens; 1/300 sec at f4; Fujichrome Sensia 100; tripod; hide.

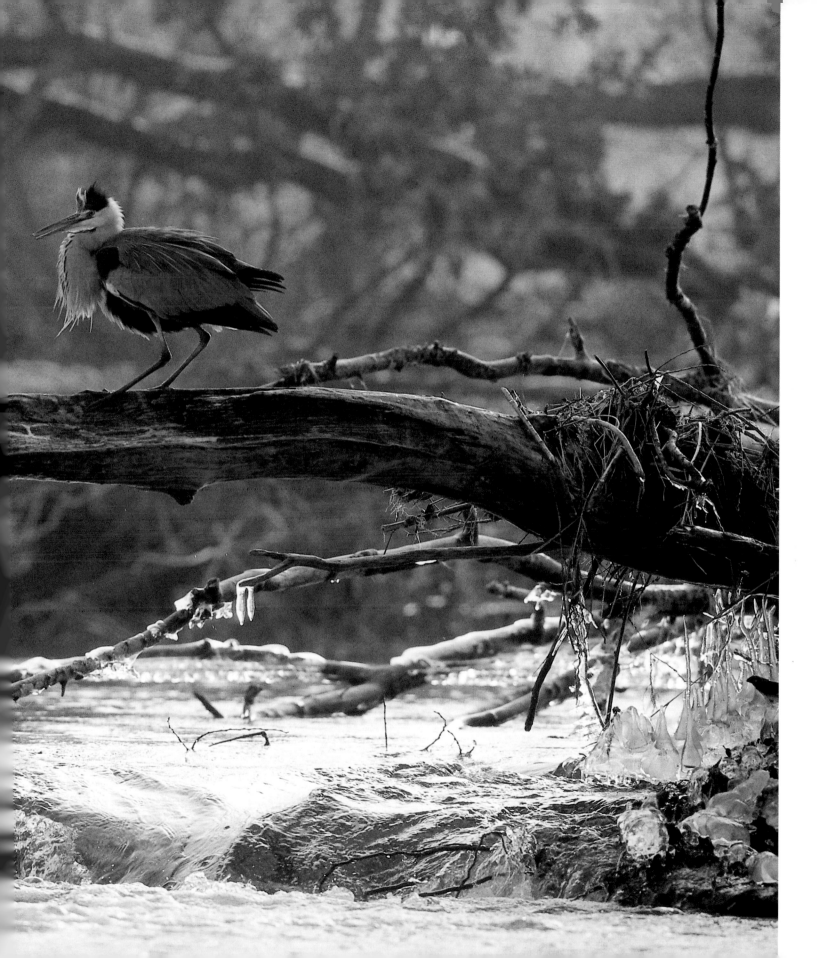

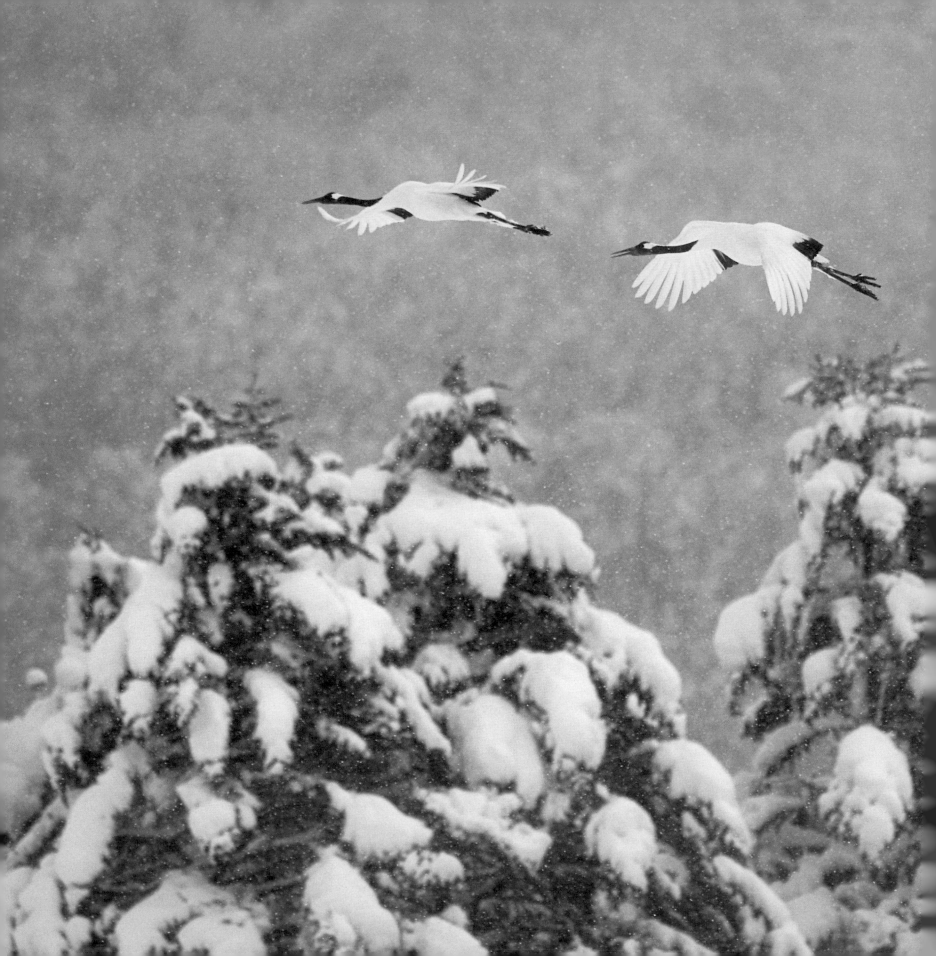

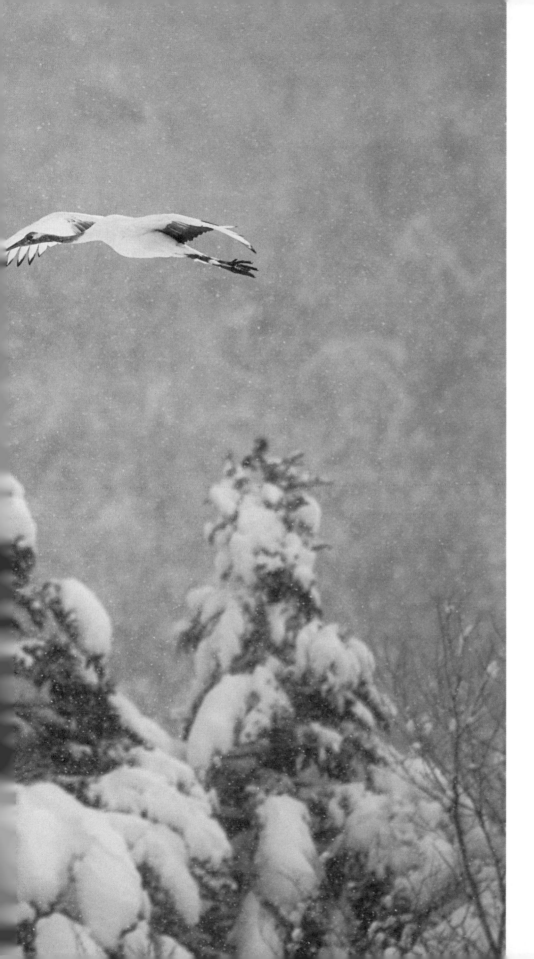

JAPANESE CRANES IN A SNOWSTORM

I waited eight days for the opportunity to photograph Japanese cranes in flight, staking out an area in Akan National Park in the northern island of Hokkaido, Japan. At last the moment arrived. More than 40cm of snow fell that day, but despite the snow storm, a crane family – two parents and their chick from the previous year – set off at the end of the day heading for their roosting spot. Following a drastic decrease in the numbers of Japanese cranes after the Second World War, mainly because of habitat loss, the population has recovered, thanks to conservation initiatives.

Nikon F5 with 600mm lens; 1/250 sec at f4; Fujichrome Provia 100; tripod.

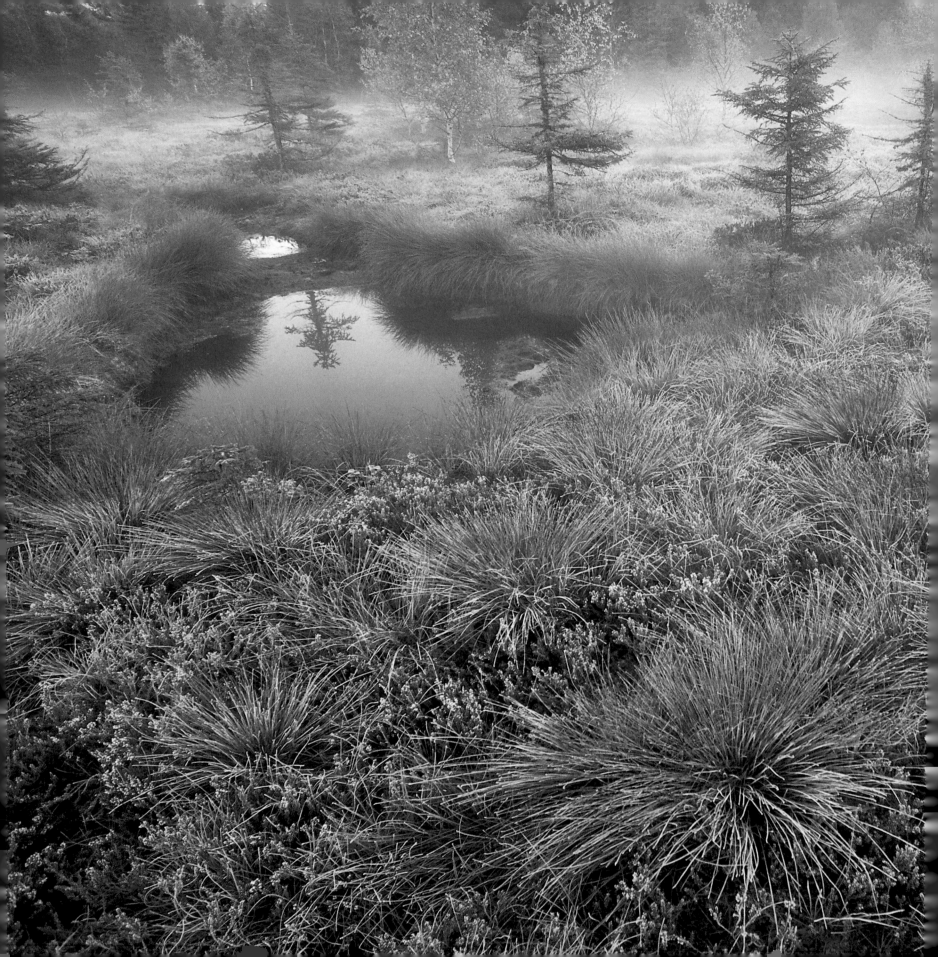

PEAT BOG ON A WINTER MORNING

Peat bogs are wild, mystical places where you can let your imagination run riot. This bog, in the Vosges Mountains of eastern France, was where my father took me when I was 13 to spend my first night in a hide watching capercaillies. For the past few years, there has been a big effort to protect peat bogs in France, the more remarkable of which have now been saved.

Nikon F801 with 20mm lens; 1/2 sec at f16; Fujichrome Velvia 50; tripod.

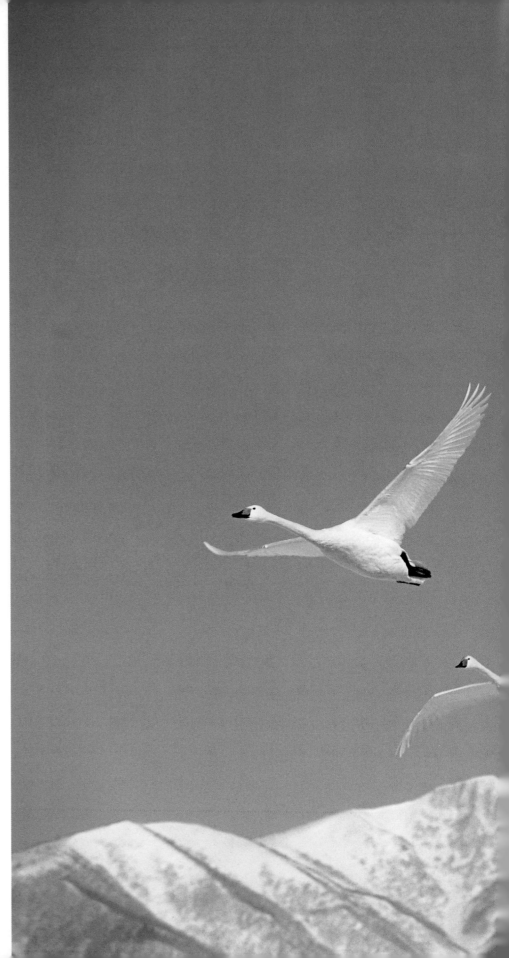

WHOOPER SWANS IN FLIGHT

In February, temperatures in Akan National Park in Japan's northern island of Hokkaido fell to -30ºC. These whooper swans were soaring over Mount Mokoto heading towards the lakes, which hadn't frozen because of the hot-water springs there. Visually, the scene was stunning, but to appreciate it fully, you would need to have been there to hear the swans' beating wings and non-stop calls.

Nikon F5 with 80-200mm lens and 1.4x converter; 1/500 sec at f8; Fujichrome Provia 100; tripod.

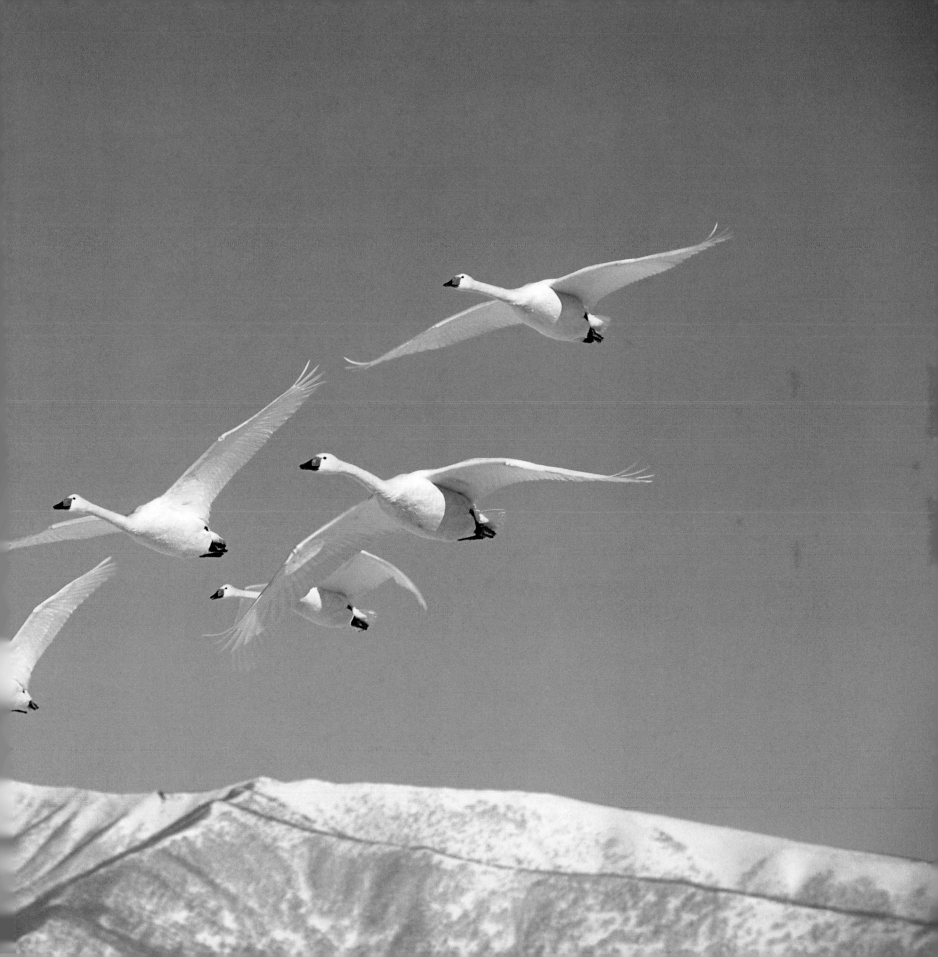

The BG Young Wildlife Photographer of the Year Award
Bence Máté

This award is given to the photographer whose single image is judged to be the most striking and memorable of all the pictures entered in the categories for young photographers aged 17 or under.

Bence Máté, aged 17, took his first photographs four years ago, with a Russian camera he borrowed from his parents. He practised taking wildlife photographs in the countryside surrounding his village, Pusztaszer, in Hungary, and by breeding rabbits, had soon saved enough money to buy his own photographic equipment. Bence built hides to enable him to get closer to birds and other animals and has spent hundreds of hours in them taking photographs and just watching the wildlife. Within cycling distance is a protected area, where he does a lot of his photography. He has already won several prizes in photographic competitions and has recently become the youngest member of the Hungarian Wildlife Photographers' Organisation.

CHAFFINCH WITH ITS POOLSIDE REFLECTION
Last spring, I dug a shallow pool, which is now regularly visited by lots of birds and mammals. I've spotted 41 different bird species visiting it, including a honey buzzard. Some days, more than 500 birds come to drink or have a bath. I sit nearby, motionless, for ages, and I always see something new. I took this particular photograph because the mossy boot's and chaffinch's reflections were so striking.
Nikon F100 with 300mm lens and 1.6x teleconverter; 1/60 sec at f2.8; Fujichrome Velvia 50.

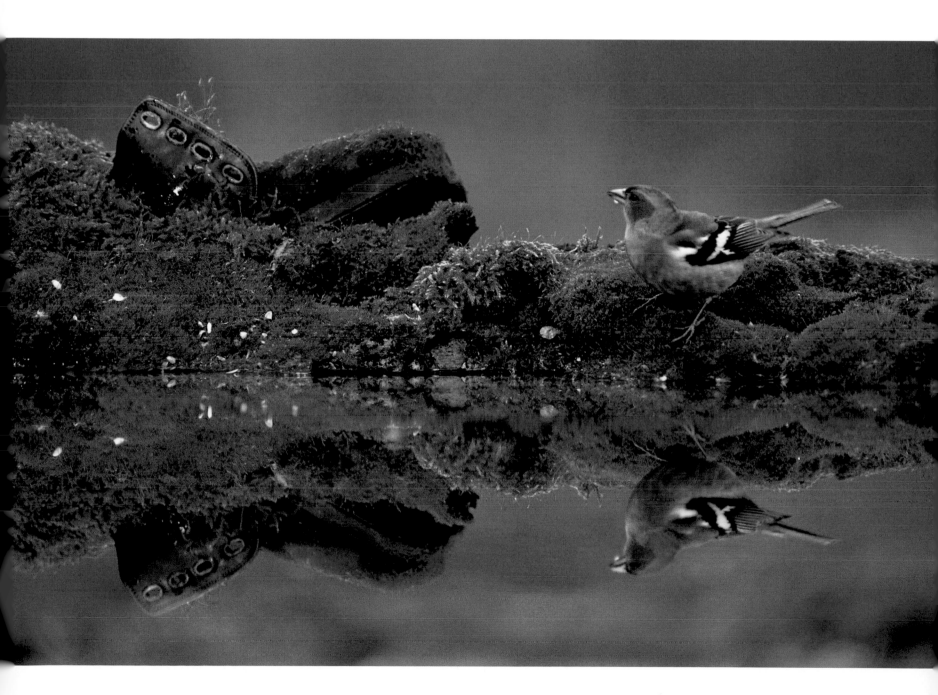

Young Wildlife Photographers of the Year

10 years and under

Maximilian Hahl
Germany

ALPINE IBEX
One evening in October, my Dad and I took a cable-railway up a 2,000m-high mountain called Gemmanalphorn in Berner Oberland, Switzerland. We spent the night camped in a cave. The next day, we walked to an area where you can get close to Alpine ibex (they were hunted to extinction in the area but have since been reintroduced). At first, it was very misty, but then it cleared up and we were able to photograph the ibex in a really good light. These animals are so used to people walking by that, if you stay calm and still, you can sometimes get to within a metre of one.
Nikon F70 with 20mm lens at f8; Fujichrome Sensia 100.

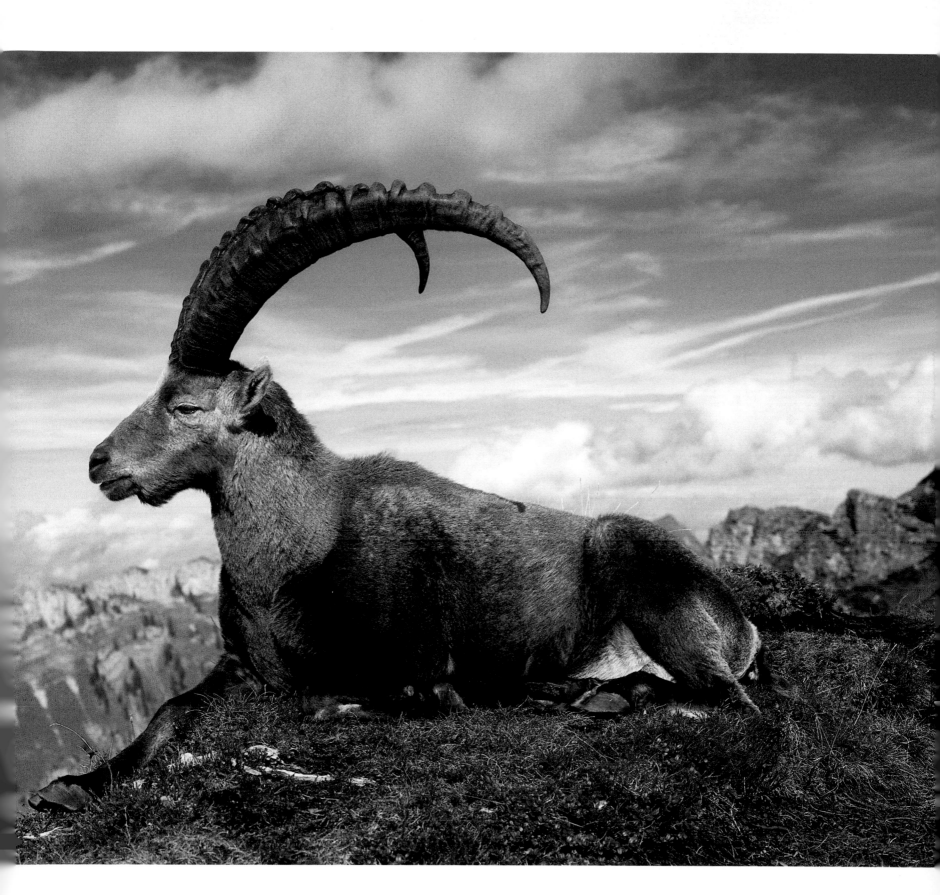

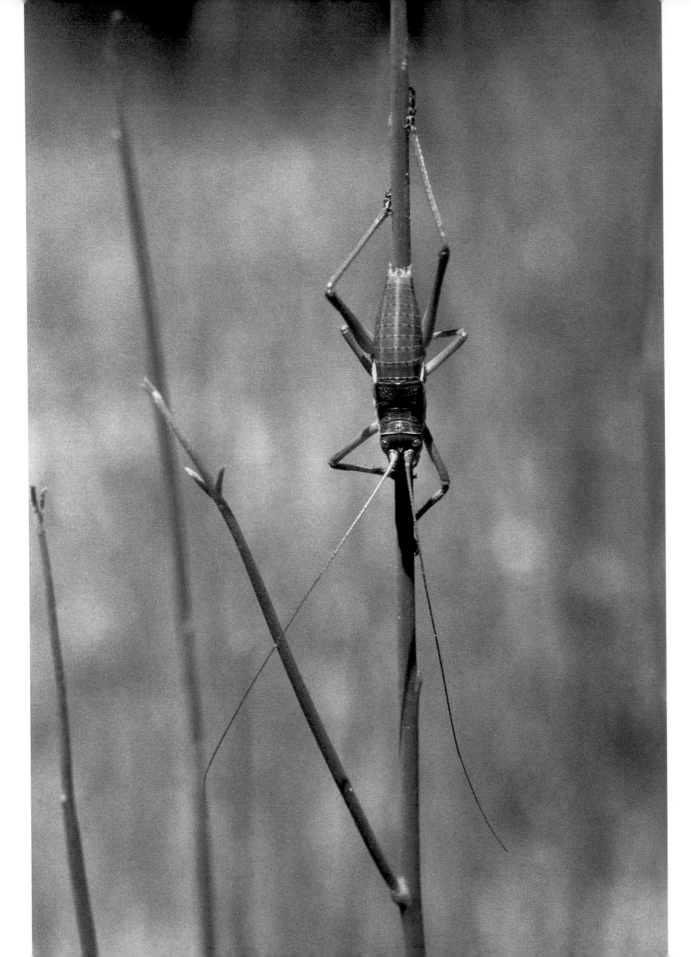

RUNNER-UP

Maximilian Hahl
Germany

BUSH CRICKET

My family went to a forest in Tuscany, Italy, for a summer holiday. It was very hot and dry. When I explored a sunny glade near the campsite, I found loads of different insect species, and I spent a long time watching them. I discovered a few bush crickets, but they stayed silent, probably because it was too hot to sing. I had to look very carefully to see this saddle-backed bush cricket because it had such good camouflage.

Nikon F70 with 135-400mm lens at f5.6; Fujichrome Sensia 100; tripod.

Chris Wilton
South Africa

**WHISTLING DUCKS
AT SUNSET**
My family was on a trip to
Mkuze National Park in South
Africa. At dusk, we drove to
the Nsumo Pan to look for
animals coming down to
drink. I saw this flock of
white-faced whistling ducks
resting in the shallows just in
front of us. Then the sun
appeared from behind a
cloud-bank, and I knew that it
would make a good picture.
Just afterwards, all the ducks
suddenly took off together
and headed towards an island
at the western edge of the
pan. Some were whistling to
each other as they flew.
**Nikon F801s with 28-70mm lens;
1/125 sec at f8; Fujichrome Velvia
50; polariser.**

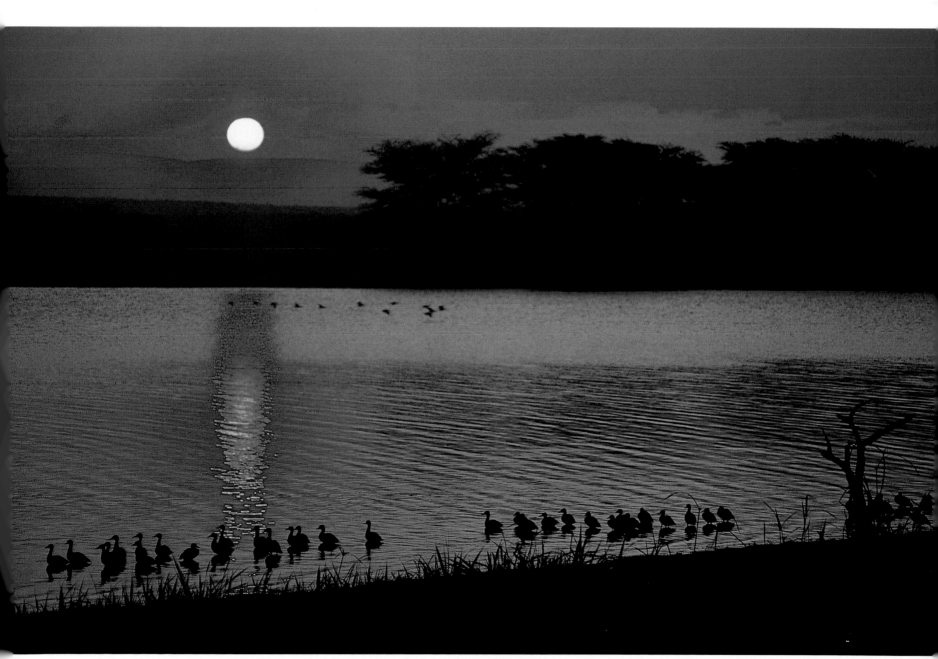

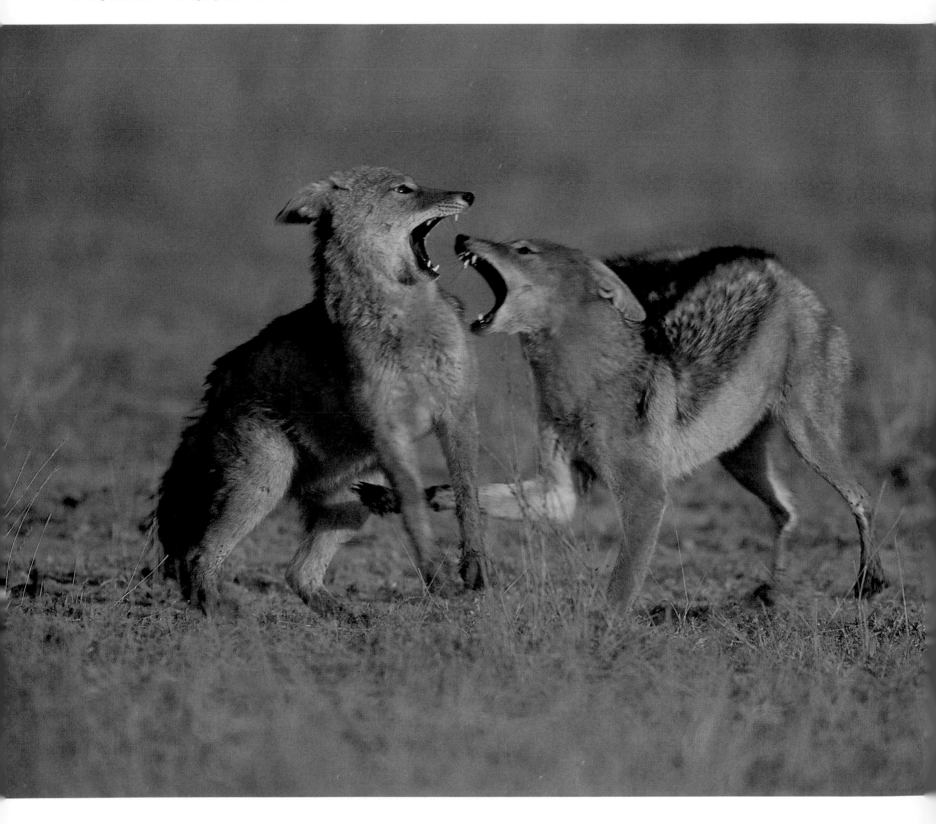

11-14 years old

Fanie Weldhagen
South Africa

GROUND SQUIRREL

A colony of ground squirrels lived in underground burrows around our campsite on the South African side of the Kgalagadi Transfrontier Park. They came out in the day to search for food, squeaking 'tschlp-tschlp' to each other when they played. Some of them have become very confident. Once, one went under the chair my brother was sleeping in. This one took an interest in my camera but kept some distance away.
Nikon F100 with 300mm lens; auto-exposed at maximum aperture; Fujichrome Provia 100; beanbags.

WINNER

Fanie Weldhagen
South Africa

BLACK-BACKED JACKALS FIGHTING

Late one afternoon, in the Kgalagadi Transfrontier Park, we watched a single male black-backed jackal drinking at the Kousant waterhole. When he finished, he went to lie down and bunched himself up against the cold. Just then, two more jackals arrived – a male and a female. We had seen this pair several times before, and the waterhole must have been part of their territory. The single male got up and started paying a lot of attention to the female. Her mate didn't like it at all. He growled, and the two males had a short fight. Then the single male had to leave.
Nikon F100 with 500mm; auto-exposed at maximum aperture; Fujichrome Provia 100; beanbags.

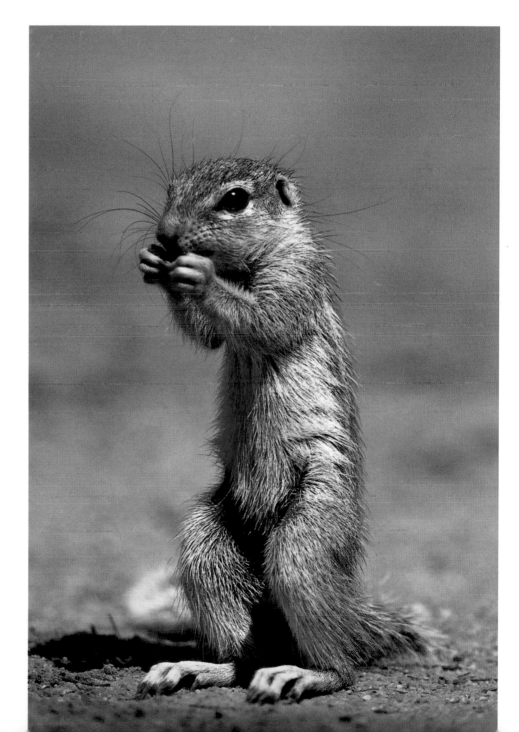

11-14 years old

RUNNER-UP

Oliver Kois
Germany

HERRING GULL
On holiday with my family in
France, we stopped at Étretat
on the Normandy coast.
We climbed a hill to admire
the fabulous view when,
suddenly, this herring gull
appeared right in front of me.
We stared at each other for a
few moments, and then I took
this picture.
**Canon EOS 300 with 20mm lens;
1/90 sec at f4; Fujichrome Sensia
100; flash.**

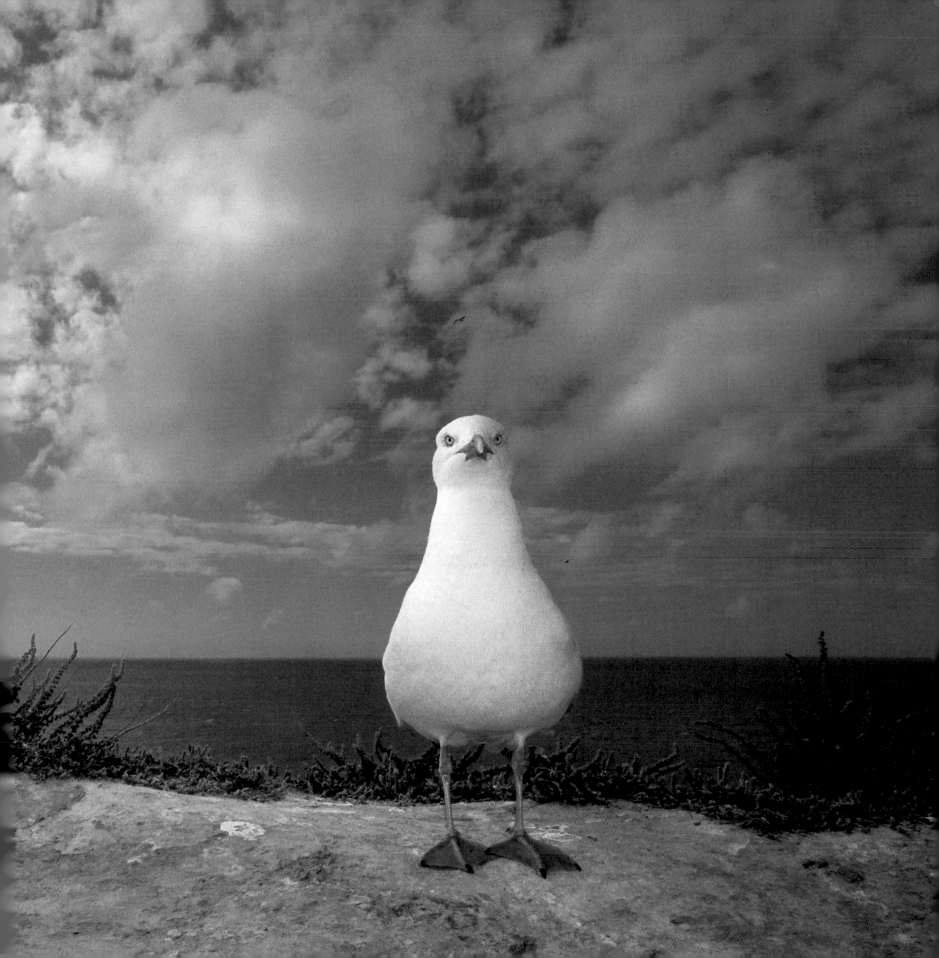

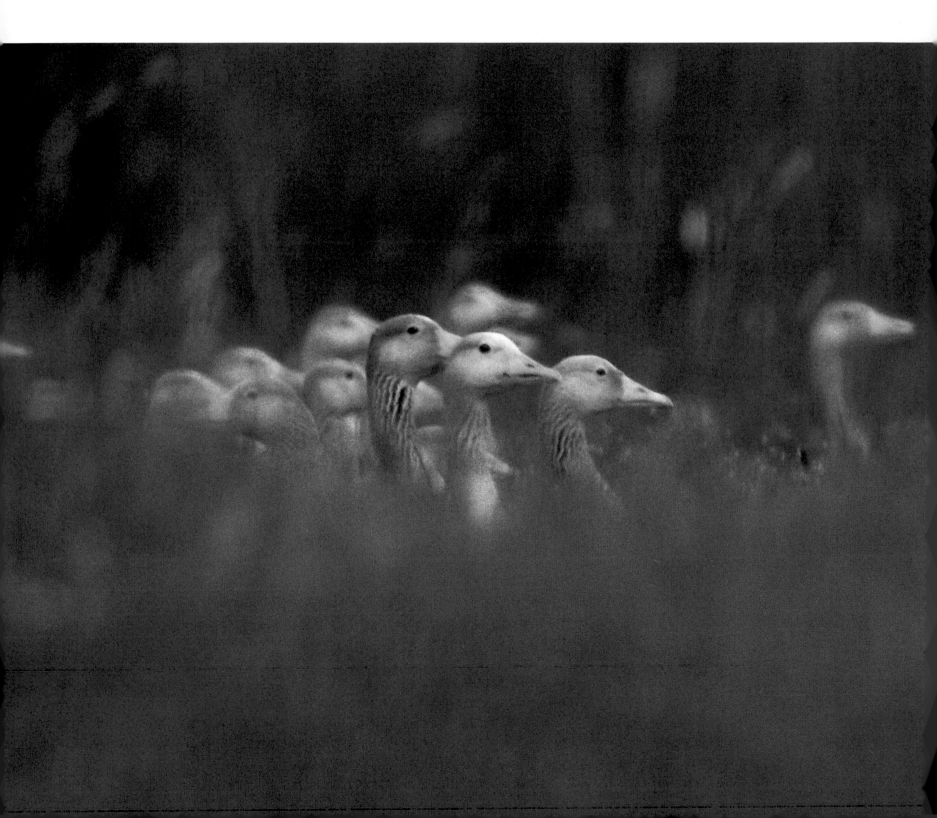

WINNER

Bence Máté
Hungary

GREYLAG GEESE
I put up my hide at a place frequently visited by geese, but they kept well away. I left the hide up for a few days and stealthily returned one dawn. Again, I didn't see a goose all day. But in the late afternoon, my rocking hide roused me from a nap – a stork was perched on top, shaking its wings. At the same time a whole flock of geese was walking by the hide. The two days' wait were well worth it.
Nikon F100 with 300mm lens; 1/125 sec at f2.8; Fujichrome Velvia 50.

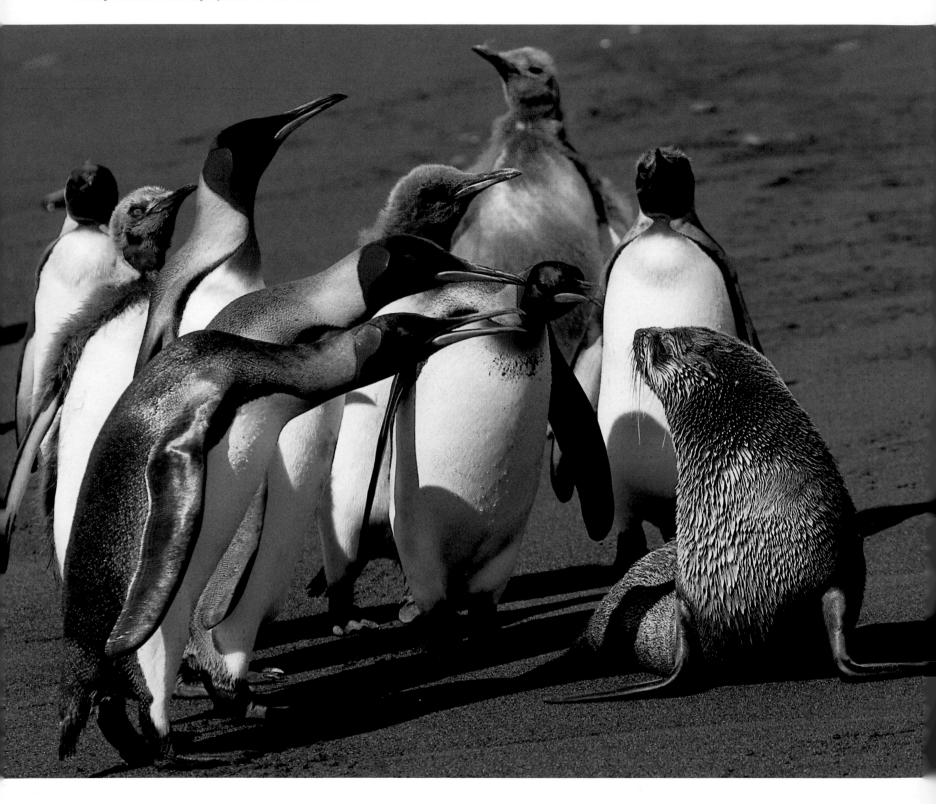

15-17 years old

RUNNER-UP

David Scott
Kenya

KING PENGUINS MOBBING A YOUNG FUR SEAL

The throngs of king penguins at Gold Harbour in South Georgia generally pay no attention to the massive elephant seals resting along the shore. But when this young fur seal hauled itself out of the waves, a group of king penguins immediately began to mob it. This was probably because, though adult fur seals feed mainly on krill, they sometimes take penguins. The birds slapped their flippers against their bodies and trumpeted loudly, trying to shoo the fur seal away. But the little seal refused to be harried and did its utmost to ignore them.

Canon EOS 1 with 70-200mm lens; 1/500 sec at f8; Fujichrome Sensia 100.

HIGHLY COMMENDED

Iwan Fletcher
UK

SANDERLING AT REST

When the tide is out in Foryd Bay in North Wales, large areas of sandbanks are exposed, where sanderlings regularly feed. I managed to photograph this pair by crawling along the sand with my camera and lens resting on the ground. By moving slowly towards the sanderlings and keeping low, I managed to get within three metres of the birds. As long as I made no sudden movements, they continued preening or sleeping and ignored me completely. Sanderlings are regular visitors to this part of North Wales, migrating from their high-Arctic breeding ground in late summer.

Nikon F90x with 170-500mm lens; 1/500 sec at f6.3; Fujichrome Velvia 50.

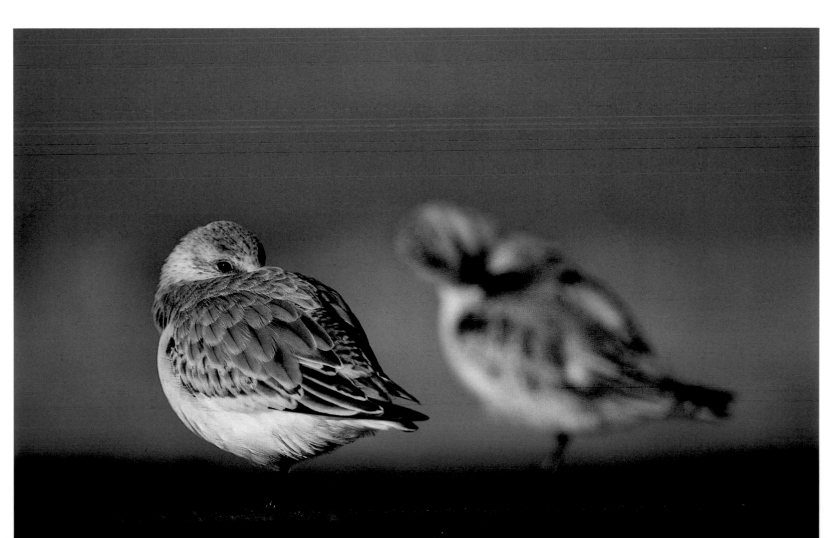

15-17 years old

HIGHLY COMMENDED

Christoph Müller
Germany

VIPERINE SNAKE SWIMMING

Last April, I found a few viperine snakes swimming near a small waterfall in a little river in Extremadura, Spain. For the next few days, we watched up to 10 individuals there, and I photographed this one from about 5 metres away. When threatened, this snake, which generally grows no longer than 80cm, will raise the front part of its body, inflate its head and spit in an intimidating manner, pretending to attack. But this behaviour is just theatrical, and the snake is completely harmless.

Canon EOS 100 with 500mm lens; 1/750 sec at f5.6; Fujichrome Sensia 100.

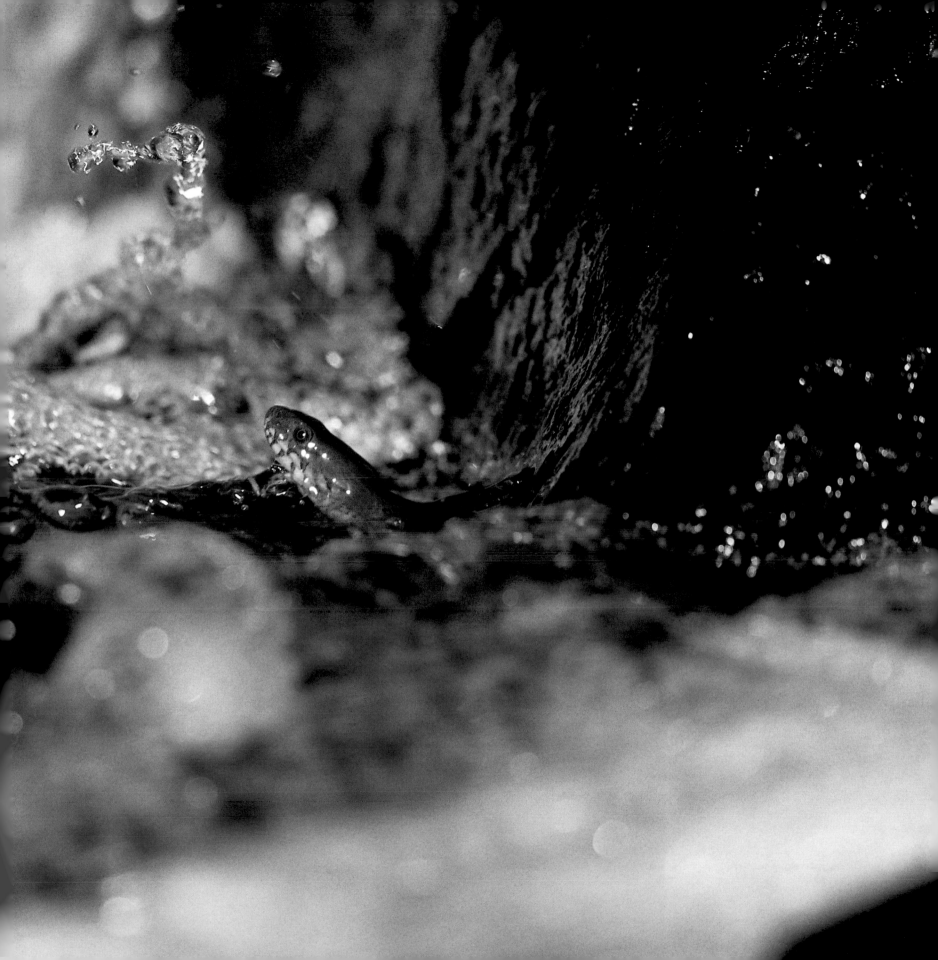

15-17 years old

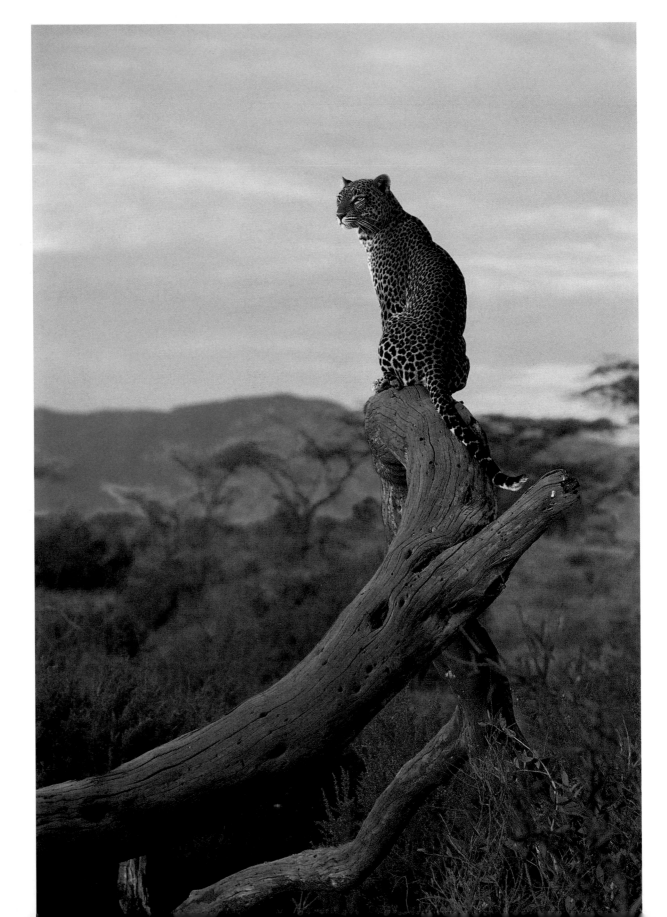

Charlotte Renaud
France

LEOPARD SEARCHING FOR HER CUB

While visiting Buffalo National Reserve in North Kenya, we became used to seeing a female leopard with her seven-month-old cub. One morning, the leopard called for her cub, which didn't answer immediately. The mother climbed up this fallen tree to call and look until her cub reappeared. The light was very beautiful, and I waited until the leopard's pose was just right before taking the shot.

Nikon F801 with 180mm lens; 1/125 sec at f4.5; Fujichrome Sensia 100.

The RSPB Wildlife Explorers Award
Close to Home

This is given to the young photographer with the best photograph illustrating plants, animals or wild places close to where they live.

Dan Slootmaekers
Belgium

NURSERY WEB SPIDER
One sunny day in May, I found this nursery web spider in our back garden in Belgium. There was no wind, and the spider was sitting completely still, about 20cm above the ground, suspended from a thread of web. The spider's name comes from the fact that, when the egg sac is ready to hatch, the female creates a nursery for her young by attaching the egg sac to low vegetation, spinning a tent around it and partially opening the sac so the babies can emerge into the nursery, which she then stands guard over.
Canon EOS 500 with 100mm macro lens; Fujichrome Sensia 100; tripod.

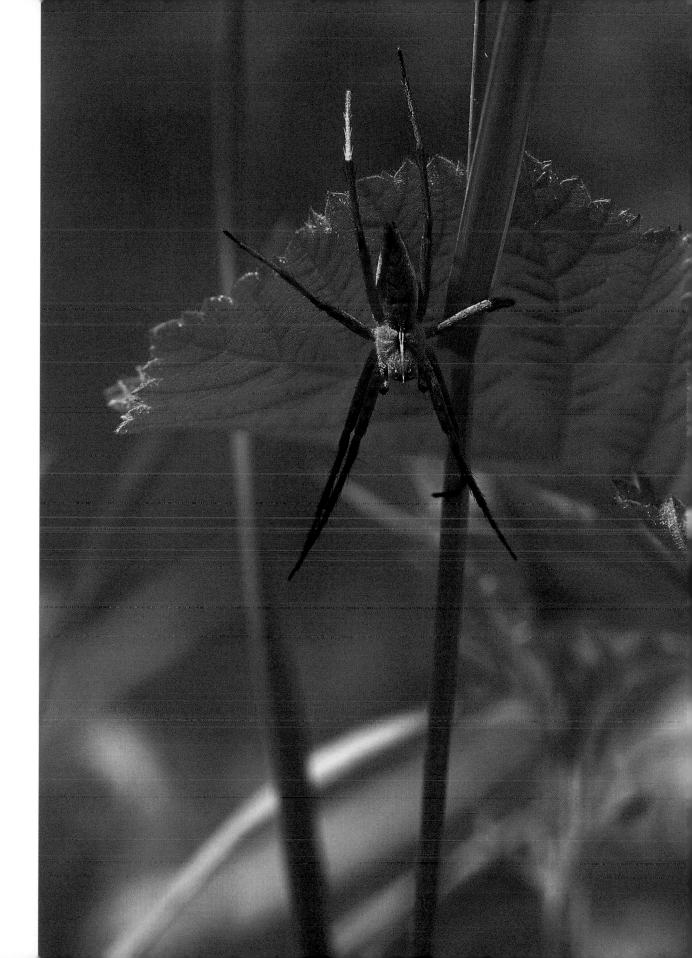

Index of Photographers

The numbers before the photographers' names indicate the pages on which their work can be found. All contact numbers are listed with international dialling codes from the UK – these should be replaced when dialling from other countries.